The Romance Fiction of
Mills & Boon, 1909–1990s

The Romance Fiction of
Mills & Boon, 1909–1990s

jay Dixon

First published in 1999 by UCL Press

UCL Press Limited
1 Gunpowder Square
London EC4A 3DE
UK

and

325 Chestnut Street
8th Floor
Philadelphia
PA 19106
USA

The name of University College London (UCL) is a registered trade mark used by
UCL Press with the consent of the owner.

British Library Cataloguing-in-Publication Data
A CIP catalogue record for this book is available from the British Library.

Library of Congress Cataloging-in-Publication Data are available

ISBN: 1–85728–266–3 HB
 1–85728–267–1 PB

Every effort has been made to contact copyright holders for their permission to
reprint material in this book. The publishers would be grateful to hear from any
copyright holder who is not here acknowledged and will undertake to rectify any
errors or omissions in future editions of this book.

The permission for the use of extracts taken from Mills & Boon® publications has
been kindly granted by Harlequin Books S.A. Switzerland with acknowledgement to
Harlequin Mills & Boon Limited, UK.

Mills & Boon is a registered trademark owned by Harlequin Mills & Boon Limited,
UK. Temptation is a registered trademark owned by Harlequin Enterprises Limited,
Canada. Silhouette is a registered trademark of Harlequin Books S.A., Switzerland.

Harlequin, Harlequin Presents, Harlequin Romance, Temptation and MIRA are
registered trademarks owned by Harlequin Enterprises Limited, Canada. Mills & Boon
Enchanted is a registered trademark owned by Harlequin Mills & Boon Limited, UK.

Typeset by Graphicraft Limited, Hong Kong
Printed by T.J. International, Padstow, UK

This book is dedicated to:

The memory of John Boone and Jacqui Bianchi – may their dedication to the genre of romance fiction live on in their successors.

All the past, present and future authors and readers and editors of Mills & Boon romances – may your enthusiasm for the genre never wane.

All those women who have ever defined themselves as feminist – long may we live.

Mike Smith – because I promised, and because without whom this book may not have been written.

My parents, Ida and Jack Dixon – with love and gratitude for all the years of support and encouragement that they have given me in all my endeavours.

Contents

Foreword

Rosemary Auchmuty

A great deal of patronising nonsense has been written about Mills & Boon romances. As "popular culture" they are fair game for literary dismissal; as books for women they invite condescension and ridicule; as the pioneers of brand-name publishing, whose readers are attracted by a logo rather than an author's name, they have come to stand for all that is worst in formulaic writing and cynical mass-marketing. Apart from their (millions of) readers, few people have anything good to say about Mills & Boon romances; while many who have never read one are quite prepared to denigrate the genre without regard for evidence or truth. As Sheila Ray, author of *The Blyton Phenomenon*, wrote of another equally derided icon of popular culture, "the sternest critics do not see any need to get their facts right".[1]

jay Dixon's book is different.

Dixon writes as an *insider*, an avid reader of Mills & Boon romances. "Personally, I never travel anywhere without one," she tells us. She has read – and enjoyed – hundreds of Mills & Boon romances, dating from the birth of the genre in the early years of this century up to the present. So she knows what she is writing about and can set the record straight. As a former employee of the firm, personally acquainted with key personnel including many authors, she has a staggering breadth of knowledge of the genre, its creators and its critics. For those of us who are not so deeply immersed, many surprises lie ahead in this book.

Dixon challenges many popular myths about Mills & Boon novels. For example, it is often said that Mills & Boon never depicted premarital or extra-marital sex until very recently. Dixon

shows that, on the contrary, both have featured in novels of every decade from before the First World War. We tend to think of the typical Mills & Boon hero as aggressive and masterful and the heroine as passively awaiting her prince. But Dixon points out that the macho hero conventionally associated with Mills & Boon only made his appearance in the 1970s, his predecessors including men who were younger, poorer, and/or physically inferior to the heroine, and his successors tending towards the "New Man". Mills & Boon heroines, too, are far from the stereotypes of feminine passivity that their critics have led us to expect. They are usually working women – women with life goals independent of their desire for a man's love – women who are not prepared to take their men as they are, with all their masculine imperfections, but who seek to transform them through love, to bring them firmly into the more humane and egalitarian feminine value system. Many, indeed, are already married, and the plot turns not on winning Mr Right but on transforming a problematic marriage into a fulfilling one.

Equally importantly, Dixon writes as a feminist. She demonstrates, as other feminists have tried to do before her, that even an apparently reactionary genre like Mills & Boon romances can be read positively by women. What makes her work different from that of most of her predecessors is that, as a Mills & Boon enthusiast who is herself a feminist, she is living proof that such messages can be taken from the books. In this sense her book is one big primary source, one woman's first-hand account of her reading life.

But it is more than this. Dixon understands the conventions of the genre as only an insider can. She can "read" the symbols (for instance, the home as the place of feminine power into which the hero must be brought) and explain the significance in plot terms of particular scenes, such as the violent sexual assaults on heroines by 1970s' heroes, to which feminists have not unnaturally objected. At the same time she understands the feminist objections. She recognizes above all that Mills & Boon romances are historical documents and must be read in the context of the time and manner of their production. In this sense her book is a painstaking historical account of the genre's development over the century and the ways it has responded both to historical events such as war

and to ideological changes, especially those relating to ideas of sexual equality and women's role.

Here again we find many surprises. Mills & Boon heroines, it seems, often challenged contemporary ideologies, for example around work. In the interwar years, at a time when women's magazines and middle-brow novels placed women firmly in a domestic situation, Mills & Boon heroines engaged in professional careers and forced their men to recognize the importance of economic independence for women – even after marriage! More recently, they have attempted to transform the workplace to accommodate to the needs of women and to find creative solutions to the problems of two-career families (solutions which do *not* involve the heroine's giving way to the man). Mills & Boon novels explicitly argued for divorce law reform both pre-First World War and between the wars and again in the 1960s. Throughout the century, plots have changed to meet readers' changing expectations, showing that Mills & Boon authors respond to an audience which is far from passive and unquestioning.

The novels have their limitations, of course. Conservative in many ways, they are also homophobic and racist. The heterosexual bias is perhaps inevitable given the product's underlying message, that women can change men through love, but there can be no excuse for the fact that there are never any black protagonists. But Dixon concludes that in many important respects the novels are feminist, not simply because they depict women's experience from women's point of view, but because they consistently argue that men must change to meet women's standards. Though the solutions offered by each book are individual ones, the cumulative effect of such a mass phenomenon can be seen as a challenge of social dimensions.

At the close of the twentieth century Mills & Boon is at a turning-point in its history. Now part of a North American conglomerate, it has lost its personal relationship with its British readers and is apparently losing ground to competitors. But the popularity of the romance shows no sign of waning. It remains one of the most important cultural artefacts of our time, the favoured reading matter of millions of women in the western world. It deserves serious consideration by an accurate and sympathetic consumer/scholar,

and I can think of no one better qualified to provide this than jay Dixon. She gives us both a fascinating account of the Mills & Boon romance in its historical and ideological context and a personal defence of a much-maligned literary genre, whose significance is only just beginning to be properly appreciated.

1. Sheila Ray, "The Literary Context"; in Rosemary Auchmuty and Juliet Gosling (eds), *The Chalet School Revisited*, London: Bettany Press, 1994, p. 104.

Acknowledgements

I would like to thank the following readers, authors and editors who kindly completed a questionnaire for me on their experience of Mills & Boon romances:

Linda Allsopp, Lisa Appignanesi, Elizabeth Bailey, Jay Blakeney, Sue Curran, Sue Fern, Catherine Haigh, Felicity Jelliff, Daphne Clair de Jong, Caroline Kaye, Helena Muriel Lumb, Sheila Holland, Leonie Horsley, Linda McQueen, Carole Mortimer, Marie Murray, Janet Nicholson, Rose Shepherd, Carolyn Smalley, Sara Steel, Cathy Wade, J.S. Walton, Frances Whitehead, Jeanne Whitmee, Cathy Williams, Mary Jo Wormall.

I would also like to thank Ida Pollock for permission to quote from *Flight to the Stars*; James Malcolm for permission to quote from Margaret Malcolm's novels; Doreen Montgomery of Rupert Crew Limited for permission to quote from Mary Burchell's *Wife to Christopher*, *Such is Love* and *After Office Hours*; David Higham Associates for permission to quote from Elizabeth Hoy's *Give Me New Wings*, and Paul Bulos of Mills & Boon for all the work he put into discovering the copyright holders of all the romances from which I quote in this book, and for granting me permission to quote from all the novels to which Mills & Boon held the rights.

Also Peter Brooker, who first encouraged me to study the genre, and the anonymous reader for UCL Press who said I was the person to write this book. I hope the result meets with her approval.

Also June Purvis, who suggested the book, and Steven Gerrard, who agreed with her! I would also like to thank Rosemary Auchmuty for her Foreword, which made me think that perhaps the book has been worth writing after all. The copyeditor is often

the silent and unthanked partner in the production of a book. I, however, would like to thank both Chris McLaughlin and Carol Saumarez for their labours on my behalf. A special thanks is due to Sarah Daniels whose pertinent comments gave me the opportunity to clarify parts of the text at a late stage in the editing process. Any remaining obscurity is due to my intransigence, not her editing skills!

Also Kelly Boyd, Lucy Bland, Patricia de Wolfe, Jack Dixon, Alison Oram, Karen Seago, Carolyn Smalley and Imelda Whelehan who all read and commented on an early draft, and made me re-think my original structure, and the anonymous reader who commented on the second draft. They all raised some pertinent points; I hope the final result is worthy of their efforts.

Last, but most importantly, I would like to thank all those friends who, over the past ten years, have listened so patiently to me as I alternately enthused and complained about "my book", and who offered encouragement and support when I needed it.

jay Dixon

Introduction

Mills & Boon have a happy knack of discovering the popular author

When I first started the research for this book, over ten years ago, I had to overcome the perception that Mills & Boon romances were not worthy of serious study. Although no one would have disputed the *Illustrated London News* critique of the 1910s quoted in the title of this chapter, neither would they have taken the sentiment any further. Since then, as more universities have included the study of popular literature in their courses, this view has changed. Nevertheless, some of the old arguments against reading romances are still being put forward by the media and literary critics, and yet most are based on prejudice, and ignorance caused by blinkered thinking. This book sets out to challenge these perceptions.

One of the main criticisms of Mills & Boon books is that their plots are all the same: girl meets boy, they encounter problems, girl runs away, girl returns, all is miraculously explained away, and marriage ensues. This, of course, is the plot of Charlotte Brontë's *Jane Eyre*, Jane Austen's *Pride and Prejudice*, Samuel Richardson's *Pamela*, *Cinderella*, and *Beauty and the Beast*. Parallels can be drawn back to Greek and Roman myths, for it is one of the few plots in the history of fiction.

Another storyline is that of the lone male fighting against megalomania and saving the world – or his corner of it – from destruction. Think of westerns, with their "good guy" fights "bad guy", "good guy" wins plots. Think of all the James Bond novels, thrillers, and detective fiction. In the latter order is restored to society after crimes have been committed. Or, as Mandel defines their plots: ". . . the Problem, the Initial Solution, the Complication, the Period of Confusion, the Dawning Light, the Solution, the Explanation"

1

(1984:16). This plot can be traced back to the story of Christ – a lone male who has come to Earth to save the world and everyone in it. Perhaps this is why novels based on the "lone male" plot are more highly regarded in western culture than those based on a love plot.

All genre fiction has its own characteristic plot line, whether it be love conquers all, or the lone avenger saving the weak. Thus to decry romance fiction on the grounds that the plot is always the same is to betray an ignorance of a fundamental element of all genre fiction – the familiarity of the plot. What is more revealing is how the author either works inside, or expands the parameters of the particular genre – of any type. As will become apparent through the arguments developed in this book, the authors who have written Mills & Boon books have expanded the parameters of the romance novel throughout history.

The reason crime novels garner respect is often said to be because they are male – not just that they are written by men, about men, for men (which is no longer true, in any case) but because they put forward male ideals. (Arguably, this is because in our patriarchal world, where men still control most of the production, distribution, and reviewing of books, men are revered.)

Accordingly, aficionados of this type of fiction claim that they are superior to romances because their stories are more realistic. Oh yes? When did you last meet a spy? Or an adventurer who could overcome all obstacles – Indiana Jones in the flesh? And when did you last meet a pair of lovers?

The view that Mills & Boon books are just junk literature that does not address the problems of the real world, is exemplified by Baker in her book on post-war women's literature:

> Romantic fiction, whether in the form of novels or women's magazines, was escapist . . . Marriage itself was the goal . . . [and] traditional "happily ever after" endings in fiction reinforced the view that marriage marks the end of a woman's growth; that once she gets her man her "story" is told. (1989:45)

This reveals both a dismissive attitude towards women's fiction and an ignorance of romance texts. The books do, in fact, deal with specific problems women have faced throughout this century

and the stories do not necessarily end with wedding bells but continue after the heroine's marriage.

The Mills & Boon romances of the post-Second World War period depict problems that are specific to women. In the late 1940s the mainspring of their stories are such topics as the lack of job opportunities for women (both single and married); the difficulties that arise when living with in-laws due to the housing shortage; and the problems faced by wives when trying to revive marriages to men who have become strangers after being away at war for six years. In other decades Mills & Boon books concentrate on problems such as combining marriage and career; the healing of servicemen after war; and the acceptance of all aspects of one's femininity. They also revolve around the changing of a fleeting male lust into a love that will endure through life's downs as well as its ups, which is the main topic of all romance fiction. In romance ideology love solves all problems. In that sense, of course, Mills & Boon books do not offer any practical solution to the individual problems of the reader. What they do do is to voice the difficulties women face in a world that is organized by men for their own comfort.

In reality, what many of the critics of Mills & Boon books are belittling is the writing style and language that is used, although they either do not state this, or deny having this intention. Watson's *Their Own Worst Enemies: Women writers of women's fiction* (1995) being a case in point. Her book is a diatribe against not just romances, but all genre fiction written by women and including a love interest. She argues, as many feminists do, that Mills & Boon books show women buying into the patriarchal ideology of marriage. One could say the same about *Jane Eyre*. The only reason Jane Eyre does not marry Rochester initially is because he is already married, not because she rejects the institution of marriage altogether. *Jane Eyre*, of course, belongs to the genre of classical literature, and has been reinterpreted by some critics, writing for the modern feminist reader, as a book in which the heroine is fighting against patriarchy for her autonomy as an individual. However the fundamental plot of *Jane Eyre* is not different than that of a Mills & Boon romance.

Mills & Boon books are not, and have never claimed to be, classical literature. Consequently, they are dismissed by those who

do not read them as "trash" purely on the grounds of their literary style. But Mills & Boon books speak to the same desires and fears as *Jane Eyre* – the changing of the hero from the Beast into the Prince in order to make the marriage work *according to the heroine's terms*. In so doing they can be said to have the same feminist agenda as the romances of Brontë and Austen.

Mills & Boon books are stories; they come out of the oral storytelling tradition rather than the tradition of the written word. As a result their style is very different from that of classical literature. They use language to involve the emotions and imagination to such an extent that the world they create completely envelops the reader. Characters live, events happen, emotions are felt. Literary style is irrelevant. Emotional involvement of the reader – which is achieved by the style of the particular author – is all that matters. This kind of writing is, for the most part, intuitive. It must, to some degree, tap into the wells of the writer's subconscious if it is to be effective in conveying the emotional intensity that is the hallmark of these books.

The image of an author crying while writing a particularly upsetting scene is a cliché precisely because it is based on a truth. If the authors are not affected by their work, their readers will not be engaged and the romance will be unsuccessful. This is not to say that romance authors the world over are crying at their computers. Rather, they are tapping into what Hélène Cixous calls "the Voice, a song before the Law, before the breath was split by the symbolic" (1975:172). Thus a romance author "physically materializes what she is thinking; she signifies it with her body" (1975:170).

That is the reason why authors write the types of romances that are specific to their own lives, as they explore aspects of society which resonate most deeply with their own psyche. Although their first romances often closely follow those of their predecessors (as Violet Winspear in *The Viking Stranger* (1966) set in America with a Danish hero and Penny Jordan's desert romance *Falcon's Prey* (1981) both built on established formats early in their careers) in later novels authors find their own voices. (Winspear found her own type of Latin hero, and Jordan found her own plot line of the misunderstood heroine and autocratic British hero.)

In this respect, I would argue (against the sceptical view of some critics) that Mills & Boon authors are sincere in what they write,

at least while they are writing. Otherwise the novels would not affect the reader. Even those authors who do not exclusively write romances must be able to engage with their text, and have respect for the genre as well as a genuine feeling for their characters. Other Mills & Boon authors, those Frances Whitehead, ex-editorial director of Mills & Boon calls "intuitive writers of romances" do this instinctively. These books are not post-modern game-playing; they are straightforward stories, which aim to engage the emotion, not the intellect, of the reader. Accordingly, they have to be read in a certain way in order for the reader to fully understand them. There has to be a willing suspension of disbelief, the analytical part of the brain has to be switched off and the emotions fully engaged. Both the reader and writer have to have an intuitive understanding of the dilemma that faces women in a male dominated world, which on the one hand, sees their sex as inferior, and an obstacle to success, and on the other, expects them to cultivate their femininity. All this may explain why very few men can write or edit these books successfully, and why most men cannot read them.

Much criticism of Mills & Boon books is ahistorical. There is a view among non-readers that the books never change. While it is true that the consistency of the plot defines the romance, Mills & Boon books have changed over the past decades. Although in their early years Mills & Boon recognized a division between categories of fiction in their catalogues, such as crime and their "Laughter Library", the only romance category they acknowledged was the society novel, set among the English upper classes. But it is possible to discern three more categories of romance from this early period that were not officially recognized – the country novel, the city novel and the exotic novel. The first two of these are set in England, in the countryside or in a large town (usually London) respectively; the latter is set abroad, generally in a country belonging to the British Empire. The society novel disappeared around the time of the First World War. By the 1930s the remaining three categories had merged, resulting in the Mills & Boon romance as it is thought of today.

Each of these categories has different views on the contemporary themes featured in the romances. For instance, in Sophie Cole's city novels, divorce is not contemplated by unhappily married

protagonists, whereas the society novels of the same period actually argue for divorce without social stigma.

Certain topics are more prevalent, or more significant during particular periods. Thus divorce – a main aspect of the plot during the early years – disappears then reappears in the 1960s, but handled differently, as these later authors include divorced heroes and heroines. Accordingly, the following few pages outline a history of Mills & Boon using these themes.

During the 1910s the theme of class and wealth runs through all the Mills & Boon novels. Many of the heroes are either rich aristocrats, or well-off educated men from the land-owning class. The heroine is either a younger woman, also from the upper classes, or a middle-class woman earning her own living. Heroes are no longer aristocratic after the 1910s and it is not until much later in the genre's history that the upper and middle classes meet again in marriage. In these later romances the class difference becomes a problem to overcome, as in Sally Wentworth's *Summer Fire* (1981). In this book the heroine disapproves of the aristocratic hero on principle.

During the 1920s the hero is more likely to be an expressively passionate Latin lover than an English gentleman. These books are more sexual in nature, and love and passion are inextricably linked. They are set abroad with travelling heroines who earn an independent living. The authors who began writing in the early years of Mills & Boon continued to set their novels abroad, while the authors who started writing in the 1930s developed a domestic atmosphere in their books, setting them mainly in England. During the 1930s the emphasis is placed on the heroine who exemplifies a certain type of English womanhood. Plots typically revolve around her introduction to sexual intercourse, or the married woman's need to work. These themes continue into the later 1940s.

By the 1950s the novels have become thoroughly domestic, and many of the plots involve the widowed heroine's need for a job to support herself and her children. Often she does this by becoming a housekeeper to the hero. It is in this period that the heroine, for the first time, is confronted with a glamorous and/or career woman as a rival for the hero's love. Although the other woman has appeared in previous eras, in the 1950s, the contrast between the

domestic heroine and the working other woman is prevalent. This particular juxtaposition continues into the following decades.

The domestication of the settings of Mills & Boon books did not last long. By the end of the 1950s they had moved out of the home, out of England altogether, and were situated once again abroad. The books of the 1960s have working, independent heroines, and sheik-heroes return with Violet Winspear's *Blue Jasmine* (1969), her tribute to E.M. Hull's *The Sheik* (1919). *Blue Jasmine* ushered in the more sexual books of the 1970s with love once again portrayed as a passionate emotion, as it was in the 1920s. Although not acknowledged in Britain in the marketing of the books, at that time, this more sexual novel split Mills & Boon romances into two categories. This division continues today – there is the more sexual line of books often depicting a violent battle of the sexes acted out between the hero and heroine, and the less sexual line portraying a more gentle relationship between the sexes. In America these two lines are called respectively; Harlequin Presents, which sells in significantly higher numbers, and Harlequin Romance and in Britain it was not until 1996 that the books were labelled Mills & Boon Presents and Mills & Boon Enchanted respectively.

During the 1980s the parameters of Mills & Boon books were expanded as both authors and editors experimented with the form of the romance. For instance, the journalist heroine of Madeleine Ker's *The Wilder Shores of Love* (1987) became a heroin addict during a drug investigation after one of her contacts forced the drug on her. New, more far-reaching authors, many of them journalists, brought a different understanding of the genre to the novels. In Pippa Clarke's *The Puppet Master* (1985) the hero manipulates events in order to meet the heroine in favourable circumstances. Previous authors would have had the events happen by chance construed as "fate". These new authors wrote in a less emotional style. Emma Goldrick even brought a comedic style to the writing.

Many of the authors from the 1980s such as Vanessa James and Pippa Clarke, had left Mills & Boon by the 1990s to write blockbusters under their own names – Sally Beauman and Rosie Shepherd respectively. Madeleine Ker, one of the very few successful Mills & Boon male authors, also left to write under his real name of Marius Gabriel, feeling that he had stretched the genre to it's

limits. Others, such as Emma Darcy and Susan Napier have stayed. The 1990s have seen a more emotional type of romance being written by new authors, although now Harlequin are demanding that all books contain at least three of the key elements that they believe sell; such as plots involving children, cowboy heroes, and Christmas, the more creatively spontaneous and emotional romance may well disappear.

This brief outline of the history of the Mills & Boon romance does not take into account the diversity of the books at any given period. For example, it is possible to find heroines with non-domestic, even unusual jobs during the 1950s, as Deborah Phillips noted at the Liverpool Roses and Romance Conference in 1995. This chapter aims solely to introduce the main themes of Mills & Boon romances during each decade.

So, the argument that "Mills & Boon books are all the same" is ahistorical because it ignores the true history of the genre. Although the base plot, as with all other genre fiction, remains constant, themes vary from decade to decade and author to author. These themes become plot-types, such as the marriage of convenience in which the two protagonists marry for some mutual benefit before falling in love with each other; or the career-woman heroine, who is forced to choose between marriage and a career by the hero until he eventually has to recognize her right to both; or the wounded hero, who refuses to love the heroine because he does not acknowledge the existence of his own emotions.

These plot-types are significant not just because they express something within the subconscious of a particular writer (and reader), but because they reflect an aspect of the society from which they come. By using the same plot-type again and again Mills & Boon authors can be seen as putting forth an argument for political and social change. This is not to say that these books are didactic in any way. They do not argue for a point of view in the same way that a political pamphlet does. But literature, by portraying certain events and not others, or by choosing a particular setting can actually put forth an argument for or against a certain position. An obvious example is Charles Dickens whose novels portray a particular world to such effect that, in the English language, "Dickensian" is immediately recognizable as a reference to a world of poverty and social injustice. In this respect, I would

contend, Mills & Boon books argue for a change in the way society is organized, from male-oriented to female-oriented.

Mills & Boon books give women power. They do this in various ways: by portraying women's healing power after war; by showing women fighting, not just to enter the workplace but, to change it to suit their needs; by transmuting sex into lovemaking; and by insisting on the equality of the sexes through portraying the hero as the heroine's brother. But the most forceful empowerment of women occurs in the confrontation set up between the public and private spheres. They do this by using the symbolism of "home", which in Mills & Boon ideology is the woman's sphere – standing for stability, safety, peace and strength. It also represents the continuity between past and present, between the generations, and a promise for the future. So, even when it appears to be the hero who establishes or confirms the heroine's social identity by marrying her, it is in fact the heroine who is drawing the hero into the female world.

This is exemplified in Stephanie Wyatt's *This Man's Magic* (1987). At first glance it could be seen that the hero bestows an identity on the heroine. The hero establishes the heroine in society when he helps to bring her jewellery designs to the notice of the wider public. He also restores her to her family, when he insists that her father and stepmother recognize her after ignoring her existence all her life. At the end of the novel he promises her children and a country home, once again, seemingly, granting her a social identity. But the heroine is descended from aristocracy, and is independently wealthy. So, at one level, she already has a place in society, albeit one she has rejected for a career. At the same time, while the hero keeps his town flat for when they may have to be in London, it is the country house which is to be their main place of residence. This indicates that he is giving up his bachelor (which in Mills & Boon books translates as "male chauvinistic") lifestyle. Finally, in the last sentence of the novel he says to her, "Come on, my darling, let's go home." With this use of the word "home", it is made clear at a symbolic level that he is going to join her in the female world of permanence, rather than take her into the patriarchal world of emotional instability and sexual permissiveness that he has known.

Before condemning Mills & Boon novels you have to accept that the romance genre is about love, just as detective fiction is

about crime, and science fiction is about other worlds. Certain things must happen in books of these genres – a relationship has to be formed, or a crime has to be solved, or humans have to encounter alien beings. However, the rules are also broken and often in the process either a new sub-genre is created (such as when Gothic novels split into romance and crime novels) or the genre is changed irrevocably (as *The Sheik* left a lasting impression on romance fiction and the character of the hero).

In order to enter the world of the romance, the method of analyzing literature which is taught in schools and higher education must be abandoned. I have heard it argued that romance authors play games with their readers. This was in reference to a passage from a Silhouette book, where the sexual language of an interrupted sex scene had been continued into the following, non-sexual scene. The commentator claimed that the author had done this deliberately in order to amuse her readers. I would argue, however, that this shows a fundamental misunderstanding of how this type of fiction is written. An author who has just described a sex scene will continue to think in sexual metaphors. The author's mind is still running in the sexual groove, as it were. Therefore, in the heat of writing, he or she is more likely to pick a word with sexual overtones.

This type of instinctive writing is illustrated, by Mary Wibberley in her book *To Writers With Love*, where she says that in *Linked from the Past* (1984) she was not conscious of the way she was writing: "I laid at least three 'clues' *that I was not aware of*, but which, as I continued to write, gradually fell into their place – and only then did I realise why I had done that" (1987:40, original emphasis).

The romance genre has to be accepted on its own terms and judged by its own criteria, and should not be compared to other types of literature. To do so is to compare *haute couture* with retail clothes. The intents of the couturier and the mass manufacturer are different, as is the result. The way to deduce the merit of a romance novel is not to compare it with *War and Peace* but to compare it with another romance. Has the author expressed the emotions of the characters – whether it be love, hate, jealousy or despair – credibly? Are the characters believably serene, warm, arrogant or fun-loving? Do their actions seem in keeping with

their character and the events of the story? Does the author draw you into the story so that you feel every emotion, see every setting, burn at every injustice, fall in love with the hero and become the heroine?

Above all: does the author speak to your concerns? If not, the novel is not a "good" romance for you, but another romance by another author might be. Some feminists re-read *Gone With the Wind* every year but cannot stomach *Rebecca*. We all have our different fantasies. As Clair in *Dangerous Men and Adventurous Women* puts it: "A smoking .45 and six corpses at his feet is a male fantasy. A woman will settle for one live hero as hers. And if she places a dainty foot upon his neck, it is only to invite him to kiss it" (1992:71).

Not all fantasies are gender specific. Women can have fantasies about smoking guns. But then women are socialized into the male world, and have to be aware of men's milieu in order to negotiate it. Men, on the other hand, do not face the problem of feeling divided between two different worlds, and find it difficult to understand women's lives, tending to act as if there is only one culture – theirs. Therefore most men cannot enter the world of romance. For, as will become apparent in the following chapters, Mills & Boon romances primarily depict the world from a woman's viewpoint. And in so doing, they immerse the reader in a female world of experience; both the external reality of the social world they live in at any given period, and the desired world of their hopes and dreams.

A Short History of Mills & Boon –
A very profitable small firm

Mills & Boon are the publishing success story of this century. The firm was started by Gerald Mills and Charles Boon in 1908 with £1,000 capital. They had both previously worked for Methuen – Mills as Education Director and Boon as Sales Manager. Their first office was in Whitcomb Street, London W1, but in 1909 they moved to 49 Rupert Street. In their first year their turnover was £16,650 publishing in all fields – educational, general non-fiction and fiction. Their early general books included theatrical and other reminiscences, travel guides, "how-to" games books, various forms of self-help and children's books. They also published craft books, which they continued to do until 1980.

Their fiction list in the first decade of their business covered crime, plays, comic novels and historical novels. They also published Hugh Walpole's *Mr Perrin and Mr Traill* in 1911 and in 1912 his *Prelude and Adventure*. In the same year they produced P.G. Wodehouse's *The Prince and Betty* and E.F. Benson's *Room in the Tower*. Some of their early women novelists included I.A.R. Wylie, now best known for her book *The Daughter of Brahma*, published by Mills & Boon in 1912, and Beatrice Grimshaw, whose *When the Red Gods Call*, a blockbuster sensation of its day, they published in 1911. They also published Elizabeth Robins' play *Votes for Women*, which was based on her pro-suffragist novel *The Convert*, in 1909, and Winifred Grahame's virulently anti-suffragist novel *Enemy of Woman* in 1910. In translation they published, among others, Gaston Leroux's *Phantom of the Opera*.

Few of these writers stayed with the firm for long, most worked with a number of other publishers throughout their writing lives.

One who did stay was Jack London. Mills & Boon published many of his books between 1912 and 1923, including *South Sea Tales* and *When Gods Laugh* in 1912, *The Cruise of the Snark* in 1913, as well as his wife Charmian London's log of the Snark as *Voyaging in Wild Seas* in 1915. After Jack London's death in 1916 they brought out an almost complete collection of his books in 1918.

Apart from publishing established authors, Mills & Boon were described in the *Morning Post* as publishers of "clever first novels". By the 1920s it was established practice for them to publish four new promising authors in July of each year.

They also published a group of books which dealt primarily with human emotions, the successors of which were to make the name of Mills & Boon synonymous worldwide with category romance fiction.

These early romances can be separated into four distinct groups, according to the setting where the action takes place: exotic, society, city and country. The exotic and society novels are set among the English upper classes, the former in such countries as South America, Africa, Burma and India, the latter in southern England. The city and country novels have middle-class protagonists and, like the society novels, are also set in southern England, generally London and the south-east respectively. The society novels disappeared in 1914, and the other categories gradually merged, so that by the beginning of the next decade, although some novels could be associated with particular categories, the differences in content between these categories was no longer clear and the new writers of the 1920s made no distinction between them.

Many present-day historical romance novelists portray the Edwardian period as the "*belle-époque*" – a glamorous golden age. However, in reality, for many people this was a time of hidden fears as general unrest threatened the stability and self-confidence of the upper classes. These fears are reflected in the Mills & Boon books of the day – even the society novels. In all the novels of the 1910s there is some type of external menace, from E.M. Forster's "abyss" of poverty that haunts the city novels, to the alien African country of the exotic novels, the threatened menace from the city in the country novels, and the deceit and murders of the society novels. This is not to say that these early novels were expressing a

social critique. Rather, it is to argue that from the earliest days of their history, Mills & Boon books have symbolically represented aspects of the society in which they were written.

The society novels had a figure of Cupid for their logo, a figure which was to reappear in the 1940s bearing a placard inscribed "A Mills & Boon Love Story". One of the most popular authors of society novels was Joan Sutherland, who set her books among the landed gentry. Her canvas is broad, and many of her characters, especially the women, lead unhappy lives. Generally, however, the books end happily for the main protagonists who are ensconced in a loving marriage – a staple of Mills & Boon romances which has never changed. Another theme that is central to Mills & Boon books throughout the decades is that trust and love go hand in hand, and that one without the other is worthless. This is apparent in *The Cheat* (1909) by Laura, Lady Troubridge, who wrote seven society novels for Mills & Boon between 1909 and 1912. She was the sister-in-law of Una Troubridge, who was Radclyffe Hall's lover, and was herself a member of the social élite.

The exotic novels are still common today, with authors setting their books in most continental countries, America and Canada, South America, Australia and New Zealand and various African and Arabian countries. The main difference between the earlier novels and those of today, is that the earlier heroes were always British and the heroines occasionally European; these days the hero, and sometimes the heroine, are more likely to be natives of the country in which the book is set.

One of Mills & Boon's most prolific authors of exotic novels was Louise Gerard, most of whose romances were published in America, Norway, Sweden, Denmark and Holland, as well as in Britain. In a back cover blurb on one of her books Louise Gerard writes that she was born in Nottingham and educated at the high school there. Having always wanted to travel, at the age of 19 she went to West Africa which would be the setting for many of her books. Gerard always visited the countries that she used as settings, and, as a result, visited most of Europe (including Russia), Morocco, the Canary Islands, Tunisia, Madeira, Algeria and "The Great Sahara Desert". She dedicated all her books to a woman friend who was a Fellow of the Royal Geographical Society, and who, presumably, was her travelling companion. Gerard also wrote

Mills & Boon's first medical romance, *Days of Probation*, published in 1917. Medical romances appeared in the company's list from then on, eventually becoming a distinct line in 1977.

Many authors wrote country novels, including S.C. Nethersole and Marian Bower. These were set in southern England, portraying country life and hard-working heroines and heroes. The heroines, generally independent-minded women, often suffer hardship – either economic or emotional – before being united with their heroes.

Sophie Cole was one of Mills & Boon's most prolific authors of this period. She wrote her first book for Gerald Duckworth and Co., and then moved to Mills & Boon, publishing 60 books with them between 1909 and 1941, (including 3 guide books for London), before moving to Ward Lock with whom she published her last 5 novels. She wrote city novels, all set in London which she knew well, although she lived in Henley-on-Thames.

Like many other publishers, Mills & Boon faced a crisis over its financial welfare in the 1920s. During this period, publication of all categories of books increased, attaining record levels, although there were also "dramatic increases in production costs and lower profits" (McAleer, 1992:51). Mills & Boon were not unaffected by this, nearly going into bankruptcy, mainly, according to Charles's son, John Boon, because of two factors: lack of capital and the absence of a backlist. Gerald Mills's death in 1928 brought the financial crisis to a head, as a considerable portion of the company was in his estate. The problem was solved by J.W. Henley, also from Methuen, who bought about a third of Mills's equity becoming joint managing director with Charles Boon.

At the same time the firm, though still continuing their other fiction and non-fiction publications, laid down the foundation for their future economic success by beginning to specialize in romance fiction, which was published in hardback only and sold mainly to the commercial libraries. They added to their list Elizabeth Carfrae, one of the new breed of authors who wrote "racily" according to *The Scotsman's* review of her *The Devil's Jest* (1926). They also retained Denise Robins, one of their most popular authors, who remained with them "for eight or nine years" before "somewhat reluctantly" moving to Nicholson & Watson for a £1,000 advance, which Charles Boon refused to match (Robins, 1965:136). However, M.J. Farrell, who published her *Knight of*

the Cheerful Countenance with Mills & Boon in 1926, did not stay with them, nor did Georgette Heyer. It was Heyer's third historical romance (not her first, as both Mills & Boon and McAleer (1992) state), titled *The Transformation of Philip Jettan*, which was published by Mills & Boon in 1923, under the pseudonym Stella Martin. It was subsequently republished by Heinemann, minus its original final chapter, as *Powder and Patch*, under her usual name.

Despite, or perhaps because of, the Depression of the 1930s Mills & Boon prospered. Charles Boon noticed the rapid proliferation of the commercial libraries and the rise in sales of medical, historical and contemporary romances (which did not become separate series until 1977). Consequently, from this time until the mid-1950s, general books were dropped and the firm concentrated on romance fiction. At first the company produced only hardback romances, which had a uniform appearance – brown bindings with the title and author embossed in black inside a black margin. The logo was always set in the right hand corner – and they had brightly coloured jackets. They were known as "the brown books" (Alan Boon, TV interview). This was the golden age for Mills & Boon hardback publishing, they were "doing extremely well in a period when most publishers were not doing well. It was a very profitable small firm then", as John Boon told McAleer (1992:105). This was the start, following the trend of the day, of advertising Mills & Boon books as commodities, rather than promoting individual authors. The company developed a mail-order catalogue system (now known as Reader Service), which informed readers of future publications. They also continued to advertise forthcoming books in the backs of the novels, a practice which continues today.

Mills & Boon were at the front of, helping to fuel, the beginning of a modern phenomenon in reading. Until the 1930s books had been read for pleasure, but it is at this time that the word "escapism", in the sense of "the tendency to, or practice of, seeking distraction from what normally has to be endured" (*Oxford English Dictionary*), is first applied to books. At a time of economic insecurity, in areas of what J.B. Priestley called, in his *English Journey* of 1933, "the England of the dole", reading escapist literature may have been one way of coping. For others, who were in full-time employment, the 1930s was a period of increased

prosperity, and reading any fiction may have had an element of aspiration. Mills & Boon books of the period do not portray extremely wealthy people, but do depict middle-class women who are in interesting jobs and men who are barristers or businessmen – the employer not the employee. This is the case with the novels of two new authors who started in the 1930s – Mary Burchell and Sara Seale, both of whom became extremely popular. Burchell continued writing for Mills & Boon until her death in 1987; Seale continued into the 1970s.

Despite Charles Boon's death in 1943, the company continued expanding. Although paper rationing meant that the books of this period were shorter, the Second World War was in many ways a boom time:

> World War II presented Mills & Boon with a dilemma. Paper rationing meant fewer books could be published, but demand for romantic fiction was stronger than ever: entertainment was limited, and the troubles of the world made for heavy reading. Every novel that could be printed was sold, and lending libraries enjoyed an even brisker trade. (Mills & Boon press release, "The Changing Face of Romance", 1984)

Many new authors joined the ranks in the 1940s, including Janet Fraser, now better known as Rosamunde Pilcher, who wrote 10 books for Mills & Boon between 1949 and 1963. Two of the most prolific new authors of the war period were Phyllis Matthewman (who wrote for other publishers as Kathryn Surrey) and Margaret Malcolm; neither however, wrote books set during the war. This was not unusual for Mills & Boon books published during war-times, their main concern being, as always, heterosexual love relationships. A few of the novels were set against a background of war, but the majority of romances which dealt with war concentrated on the period following the war and the problems caused by returning soldiers settling back down to civilian life. A constant in post-war Mills & Boon books – after both world wars, and again after Vietnam – is the theme of healing the psychological scars left by war – by love. The Korean War of 1950–53 seems to have been ignored, perhaps because Mills & Boon authors, in their romances of this period, were still trying to come to terms with the aftermath of the Second World War.

However, Mary Burchell did set one of her 1957 romances – *Loyal in All* – in Hungary, during the uprising.

The way Mills & Boon books dealt with the war years of the 1940s and the following years of peace and reconstruction support Lerner's thesis that the usual periodization of history often does not fit women's experience:

> Traditional history is periodized according to wars, conquests, revolutions, and/or vast cultural and religious shifts. All of these categories are appropriate to the major activities of men ... What historians of women's history have learned is that such periodization distorts our understanding of the history of women. (1979:175)

As Batsleer points out:

> In the school textbooks and in the standard accounts, women rarely appear as actors upon the public stage of history. The romantic novelist reinstates women and reverses the account. Here the history that men have made becomes the backdrop and women the protagonists in a drama of quite different significance. (1985:95)

In accordance, Mills & Boon romances cannot be neatly divided between war and post-war books. Many of the post-war novels deal with the emotional after-effects of the war, whereas many of the novels published during the war do not mention it. For the female authors and readers, the Second World War did not effectively end until well into the 1950s, when the last of the returning combatants were reintegrated into society as whole human beings. I discuss the treatment of war by Mills & Boon authors in Chapter Six.

In the 1950s Mills & Boon moved to 50 Grafton Way, Fitzroy Square, London W1, where they stayed until 1970. At the same time they returned to publishing general books as the commercial libraries began to decline. In the 1960s they increased their educational textbook list, but it was not compatible with their growing romance list, and they finally sold it in 1980 to Bell and Hyman.

Realizing that their romances would still be in demand after the commercial libraries closed, but that sales would depend as much on readers having easy access to the books as on the books being

reasonably priced, Mills & Boon looked for alternative outlets. They decided that, because of the lack of bookshops in smaller towns and villages, newsagents were the most appropriate outlets for selling books – a policy which still continues (although most of their sales are now through the larger chains – W.H. Smith and John Menzies). Mills & Boon books can also be found, these days, in larger supermarkets, both in Britain and America.

The success of Mills & Boon in the 1950s attracted the attention of Harlequin Books (now of Toronto, originally of Winnipeg). This Canadian firm, bought by Richard and Mary Bonnycastle in 1958, had begun to publish, mainly reprints of westerns, mysteries and thrillers, with a few general books in 1949. It was Mary Bonnycastle who increased their romance output. The first Mills & Boon they published was Anne Vinton's medical romance *The Hospital in Buwambo*, in 1957. In 1958 they added a total of seven Mills & Boon medical and contemporary romances to their list. This started a regular exchange, with Harlequin publishing many Mills & Boon titles, and Mills & Boon importing Harlequin's books for distribution in Britain. This increase in sales and thus financial revenue enabled Mills & Boon to start publishing paperbacks in the 1960s.

Many authors still remembered today were writing for Mills & Boon in the 1950s including Pamela Kent, Fay Chandos (who started in 1937), Lilian Chisholm, Rosalind Brett (who also wrote as Kathryn Blair and Celine Conway), Joyce Dingwell, Marjorie Lewty, Rachel Lindsay, Anne Lorraine, Roberta Leigh (who in the 1960s wrote the series of Torchy Books) and Alex Stuart who was a friend of Paul Scott, and who, as Violet Vivian Stuart, was a well-respected naval historical novelist. She also wrote as Fiona Finlay and Barbara Allen and in 1960, with Denise Robins, Barbara Cartland and Netta Muskett, formed the Romantic Novelists' Association. Mary Burchell was their second President, serving from 1966 to 1986.

Mills & Boon was still a small firm at the beginning of the 1960s, publishing some eight romances a month, all of which were taken by Harlequin for the North American market. In 1964 John Boon became managing director, with Alan Boon, his brother, who had been working for the firm since 1929, as editorial director. Alan Boon was thus responsible for taking on two very different authors in the 1960s – Betty Neels and Violet Winspear. Neels,

married to a Dutchman but living in England, wrote mainly medical romances, featuring an older, Dutch millionnaire surgeon-hero and an English, often not pretty, clever, or brilliant nurse heroine. Her books depict the work and domestic round in cosy detail. But Winspear's romances, set abroad, were more highly charged: "She was adept at providing the fast-paced, flamboyant romantic exploits that, on the surface at least, seem in keeping with the 'swinging sixties' and their transition into 'the permissive society' of the next two decades" (Cadogan, 1995:238).

Anne Mather had previously published with Robert Hale, but joined Mills & Boon in 1966 with *Seen by Candlelight* (*Design for Loving*). She was to become one of their most popular, and occasionally controversial, authors.

In 1970 Mills & Boon moved to 17–19 Foley Street, London W1, and in 1972 they merged with Harlequin, who had been publishing only romances of various kinds since 1964. In 1975 a controlling interest was sold to the Torstar Corporation, a Canadian communications company. At the same time separate publishing organizations (not just sales outlets) were set up in countries outside North America and Britain, including the British Commonwealth countries and a number of non-English-speaking countries – France, Germany, Italy, Holland, Greece, Japan, Scandinavia and South America. However, the editorial department of Mills & Boon, which originated most of the books, was still small and in 1976, the year she joined, it consisted only of Frances Whitehead and Alan Boon. In 1974 Mills & Boon published Anne Mather's *Leopard in the Snow*, which was later turned into a film. Her *Living with Adam* (1972) featured a young heroine living platonically with her stepbrother, and many readers wrote in to object to this aspect of the plot as immoral. However, times had moved on, and the 1970s saw the beginning of an increasingly sexual storyline, exemplified by such new authors as the New Zealander Robyn Donald, the American Janet Dailey and the English author Charlotte Lamb (who had previously published with Robert Hale, as many Mills & Boon authors had).

The merger with Harlequin and the expansion abroad enabled Mills & Boon to increase their paperback publishing. In 1974 they introduced, for the first time, their now famous rose logo on Jean MacLeod's *The Black Cameron*. In 1972 they sold 27 million

books in Britain, producing 14 hardback and 9 paperback novels a month; by 1973 their sales had increased to 30 million. Their hardback copies sold mostly to libraries, which still do a thriving trade in Mills & Boon books, but they added to their paperback sales by creating a subscription service, through which readers could buy each month's publications by post. By 1978 Mills & Boon had increased their output of paperbacks to 12 a month.

They had obviously tapped into a gap in the market, with a massive worldwide readership, which increased during the 1980s. Jacqui Bianchi, as editorial consultant throughout the 1980s until her tragically early death in 1988, worked to expand the parameters of the romance. Some of the authors she signed were unsuccessful; but many succeeded, notably Emma Goldrick with her comic romances. Bianchi was also involved in the reaction of a number of authors in the mid-1980s against the confrontational plot, in which the hero and heroine clash throughout the novel, which I discuss more fully in Chapter Eight. They included Vanessa James (now better known as Sally Beauman), and Emma Darcy and two new authors, Susan Napier and Dana James, both of whom were taken on by Elizabeth Johnson, then an editor on the contemporary side, now the senior editor of the historical and medical romances.

Jacqui Bianchi was also Penny Jordan's editor, one of the major Mills & Boon authors of the 1980s. Her romances tend to be set in England, and feature a hero who constantly misunderstands the heroine's actions and is angry with himself for his attraction to a woman who he consequently finds less than innocent. Jacqui was herself an author of historical "bodice rippers" and many of her authors gradually increased the amount of sexual violence in their novels. As another editor put it: "It seems to work as a kind of osmosis – she never says 'Put more violence in', but it seems to happen anyway" (private communication).

Mills & Boon lost a few authors with Jacqui's death. Pippa Clarke commented that after Jacqui died, "I no longer had a dialogue with an editor", and she left to write longer books under her own name of Rosie Shepherd. Other authors moved to different editors within Mills & Boon, among them Frances Whitehead, who was later to become editorial director. As editor she was instrumental in encouraging Charlotte Lamb to write more sexual novels, and had taken on Janet Dailey, who was to become one

of Mills & Boon's most famous authors. Frances also brought in Carole Mortimer, another very popular author, whose plots became less confrontational as in her later novels the heroine tended to be of a more equal status as the hero and so less likely to fight her own desire for him.

By the mid-1980s Mills & Boon was a publishing phenomenon, selling in the region of 250 million copies of their books worldwide. This helped to make Harlequin the world's largest publisher of romances, with 80 per cent of the world market, including translations into 18 languages, and with sales in some 98 countries. In 1981 Mills & Boon moved to 15–16 Brook's Mews, London W1, where they stayed until 1986 when they moved again to their present address in Richmond, England.

In 1983 they became the third most profitable publishing company in the UK, and at a time when many publishers found themselves under threat from both the high costs of printing and production and the competition of other media, particularly television, Mills & Boon not only survived but thrived. In the mid-1980s they were selling 30 million books in the UK alone, in print runs, for some authors, of about 100,000 per book and achieving a 65 per cent share of the romance novel market. In addition they sold over 70,000 of their Mother's Day packs, and 60,000 of their Holiday Romance packs. According to Fiona Kennedy of W.H. Smith, in the late 1980s: "Mills & Boon's were holding up well despite the recession." And even though American publishers, such as Bantam with their Loveswept series, were trying to cash in on the British market, "it seems to have made no difference to Mills & Boon's domination". In fact, Bantam took a severe beating and had to withdraw from the British market.

In 1984 the combined output of all the Mills & Boon series – contemporary titles, Love Affair and Temptation, Masquerade (historical) and the medical doctor/nurse romances – was 23 books a month. By the mid-1990s this had increased to 16 contemporary titles, 4 Temptation, 2 historical, 4 medical and a 2-in-one "By Request", which are re-issues. The Love Affair series was dropped in 1987, although many of them are now reappearing under the recently launched MIRA imprint. Mills & Boon also publish, under the Silhouette imprint bought from Simon & Schuster in 1985, 4 Intrigue, 6 Desire, 4 Sensation and 6 Special Edition

novels per month. These generally have American settings and authors, although there is the occasional non-American author, including Lucy Gordon (English) and Laurey Bright (an Australian, who writes for Mills & Boon as Daphne Clair) and the occasional non-American setting.

Silhouette books are beginning to outstrip Mills & Boon books in popularity, which led in 1994 to a purge of English authors from the Mills & Boon list. Torstar replaced the English editorial director Frances Whitehead with the Canadian Karen Stoecker and stopped publishing those authors who were not selling, encouraging the more popular authors to increase their output. Authors are also, for the first time in Mills & Boon history, given a regular update of their sales figures, and encouraged to write books around the themes that sell well – which are currently Christmas; children; "shared past" plots, and cowboy heroes. The latter, perhaps, reveals a lack of understanding of British culture by the Canadian management whose view is that if a book (or an author) does not sell in America, it is not a book (or author) worth publishing. This, of course, ignores cultural differences and may, ultimately, be to Harlequin's detriment. George Paizis, in his research on the cross-cultural reception of Mills & Boon books, discovered that many aspects of American culture (such as gold mining) do not translate easily, nor do they carry the same mythical resonance for readers in other countries. The British culture is more easily understood by non-American readers (private communication).

Harlequin's authoritarian stance also negates the diversity in the storylines that has always been one of the strengths of Mills & Boon which, under British management, was generally left to the author, which, according to Frances Whitehead, "worked very well". The Canadians are changing this, making writing for Mills & Boon a more journalistic endeavour than has been the case in the past. According to Frances Whitehead this determination "to change reader's interests by 'educating' them – with chosen themes" – meant that editors "began to patronise and almost to despise the reader . . . Obviously the author's personal views may well come out in her writing, but trying to 'instruct' readers never works because they resent it, readers are not fools" (questionnaire, 1995).

This more interventionist approach on the part of editors may exclude the "instinctive" romance writer. If so, this may cause

Mills & Boon romances (and, indeed, the American Harlequins) to lose their *joie de vivre* and readership. As Anderson pointed out:

> Popular romantic fiction . . . will only continue to be an interesting genre if its authors [keep] a passionate belief in their convictions, the total commitment . . . which [gives] to that inimitable prose style its power, emotional drive and luxuriant vitality. (1974:277)

Today it seems as if Mills & Boon are losing their pre-eminence in the romance market. With the death of John Boon and Alan Boon not involved in the day-to-day running of the firm, it has lost its personal quality. However, despite the expectations of some feminists in the early years of the Women's Liberation Movement, romance literature refuses to die and by the millennium expectations of the death of Mills & Boon will surely be proved premature. Whatever the future of Mills & Boon, the following chapters are a homage to the firm, with grateful thanks for the books they published between the years 1909 and 1996, which have given countless hours of reading pleasure to me and millions of other women worldwide.

Chapter Two

Reader, Author, Editor – *Many hours of pleasant reading*

With a massive world-wide rise in sales of Mills & Boon books in the 1970s coinciding with the beginnings of the Womens' Liberation Movement, feminists among other critics began to ask, "why do people read these books?". Why was it still true that these books gave "many hours of pleasant reading" to women throughout the world (as claimed on their jacket blurbs). These were the questions Janice Radway set out to answer in her book *Reading the Romance*, published in 1984.

In analyzing the responses to her readers' sample Radway claimed to be able to uncover the unconscious reasons for their answers. However, she admitted in her introduction to the later British edition of 1987: "Even ethnographic descriptions of the 'native's' point of view must be an interpretation of . . . my own construction of my informants' construction of what they were up to in reading romances" (1987:5).

Agreeing that her interviewees' descriptions were mediated by her own "conceptual constructs and ways of seeing the world", and that this would be the case with any analysis by an outsider of others' reading responses, I have chosen to analyse my own personal reaction. Of course, I may be mis-remembering events. I may be deceiving myself, or I may be deliberately manipulating my story in order to fit the argument I want to present. Nevertheless, this approach seems to be a more honest way of analyzing reader response than either consciously or unconsciously imposing my ideas in interpreting the words of other readers. What follows is an examination of my experiences as reader, author and editor, interspersed with comments from other readers, authors and editors

who answered questionnaires on their own experiences and views of Mills & Boon in 1991 and 1994/5.

I inadvertently started on the path to writing this book in the mid-1970s, when I first started reading Mills & Boon romances. How or why I came to buy the first one, I do not remember, but I do know that at one point I was reading up to three a day. I even tried to write one, which was a complete failure.

In early 1985 I joined Mills & Boon as head of copyediting, where I was editing, on average, four manuscripts a week, and skimming at least two or three others. I left Mills & Boon at the end of 1986, specifically to "write the history of Mills & Boon romances this century", as I thought of it at the time. I did the major part of the research on the early Mills & Boon books in the British Library. During this period I read roughly 30 books from each decade up until the 1950s while continuing to read some of the contemporary monthly Mills & Boon publications. (However, I did not read every Mills & Boon book in the British Library, and never contemplated doing so, as claimed by Paul Grescoe in his book, *Merchants of Venus* (1996)).

Although my position as a reader in relation to the text and what it demands of me may not have altered, my own state of mind and my position in relation to the rest of the world has changed immensely in the 18 years that I have been reading Mills & Boon books. When I began reading them I was a depressed housewife, in my late twenties with no children, working as a freelance editor from home, haunting my local secondhand bookshops for any Mills & Boon I could find. I moved, via an amicable divorce at the age of 32, into a professional position as an editor at Mills & Boon and from there into an analyst of the genre.

What has not changed is my white, middle-class, English public-school background, and my allegiance to feminism, which I adopted at university in the early 1970s and which is still as strong, though not as active, as ever. In fact my most visibly active period within the feminist movement was during my period of employment at Mills & Boon when I was organizer of the London Women's History Group, during which time I also served on the collectives of the First International Feminist Bookfair and the first National Feminist History Conference, while continuing as a member of

what was, in 1977 – when I joined – the Women's Research and Resources Centre, now the Feminist Library.

I was, at the time, totally committed to Mills & Boon romances. I defended them against the dismissive attacks made by other feminists, and asserted my right to read and enjoy them as pleasurable texts. In other words, my commitment both to feminism and Mills & Boon ran side by side, much to other feminists' surprise. On a very basic level, I had no problem with this. It seemed to me then, and still does, that feminists should not be derisory of other women, of whatever political persuasion, nor of their needs, but that they should try to understand them, maybe change their views, but not disparage them. Mills & Boon obviously fulfils some need women have, judging from their approximately 250 million sales per year in 98 countries at the height of their popularity – a period which overlapped with the growth of Second Wave Feminism.

In fact it was other feminist critics – in particular Ann Barr Snitow's 1979 article "Mass Market Romance: Pornography for women is different" (1984) which was the impetus for starting to write this book. I realized that the books Snitow and others were analyzing were not the books I was reading, partly because they were analyzing 1970s Mills & Boon books, and I was editing those from the 1980s. Apart from this, my interpretation of Mills & Boon texts was nothing like theirs. To use an oft-repeated phrase of Mills & Boon heroines of the period "it was as if she was reading a different script."

Why was this true? Part of the answer must lie in the reasons women read Mills & Boon books. Snitow does not explain her interest in these books, except to say that because so many women read them, it is important to analyze them. I would suggest that she reads them in order to write about them, which is to say: she reads them as an analyst. The same would apply to Modleski's (1982) study. I, however was enjoying them as an avid Mills & Boon reader.

In 1969 Dr Peter Man produced a major study (extended in 1974) which found that the typical Mills & Boon reader is female, aged between 19 and 44, married, and working in a clerical job. She does not only read romances, but they are her favourite type of fiction. More recent analyses have discovered that the Mills & Boon

readership extends across all cultures, ages and class background. Many of the women who read Mills & Boon books are at home with young children, but readers also include working women, from typists to high-powered executives as well as students.

Fowler disputes these findings, arguing that there is little cross-over between genres for readers, and that reading habits are class-based, with most readers "cut off from involvement in public political issues and unable to see a solution to their grievances" (1991:136). However, Owen's 1990 research indicates that there is a wide variety of educational background and political involvement amongst romance readers. My own small sample, specifically of feminist readers of Mills & Boon books, bears out Owen's argument, some readers having left school at 15, and others continuing into further education. One woman was slightly dyslexic. She added a postscript to the questionnaire:

> Without the introduction to them I doubt I'd have ever read a book . . . These books were so lightweight and simple, that once I realised I could read a book from cover to cover they became addictive for that alone. I still find starting a book difficult but I now know that I can concentrate and see it through to the end.

She had started reading them while pregnant at the age of 23, and had since gone on to do a two-year women's study course and various non-credited courses.

In other words, all types of women read Mills & Boon books. In fact, I would suggest, all women read some type of romance. But, why *romances* for *women*? Why not sci-fi? crime? Why books whose main theme is a love relationship? Why do women all over the world – from different ethnic, religious and social backgrounds – enjoy reading romances? Because, I suggest, they speak to women's situation; the common circumstances of their lives; because they say something about the society they come from, and about women's place in that society. As Jean Radford put it in 1995 at a seminar on Mills & Boon in the Centre for English Studies at Senate House in London: "They put woman centre-stage. It is her concerns, her life, which is addressed." Romances speak to women's needs and desires. What, therefore, was I – what were they – the

millions of readers worldwide – getting from these books that feminism could not or would not provide?

I remember saying during my job interview at Mills & Boon, that the books had helped me through a bad patch. This is true. They helped me survive the depression of the last years of my marriage, just as, years earlier, reading Georgette Heyer had helped me cope with boarding school.

Radway's *Reading the Romance* (1984) analyzes mainly historical romances, with 18 of her interviewees indicating "that they never read a Harlequin" (the American logo of Mills & Boon) (1984:56), although her thesis has been used as a basis for most analyses of romances since (e.g. Taylor, 1989). Her theory is based on Nancy Chodorow's argument that in the contemporary family it is the woman who does all the nurturing without receiving any from the other members of the family and because of this women never lose their desire and need for the mother. As a result women read romances because heroes in these books are often nurturing or mother figures. Women, therefore, read these books because they get from them the nurturing, understanding and love that they are not getting in their lives, whether or not they are married. My situation would seem to be a prime example of this. As an ex-nurse who read Mills & Boon books during her unhappy marriage, put it: "[Maybe] it was to compensate for what I *wasn't* getting in the marriage" (Fowler, 1991:138).

In order for the hero-as mother figure argument to work romances must not only empower the hero but infantilize the heroine – which some critics claim they do. Was I, then, seeing myself in the guise of the Mills & Boon heroine being infantilized? Well, no. The fact that an adult woman wants love from her partner does not indicate that she also wants to be treated as a child. What she does want is to be cared for and supported as an equal, just as she cares for and supports her partner – male or female. That is what I wanted from my husband; to feel that he would help me with my worries and concerns, just as I tried to help him with his.

Radway argues that when the hero shows tenderness to the heroine, or showers her with presents, or takes her shopping, he is mothering her. On the contrary, in my view, apart from acting out the accepted courtship rituals of our society, he is showing that he cares for her; that he is capable of sharing her concerns. In other

words, he is letting down his barriers and crossing the boundaries from the male to the female world. That is why the heroine responds warmly. Not necessarily because she now feels loved but because she sees the possibility of being loved, by this particular man, *on her terms*: " '*I want him*! But not on his terms', the still small voice of sanity reminded her" (Anne Mather, *Born Out of Love*, 1977:72).

In her book *In a Different Voice* Carol Gilligan argued that humans have two "voices": the relational and what could be called the "disconnected" which are "characterized not by gender but by theme" (1993:2). However, the relational voice which insists on staying connected to other human beings "so that psychological separations which have long been justified in the name of autonomy, selfhood, and freedom no longer appear as the *sine qua non* of human development but as a human problem" is, empirically, associated with women (1993:xiii).

Quoting from Anne Barton's introduction to the Riverside edition of Shakespeare's *Love's Labour's Lost* Gilligan says: "Gently, but firmly, the men are sent away to learn something that the women have known all along: how to accommodate speech to facts and to emotional realities, as opposed to using it as a means of evasion, idle amusement, or unthinking cruelty" (1982:xii). This, I would contend, is the essence of what all Mills & Boon romances argue: just as women already are, so men have to learn to be "responsive to other people, to act in connection with others, and to be careful rather than careless about people's feelings and thoughts, empathetic and attentive to their lives" (1982:xiii).

In my view the heroes' acts of tenderness, which Radway claims change the heroine's view of the hero, are actually indicative of a point of change for *him* – a watershed, between his and her world. If he cannot cross over, he can never win her. His compassion is an acknowledgment and acceptance of her power, not a means to infantilize her into submission. In other words, Mills & Boon romances in the 1970s were demanding that men *change*. And feminism was doing precisely the same thing. But was this demand particular to these two decades?

One of the major problems with most critiques of romances is that they concentrate on contemporary books and assume that books in the past have been the same in terms of their plot, length,

concerns and characterization. Consequently such analysis is only relevant to the Mills & Boon books of the 1970s and 1980s. Radway's outline of "an ideal romance" plot starts with the heroine's social identity being destroyed at the beginning of the romance. She goes on to argue that it can only be restored through the heroine's sexual and emotional response to the hero's declaration of love (1984:134). But, in the past Mills & Boon books were organized differently. Sophie Cole's books of the 1910s start either with the childhood of her heroine (as in *A Plain Woman's Portrait*, 1912) or, more usually, with an older heroine, generally in her thirties or forties, who is happily settled in a job and lodgings, both of which she retains throughout the book. The hero may disrupt her emotional life, but he does not touch her social identity. In books by other authors, particularly those of the 1920s it is often the *hero's* social identity which is destroyed at the beginning of the novel.

In Elizabeth Carfrae's *The Devil's Jest* (1926) the hero is cut out of his uncle's will, loses his fiancée, and is forced to go to a foreign country for a job, which is provided by the heroine. In this respect, it is the *heroine* who can be said to restore the *hero's* social identity, by giving him the job he needs. And because the heroine's social identity is not destroyed at the beginning of these novels it can hardly be restored at the end.

This action on the heroine's part of helping the hero also appears in later books. For example, at the end of Joanna Mansell's *Sleeping Tiger* (1987), it is the heroine who saves the hero's company by investing her inherited fortune in it. There is a similar incident in Liza Manning's *The Garland Girl* (1985). Through their actions both these heroines ensure that the hero does not lose his position in society.

I would contend that Radway's thesis that women read romances to feel nurtured is not justified, and a different conclusion must be drawn – which is that, in order for the Mills & Boon fantasy to capture the readers, the hero has to be socialized into the heroine's world – becoming more like her. The two spheres – the male public and the female private – have to be conflated in order to reaffirm the heroine's world – her values and expectations, her needs and way of life. Thus, it is not that her social identity is restored, but that the female sphere she represents is

validated. In these romances the heroine, by bringing the hero into her world and teaching him to love, makes him more worthy of her love. She also makes him more worthy of being the man she could have been, and which she can only become by possessing him through love within marriage. By the fusion of the hero and heroine in marriage as the final resolution, the books emphasize that the female sphere is necessary to the public sphere. This, it seems to me, is the basic plot structure of all Mills & Boon books, past and present.

Radway's thesis seems to apply only to current contemporary romances, and even then not to all of them. There are two further points to be made with regard to Radway's thesis. As the reading habits of Radway's readers imply there is little cross-over from historical romances to contemporary romance novels, either by authors or readers (1984:56). However, there are exceptions. I, for instance, read both. Anne Weale and Anne Mather write contemporary Mills & Boon books and longer historical romances for other publishers. Georgette Heyer wrote historicals and contemporary crime novels with a love interest. Nevertheless Mills & Boon themselves have found it hard to get readers of contemporary fiction to read historical romances – sales of their historical series are miniscule in comparison to their contemporary line. It seems, then, that readers see a significant difference between historical and contemporary romances, so it may not be appropriate to treat them as a single genre, using Radway's thesis to analyze non-historicals as some have done.

Another point related to the reading experience itself is that people read different novels depending on their mood at the time, and what they desire from the reading experience at that moment. Taking a historical view, Fowler points out that romances change and that readers' response is related to this:

> The development of the romance sugests that readers are not passive. Its paradises change, along with women's new material experiences and their greater exposure to the arenas of modernity. Such readers are still active and critical thinkers who repudiate writers too removed from their own image of society. (1991:174)

If readers respond critically in a way that changes the genre (as Thurston (1987) argues), and are not passive, it follows that they are also making active choices in their day-to-day reading. As Daphne Clair (a Mills & Boon author) said about her favourite Mills & Boon authors: "It depends on my mood and the particular book. Sometimes readers are in the mood for the type of romance that is meaty and dramatic, rather than light fantasy" (questionnaire 1995).

If you are a reader of Mills & Boon novels, you know that different authors have different storylines and different ways of writing. As one of Fowler's interviewees said: "All Mills & Boon books are good but each is completely different from the others" (1991:137). For instance, Betty Neels writes the type of novel which revolves around the domestic, with a hero who is imperturbable. There is no sex in Neels' books, except, famously, "He kissed her hard." Penny Jordan, on the other hand, puts sex in the forefront as the battleground between the hero and heroine. Using this device, her novels show women leading lives of oppression, as the hero consistently misunderstands the heroine, reading everything she does negatively. But in the end, he ends up on his knees, literally or figuratively. As Donald says of the Mills & Boon hero:

> This powerful man, confident in his standing and his masculinity, sure of himself, competent and trustworthy, discovers during the course of the romance that without the heroine he is no longer able to enjoy life. *He needs her* ... He learns, usually with some pain, that to be truly happy himself he has to make her happy.
> ... Slowly he comes to realize that the only thing that will satisfy him is her admission of love for him, her equal commitment to a shared life. Equal partners in every way, they will live out their life together. (1992:83, original emphasis)

In the 1970s I read Neels to fill my need for a knowledgeable and calm father-figure. Carole Mortimer left me with a smile on my face. Penny Jordan I read to express some of my anger against men. It is apparent from Radway's text that what her readers did not like about Harlequin Romances was the violence in them: " 'I get

tired of . . . [the heroes] using sex as a weapon for domination . . . in Harlequins and I think they are terrible' " (Radway, 1984:75–6).

Most of the British authors to whom I sent questionnaires; wrote that as far as they were aware there was no violence in the books, because they assumed I had been referring to physical fights or gun battles. However, the New Zealander Daphne Clair did understand what I was really asking, pointing out that times have changed: "What we and most readers thought of as fantasy in a more innocent era we now know is all too common in real life and we don't wish to encourage any notion that it is normal."

One reason why Elizabeth Ashton stopped writing for Mills & Boon, according to her daughter, was the increasing violence in the books which, she said, "made them so unpleasant".

The feminist readers I questioned definitely objected to that aspect of the books, which concurs with Owen's (1990) findings. Frenier (1988) argues that violence only appears in Harlequin/ Mills & Boon books, and not in other, purely American, romance lines. She also comments that Mills & Boon heroines "act like battered wives". It may be that Penny Jordan appealed to me because, although not physically battered, I felt constantly emo- tionally drained, unable to summon up the energy to adequately express my anger against patriarchal society in general, and my husband in particular. In other words, I was reading Jordan to release some of the anger I felt at women's position in society. Most commentators focus on the hero's aggression. If it is men- tioned at all, the heroine's rage is referred to as "feisty but pas- sive", but these heroines *are* angry – an anger that I, at least, identified with.

Many writers' first novels are autobiographical, and Mills & Boon authors are no exception. Anne Weale's first novel was set in Malaya, her childhood home. Vanessa James' first novel was "her" story of a journalist meeting an actor. My unsuccessful Mills & Boon was not autobiographical. It might have been a better book if it had been, but remembering the story now, there were ele- ments in it that were of psychological significance. There was no violence in it. Emotionally drained, myself, I could not summon up the energy to write that type of romance. For, though grounded in social reality (as, for instance, sci-fi/fantasy is not) these books are also an exploration of what life would be like if . . . if I were

different; if society were differently organized; if my partner were different. That might explain why an author who looks like "a mumsy housewife" and who has a happy marriage writes darkly seductive sexual novels, with aggressive heroes, and why an author with a dysfunctional family writes romances about young women growing into love, without any sexual confrontations. Winspear was a spinster living at home with her elderly mother, and who, inspired by a photograph of Bogart pinned up above her typewriter, wrote novels which are pervaded with an atmosphere of erotic sensuality.

I created a young and naïve heroine, whose state of mind I found very difficult to enter into, but which may have represented my own unconscious desire to be a less aware – less "knowing" – subject. My hero was rich, the owner of three London hotels. This was a metamorphosis of my husband's dream of owning a famous restaurant, something he talked about doing, but never actually did, preferring a financial job in the business world.

The book expressed nothing of my feminism, perhaps because I could not, then, explicitly reconcile the two ideologies although other Mills & Boon authors were to include references to feminism at a later date. What my writing did express, in the person of the heroine, was my feeling of isolation. When the manuscript came back from the typist, she had queried my use of the word "bereft". I left it in , as it was one of the key Mills & Boon words at the time, used to express the heroine's feelings of despair and desolation at her separation from the hero. It is no longer part of the language of Mills & Boon books. That is to say, it is not a "code" word carrying a symbolic resonance over and beyond its usual meaning, although it may be used by authors now without that connotation.

As head copyeditor I experienced a similar event in the mid-1980s. A new freelance editor queried the phrase, "I have been faithful to thee, Cynara! in my fashion," a quote from Ernest Dowson's poem *Non sum qualis eram sub regno cynarae*. I've been unable to trace the first time the quote was used in a Mills & Boon novel, but the author expected her readers to understand the reference without any further information in 1986, and I left it, aware that it had been used before in Mills & Boon books and

was then, for a short time, part of the vocabulary of the readers, *as readers of Mills & Boon books.*

These two anecdotes are examples of the way particular words and phrases are used in Mills & Boon books at certain historical moments. The author is not concerned with a precise vocabulary, rather, it is a question of certain code words being hammered home again and again, often without regard to placement in the sentence, or to actuality.

It has become a cliché of the (laughter-filled) criticism of Mills & Boon books that the word "hard" is used for the hero. The critics concentrate on the sexual connotations of the word when used in conjunction with the male gender. But as Dyer points out in relation to the visual media: "One of the striking characteristics about penis symbols is the discrepancy between the symbols and what penises are actually like . . . even erect the penis and the testicles are not hard, tough, weapon-like" (1985:30–1). He gives the example of the flower imagery used by Jean Genet as a counter-symbol for male genitalia, an imagery, given the way they use sexual euphemism, Mills & Boon authors could have used. However, it could be argued that there is more to the use of the word "hard" in relation to the penis than an actual description of its state when erect. In Mills & Boon novels it is not just male genitalia that are hard. Men's bodies are hard. So are their voices. Their emotions are locked away, impenetrably hard. "Men" and "hard" are not two different concepts, but become synonymous with each other. In post-structural language, they are two signifiers with the same signified. So it does not matter where the word occurs in the sentence, as long as it is connected with the hero, not the heroine. Through repetition, in different positions in the sentence and in conjunction with different nouns, "hard" comes to symbolize more than the hero. It stands for the unknowable, alien "other" of the male, and, by association, the male world – patriarchy.

During the 1960s, and previously during the 1920s descriptions of sexual intercourse appeared in Mills & Boon books. Describing sexual passion has always been difficult for the notoriously prudish British, and especially for women to overcome Victorian taboos against them knowing of, much less speaking or writing, such words as "fuck". But "fuck" is "A Germanic verb originally meaning 'to

strike, move quickly, penetrate'" and "one of what etymologists sometimes call 'the sadistic group of words for the man's part in copulation'" (*The Feminist Dictionary*). In other words, it does not describe women's participation in sexual intercourse. Where, then, do women look for words to describe their own feelings and thoughts about sex? For women sex is usually about more than a quick roll in the hay, though it can be that, too. It is an act which involves the whole body, and which is not just about penetration. Mills & Boon authors have to find the words to describe not only the whole sexual encounter, from the initial attraction through to copulation, but they also have to describe it all from the woman's point of view. So once they have found a word or phrase that expresses what they want to describe, they stay with it. Thus, there is a remarkable consistency of use of code words to describe desire and love throughout the decades.

In Sophie Cole's 1913 romance *Penelope's Doors* the heroine's shoulder accidentally touches the hero's when standing next to him in church. She feels "a little thrill of an electric shock run down her arm into her finger tips" (1913:273). In 1990, in Susan Napier's *Fortune's Mistress*, the heroine's "silk-covered elbow" brushes "the dark fabric" of the hero's suit and she feels "small electric shocks travelling up and down her arm".

Not all code words survive that long: for instance, Sophie Cole's use of the code words "red" and "green" in her early novels of the 1910s. Red, obviously, denotes passion – in her case, lust without love. Green, for Cole, I interpret as meaning a passion that is socially acceptable, that is tempered by love and controlled by the intellect. But no other Mills & Boon author of the time uses these codes, and Cole herself abruptly stops using them in 1914, presumably because in wartime "red" can only be associated with blood, and they have not been used since.

Another of my reasons for starting to write a book for Mills & Boon was the need for money. It is difficult to estimate how much authors earn per title. The following figures are based on my own informed guesswork and the few figures I have been given by some authors when interviewed (Mills & Boon and most authors refuse to divulge either sales figures or remuneration). Elizabeth Ashton, whose last book for Mills & Boon was originally published in 1982, was still receiving (small) royalty cheques in 1995 for large

print editions and/or foreign rights. Pippa Clarke's first book, which was published in hardback only in 1986, earned around £1,000. Her next two, published in paperback, earned £29,000 between them, enough to average the royalties over the three books at about £10,000 per book. Some of the bestselling authors have earned about £50,000 per book over a period of years, from world-wide sales. But earnings plummetted in the 1990s, as Mills & Boon faced competition for the first time (in Britain) from, in particular, Silhouette. Unemployment affects sales. (The miners' strike affected Mills & Boon badly, a fact that Torstar did not understand, blaming the fall in sales on the standard of "the product" as they put it, rather than on economic factors.) These earnings quoted above seem high, especially when you realize that popular authors are writing at least six books a year – Charlotte Lamb, at one point in her career, was writing a book a month. The middle-range authors, however, producing no more than four books a year, will be earning less per title – around £20,000 – £25,000 – depending on how many countries they sell in. Advances are low, around £1,000 per book, though they do rise as the author becomes more popular. The royalty percentage is less than the average paid by other publishers: about 5 per cent, however many books are sold.

Writing is hard work. There is a myth that romance authors write effortlessly, the words pouring out of them, with no hesitation or need for alteration. But writing for all of the authors I interviewed included revisions. Charlotte Lamb told me that she now works more often on computers than typewriters as it is so much easier to make changes. Previously she would often leave the first thought she had put down instead of revising as it was such an effort to re-type. I suspect that for some authors writing becomes a: "prison – that prison of the mind where thought and imagination have to be driven into one particular groove and kept there at the point of a sword" (Sophie Cole, *The Speaking Silence*, 1921:1).

This view is borne out by Sara Wood's comment that her writing routine is: "Remorseless. Long hours, no week-end breaks. If I'm not in the mood, I get in the mood."

However, all the authors interviewed were so enthusiastic about the genre that the daily grind may not be as much of a "grind" as

these quotes imply. None of them mentioned writer's block, though Amanda Carpenter's heroine in *Rose-coloured Love* (1987) is a "burnt out" author, with the storyline revolving around the hero helping her to overcome her writer's block. After my one failure I never wrote another Mills & Boon. It may have been that at the time I was splitting my emotions into two; using feminism to express my anger and romances to express my needs and love.

All the feminist readers I questioned were ambivalent about their reading. In answer to the question: "Do you enjoy reading Mills & Boon books?" one woman answered: "I did, but I'm now (after answering these questions) wondering if I ever will again." Some had stopped reading them: "I've had my illusions of love and relationships shattered and can no longer believe the ideology." One had stopped reading them after her teenage years; another, finding them "quick to read" always kept one with her in her handbag. Personally, I never travel anywhere without one. Two respondents only read them "now and again", unable to "read more than two in succession because of the banality of the plot lines". But they do read them, despite the fact that, on the surface it might seem that romance ideology and feminist politics are diametrically opposed, except that both set out to claim for women the right to attain what they want. So, as Carolyn Smalley, a Mills & Boon copyeditor and feminist, put it: "In so far as the heroine always gets what she wants, on her terms, in a strange way, Mills & Boon's are feminist." Maybe it is that sense of empowerment that I, and other readers, get from both feminism in the public sphere and Mills & Boon novels in the private.

Virginia Woolf wrote that on, or around, December 1910 human nature changed. If so, Mills & Boon, opening their doors in 1909, were in on the beginning of that change. The following chapters chart the changes in society, including the changes to women's status, as they are depicted in Mills & Boon romances themselves.

1910s – Society and Exotic, City and Country

In 1910 Mills & Boon published Sophie Cole's *A Wardour Street Idyll.* Set in London, it is the story of 30-year-old Isobel, assistant to Theodore Saxton, the owner of an antique shop. He is a pessimist who claims it is "better to be asleep than awake" a philosophy which worries Isobel, who has "a zest for life". Saxton, who has lived in India, owns an ivory Nirvana figurine which has inscribed around its base the motto "Contentment is gained by the death of desire". Isobel is repelled by this figure, believing it to be the cause of Saxton's ennui, and hides it from him. For a while Saxton appears more lively, but when he discovers the figure is missing, Isobel has to own up to "stealing" it and returns it to him, whereupon he sinks back into apathy. The two, however, are drawn to each other, until Isobel discovers that Saxton is married to a woman now well-known as the author of decadent books. They have been separated for five years, ever since she left Saxton, taking their son with her, who died six months later. Isobel therefore refuses to become involved with Saxton. One night, when drunk, Saxton attempts to seduce her. Isobel at first acquiesces, agreeing to become his mistress, but then changes her mind when she realizes how ashamed they would both be of such a relationship. A month later Saxton leaves for Paris, before the situation between them can "develop into something which could rob it of all dignity". He leaves Isobel as manager in sole charge of the shop in London, and opens another one in Paris himself. Fifteen months later, his wife dead, he returns to London and proposes to Isobel. In the last scene on a balmy evening four years later, when they are out shopping in the junk shops of London for finds for their own

antique shop, Saxton finally and significantly throws the Nirvana into the Thames.

This summary cannot do justice to the power of Cole's writing, and the atmosphere of fear which pervades the book, partly invoked by the use of the supernatural, which Cole employs in many of her books to heighten emotion. There is also the constant awareness in the novel of a mass of humanity on the verge of poverty, living on the edge of the criminal underworld, with no way out. For instance, in a scene when Isobel is out alone at night, surrounded by dark shapes, a man whispers words into her ear that she does not comprehend (and which are never revealed to the reader), but by which she, nevertheless, feels threatened.

However, what is brought out in this summary are the various themes which are inherent in Mills & Boon books to a greater or lesser extent throughout their publishing history. This chapter analyzes these themes, with reference to *A Wardour Street Idyll* and other, later, Mills & Boon books which exemplify how a particular theme is handled in the decades following the 1910s.

A Wardour Street Idyll is set in the city, but there are significant moments in the plot when the action moves to the country, most importantly when Isobel and Saxton take the children of the family with whom she lodges to the country for the day. It is on this trip that Isobel first realizes there is another side to Saxton, and begins to fall in love with him.

In *The Country and the City* Raymond Williams argues that: " 'country' and 'city' are very powerful words." Around them:

> powerful feelings have gathered . . . On the country has gathered the idea of a natural way of life: of peace, innocence, and simple virtue. On the city has gathered the idea of an achieved centre: of learning, communication, light. Powerful hostile associations have also developed: on the city as a place of noise, worldliness and ambition; on the country as a place of backwardness, ignorance, limitation. (1973:1)

For the main part, Mills & Boon novels follow this, except for the last negative association of the country, which they reject, replacing it with the more positive association of the country as a place of healing and love. This is most evident in the novels of Sophie Cole's contemporary, S.C. Nethersole, which are set mainly

in Kent, and depict farming communities. In her *Take Joy Home* the heroine cannot write in London because "The roofs and chimneys shut me in . . . I cannot breathe sometimes" (1918:221). Once back in the country, her creativity returns. Later, the hero has a nervous breakdown as a result of his stressful life as a London doctor, and is rescued by the heroine who takes him home to the country to recover.

This depiction of the country as a place of healing and love winds its way through all Mills & Boon romances of the decades, and is still being used today. In Charlotte Lamb's *Spellbinding* (1990) the hero takes the heroine to his country house to recover from a serious accident, during which convalescent period they fall in love. In Penny Jordan's *For One Night* the heroine leaves the city to bring up her illegitimate child, the result of a one-night stand with a man she had not met before, in the country, where she feels "They would be happy here, she and her child" (1987:29). She meets the father of her child, who coincidentally lives in the village she has moved to, and falls in love with him. So, in this book, the country becomes the place of emotional healing and love.

The country is also a place of traditional values, as opposed to the rushed pace of city life where values often slip. In S.C. Nethersole's *Mary up at Gaffries* (1909) the safe country life of the heroine is contrasted with the uneasy and amoral life of her father, who lives in the city. In *A Wardour Street Idyll* Saxton's wife, a drug addict, is associated only with the city, whereas the heroine was born and brought up in the country.

This positive view of the country is particularly evident in Sara Seale's romances of the 1930s onwards, where typically, her heroine becomes involved with a man from the city, who only cares for having a good time, and often leads her into trouble. But she marries the man who represents the solid, timeless values of the country, who cares for her, not for his own selfish pleasure. Again, love and the country are inextricably linked:

> In Blake himself, she was to find that measure of contentment that was surely captured happiness.
> In spring the earth was re-born . . . an English spring in the meadows . . .

"The loveliest experience you can have, Lindy. . . ."
She lifted her face to Blake's. "I know I will be happy with
you," she said, and there was proud certainty in her voice.
(*Chase the Moon*, 1933:256)

These values that are associated with the country are also associ-
ated with England. In Nan Sharpe's *From Dusk to Dawn*, pub-
lished immediately after the end of the Second World War, the
heroine, widow of a country landowner, says to her stepson: "'You
fought for Graylings because, whether you realise it or not, it
represents what England herself stands for, integrity, straight deal-
ing, kindliness, tolerance, peace'" (1945:12).

Many Mills & Boon authors' attitude towards the country is
associated with their attitude towards wealth and class. In the early
society and exotic novels, wealth and class are inextricably inter-
twined, as would be expected – the higher the class, the greater the
wealth. Aristocratic heroes are the richest men in these books and
the heroines achieve both a higher status and wealth through mar-
riage. For instance, the plot of Laura Troubridge's society novel,
Body and Soul (1911), revolves around the arranged marriage of
the middle-class heroine and the aristocratic hero.

Some critics of Mills & Boon novels have pointed out that the
hero represents England, with his country estate and his lineage
and that by marrying the heroine he gives her a position in society.
This can be said to be true of both Troubridge's *Body and Soul* and
The Girl with the Blue Eyes (1912), where the middle-class hero-
ines marry the aristocratic heroes, and of Anne Mather's 1985 ro-
mance *Act of Possession*, where the heroine comes from a working-
class background. She supports herself and her 6-year-old daughter
by working as a secretary and refuses to marry the hero because
he is "way out of her class" (blurb), but he overcomes her doubts.
However, the aristocrats of current Mills & Boon romances are
more usually Arab shieks, or Spanish *duques*, or Italian *contes*.
Or, as in Susan Alexander's *Winter Sunlight* (1987), Austrian
barons. Unusually, it is the heroine of Sophie Weston's *Shadow
Princess* (1986) who is the aristocrat, being a Russian emigrée
princess, and the hero is an American concert pianist. In none of
these cases can the hero be said to represent England.

A *Wardour Street Idyll*, though, could be read in this way, as Saxton is wealthier than Isobel, as well as being "a gentleman by birth and upbringing". However, the plots of Mills & Boon romances revolve around, not social standing, but the growth of a person, through love, into adulthood. Saxton, with his "tired indifferent eyes" only becomes "awake" again through his love for Isobel, which enables him to throw away the Nirvana figure that represents a philosophy of death.

When the hero of *Body and Soul* proposes to the heroine, he says: " 'Love as you understand it, my white lilly, and as I understand it, are two different things; but you shall teach me your way, and I will teach you mine' " (1911:147). But, true to romance ideology, she never learns to take love as lightly as he does, and in the end it is her understanding of love that prevails – she is the teacher, he the pupil who learns that "Love is the only thing that matters in this world" and that loving someone is what makes you a mature human being (1911:306).

This ability of the woman to change a man through love is made explicit in Louise Gerard's *The Witch Child*, where the heroine thinks: "Luliya knew she could mould him just as she wished . . . This wild, reckless man with all his wealth and power had been put into her hands to guard and guide aright – a new kingdom that was hers to rule" (1916:313).

Less explicitly, but nevertheless underlining the power the heroine has over the hero, the hero tells the heroine when he proposes to her in Anne Mather's *Act of Possession*:

> "My life was so carefully mapped out. There was never any question but that I would take over my father's position in the company, and Celia [his ex-fiancée] seemed a suitable addition to my status . . . It was only when I met you, I started questioning my complacency . . . I don't know what you've done to me but I can't contemplate my life without you." (1985:181–2)

In this speech he acknowledges that he has turned away from the more patriarchal view of marriage as a business merger to the more female view of marriage being based on love.

In this book the hero comes from the country, a place where the heroine, despite her city background, also feels comfortable which

underscores her suitability as his wife. Unusually for Mills & Boon books of the 1980s, the hero is both aristocratic and wealthy. For in most Mills & Boon books of the later decades wealth is associated, not with the aristocracy *per se*, but with a hero who is often a rich entrepreneur from a non-aristocratic background, who is city-born and whose connection with the country is minimal. In Roberta Leigh's *And Then Came Love* (1968) the hero is from a poor Northern working-class background while the heroine is from a family "with a mansion tucked away in the country" (1968:13). The mansion had to be sold when the heroine was 14, because her father, an officer in the Army, had died. She and her mother and brother have been living on a widow's pension ever since. She marries the hero in order to enable her brother to continue his musical studies, but eventually falls in love with him. In this book, the hero keeps the heroine in her accustomed social background, but she is also raising and validating his social status. If he represents England, it is not the traditional farming communities, but the mills and factories of industry that he stands for. This book, with its merger of "the country" and "the industrial city" (as well as the South and the North) combines the two originally opposi-tional lifestyles in marriage (as happens, for instance, in E.M. Forster's *Howard's End*). This theme of merger, or compromise, is also evident in those books of the 1990s where the hero and heroine both give up their respective lives in the country and the city in order to live in a small town where they can both follow their own careers. Such is the case in Robyn Donald's *Country of the Heart* (1987) in which the hero is a farmer and the heroine becomes a country GP.

In the society and exotic novels, and in many Mills & Boon books of the 1950s onwards, the hero's wealth is commensurate both with his personal charisma and his powerful standing in society. Thus, when he lays it all at the feet of the heroine, it becomes a symbol of the depth of his love for her. But in the early city and country romances immense wealth and, in particular, the aristocracy, are suspect. In *A Wardour Street Idyll*, for instance, Isobel is propositioned by one of Saxton's aristocratic clients, a proposition she does not understand.

All Mills & Boon novels stick rigidly to a middle-class moral-ity, which condemns sex without love. Lewis (1984) argues that

during the 1910s many women viewed sex with repugnance, and many Mills & Boon books hint at this female distaste for sex. In S.C. Nethersole's *Mary up at Gaffries*, the heroine's friend has had to marry a man she does not love in order to survive economically after the death of her father. On her wedding night the author uses the symbolism of home- and sea-sickness to describe her fear of the night ahead. On a boat crossing the Channel, she is "a girl battling with sea-sickness and home-sickness, and the sick (because hopeless) longing for just the touch of her father's kindly arms about his Little Person. The day was at an end" (1909:488). In Louise Gerard's *Life's Shadow Show* the heroine's wedding night with the man she has been forced to marry through penurious circumstances is referred to as one of "fear and shame" for the heroine (1916:196). It is described obliquely: "Then into the room that night, always filled with the sigh of winds, the scent of meadows and the music of cascades, came a man's voice, soothing and tender, and the sound of a girl's shamed weeping" (1916:195). However, this is not the only type of sex portrayed in Mills & Boon books of this period. For instance, in Gerard's *The Virgin's Treasure* the hero and virgin heroine have pre-marital sex:

> Lost in a hazy, scented maze of love, she lay in his arms. All she knew, lips, eyes, hands, hair and throat, she gave up freely for him to caress and fondle. She had not known that love could give so much, or ask so much, but since it could it was all his to have. (1915:169)

This is a scene, significantly set in the country-like surrounds of a garden summer-house, of mutual desire, and is a portrayal of affectionate sex between partners who love each other. This type of sex scene is rare, even in later Mills & Boon novels, because once the obstacles have been overcome and love has been declared and accepted, sex scenes are minimalized. It is as if the sexual passion of acknowledged lovers is literally indescribable.

These more sexual books belong to the society and exotic lines. The city and country novels are, as a whole, distrusting of passion and less sexual than those set abroad. Saxton is exiled for his attempt to seduce Isobel, when there can be no possibility of marriage between them. Most Mills & Boon novels while acknowledging sexual attraction as an element of marriage, emphasize

that the essential basis for marriage is love which includes the elements of friendship, shared interests and companionship.

In *A Wardour Street Idyll* there is no question of divorce for the hero, partly because of the stigma involved and partly because he cannot prove adultery on his wife's part. And, as is still the prevalent attitude of Mills & Boon romances today, adultery, seen without discussion as morally wrong, is out of the question. Isobel refuses to become Saxton's mistress. However, in those society and exotic books that can be interpreted as arguing for a change in the divorce laws, there are exceptions to this rule.

In Laura Troubridge's society novel *Stormlight* (1912), the heroine shocks society by running away from her brute of a husband to find protection with a rising Member of Parliament. She is intercepted on the way by his brother, who offers her his protection instead, in order to save his brother's career. They fall in love and plan to marry once she is divorced (at that time, a wife could only divorce her husband on the grounds of both adultery and one other offence, whereas men could divorce women for adultery only). The hero's mother, on hearing her son's plans to marry the heroine, says to his brother:

> "To me, a woman who leaves her husband and her home has committed an act that nothing can possibly condone, or even expiate."
> "Castleton [the heroine's husband] is a drunkard."
> "That is no excuse at all. What does the marriage service say? For better for worse, in sickness or in health."
> "My dear mother, it's universally acknowledged that the marriage laws make a very great demand on human nature."
> "I do not acknowledge it."
> He smiled.
> "You married a very good man." (1912:236–7)

The argument that a woman who finds herself married to a man who does not keep his wedding vows, nor treat her with respect, should be able to obtain a divorce without social stigma, or legal repercussions is, in Mills & Boon's philosophy, unanswerable. The heroine of *Stormlight* does obtain a divorce. However, when she realizes that by marrying her the hero will be ostracized by society and lose his good name, she returns to her husband, at his

request, to nurse him through an illness. On the eve of their re-sumption of sexual relations she kills herself, unable to bear the thought of sharing a bed with him. The book ends with the hero's thought that "the real tragedy of their love was in its incomplete-ness" (1912:316), that is, their inability, because of social forces, to consummate their love in marriage.

The fact that the heroine commits suicide could be construed as a literary punishment for her adultery, but as is evident from both the passages quoted above and the final words of the novel, as well as from other Mills & Boon books of this period and later, it is more likely to be read as a plea for a liberalization of the divorce laws. This would have been against the ideology of the time as both feminists and non-feminists during the 1913 Royal Commission on Divorce argued against divorce and for a raising of men's moral standards (Lewis, 1984). But romance ideology demands that marriage should only be entered into with love, and that in a marriage without mutual love, sex, for the woman at least, is a shameful and often abhorrent act.

In all these books the hero is the object of desire, but it is only in the society and exotic novels that the story revolves around his sexuality. With a few exceptions, in the oeuvre as a whole in this period, explicit male sexuality is displaced either on to the English aristocracy or, in the 1920s, on to Mediterranean heroes. This latter aspect remains a constant of the books ("A book with a Latin hero is always 'hotter' than one with a British hero" as an editor put it). Around the period of the First World War the aris-tocratic heroes of Mills & Boon books cease to be as explicitly passionate, perhaps mirroring the historical reality of upheavals in the social structure. As Naomi Mitchison states that it was not unusual for a man in his twenties to be a virgin in the First World War (quoted Beauman, 1983), the displacement of sexuality on to men of other nationalities may have had its basis in reality.

Mangan and Walvin (1987) argue that the Edwardian ideal of masculinity was one of modesty, frankness, unselfishness and strength. Men should be honourable and self-reliant. Mills & Boon books, however, only value the last four of these attributes which are, in the early years, symbolically represented by the colour "white". This is most explicit in Louise Gerard's *Flower-of-the-Moon* (1915), where part of the plot revolves around the attempts

of the secondary Arab hero to become as "white" as the English heroine. But despite this, she rejects him in favour of an Englishman, who is also "white" in character which is associated with his respect for women.

Gerard's later novel, *The Sultan's Slave* (1921), also expounds on "whiteness" as symbolically representing all the solid values of the British. It portrays a hero obviously based on E.M. Hull's *The Sheik* (1919). In Hull's novel the hero, although living as a Bedouin Arab, is the son of a Scottish earl and a Spanish princess. In Gerard's novel, the hero believes himself to be the son of an Arab father and a French mother, and lives as an Arab sheik. The heroine discovers that his true father was actually his mother's French husband, whom the hero's stepfather killed in order to capture his mother. Throughout the book the hero threatens her with beatings and rape but never carries out the threats. At the end, after another unconsummated threat of rape, he says:

> "My darling, help me to grope back to your white ways.
> You won't have to grope. You got there last night when you remembered my reputation and went [away] nicely and quietly like a good boy." (1921:245)

This emphasis on the colour "white" representing all that is honourable and trustworthy in a man, is one way in which the Mills & Boon books of the early years are racist. As one would expect of this period, another aspect of their racism is the language used about Jews and black people. For instance, Sophie Cole describes a Jewish woman as "wandering round the shop, sensing the treasures with the love of colour natural to her race" (*A London Posy*, 1917), and in *Flower-of-the Moon* Louise Gerard refers to "the [African] village with its squalid ways and periodic scenes of wild debauchery" (1915:52) and the "rolling eyes" of black Africans.

In other books it is the plot that expresses a view of other races. In Alice Eustace's *Flame of the Forest* (1927) the heroine is an Indian princess in love with a British man. It is made quite clear that there can be no possibility of a marriage between them, partly because of her status in relation to his, but mainly because of their different racial backgrounds. In other books, for instance Elizabeth Carfrae's *The Devil's Jest* (1926), the inter-racial marriage

of the hero and the other woman breaks down when he discovers she is half-black.

There are still no black heroines or heroes in Mills & Boon novels. Pat Cowley, head of copyediting at Mills & Boon until the early 1980s, tells the story of one particular romance she was discussing with Alan Boon. Surprised when he said it was the first Mills & Boon to have a black hero and heroine, she went back to the text for confirmation. She discovered that, although both protagonists came from Barbados, skin colour as such was never mentioned (private communication). There seems to be an in-built resistance to black heroes both at Mills & Boon offices and among their authors. When interviewed in 1991, Cathy Williams said she had never thought of using a black protagonist, even though she herself is Trinidadian.

The use of the term "white" in favourable connection with a British hero continued into the 1930s. However, gradually, it was transferred to the physical description of the heroine, especially when contrasting her with a Latin hero. In this way, the word "white" became more associated with women and feminine qualities. It is still used in this way today.

As for the masculine ideal involving frankness even in the early years the Mills & Boon hero was not always frank. It is important, however, that he never lies. In Leigh Michaels' *Leaving Home* (1985) the heroine believes that the hero, her stepbrother, has lied to the other man about her not having a trust fund:

> "You told Jerry that I wouldn't get anything –'
> "I told him," Drew corrected grimly, "that your father didn't leave you a cent. Which is literally true. He didn't ask me if my father had done anything for you, so I didn't tell him . . ."
> Drew hadn't lied after all, she thought with a sudden wave of relief. (1985:179)

As this quote shows, however, the hero can be economical with the truth.

Another aspect of the hero which is evident in all Mills & Boon novels, and around which most plots essentially revolve, is their inability to communicate with the heroines. In *A Wardour Street Idyll*, Saxton is unable to tell Isobel that he loves her, until he is ill and his barriers are down.

Just as Saxton has to suffer an acute illness, nearly all Mills & Boon heroes have to undergo a period of tribulation, generally portrayed in the books as a separation of the hero from the heroine, both emotionally and often physically, before the heroine accepts him. Radway argues that this separation frightens the hero into realizing he does not want to lose the heroine (1984:148). But, more importantly, in Mills & Boon philosophy the separation makes the hero realize he loves the heroine. It also introduces him to an emotional separation from society which many women endure throughout their lives. This experience enables the hero to accept the heroine as an individual and thus love her in the way she needs.

In Louise Gerard's *The Virgin's Treasure*, the hero must search for the heroine with the help of a map which is marked in terms reminiscent of Bunyan's *The Pilgrim's Progress*: "Slough of Despond, Sea of Trouble, Forest of Misunderstanding, Plain of Despair, Tombs of Buried Hopes and Death of Desires, Mountains of Self-Abasement, Valley of Peace, Stream of Faith" (1915:271). As well as their obvious religious references, these terms also describe the emotional journey of the book the hero must take before he can become worthy of the heroine's love which is at the core of Mills & Boon ideology.

Most literary critics of love plot novels argue that marriage marks the end of the story for the heroine. And most romances do, indeed, end with either a marriage, or mutual declaration of love, between the hero and heroine. But not all. As already described, *A Wardour Street Idyll* ends not with marriage, but a scene some years later, when Saxton finally bows to Isobel's wishes and gets rid of the statue Nirvana. In the 1980s many of, for example, Carole Mortimer's books do not end with a marriage but with the birth of the first child.

This is significant, in that children are of symbolic importance in Mills & Boon books. They often act as Cupid, bringing the hero and heroine together. In many romances the heroine is employed in the hero's home to look after the children in his care (either his own, or to whom he is guardian). In others the heroine is the guardian of the child, and the hero is a relation of the child's mother or father. In other Mills & Boon books the hero and heroine are re-united when the hero realizes that the heroine's

child is his, and was born after their original affair had ended. This is of particular significance as, these children of the main protagonists represent not only their love for each other, but also their future happiness as they are a physical link between the hero and the female sphere of home.

Another way of continuing a heroine's story after marriage is to include her relationship with the hero in later books. Sophie Cole does this in her 1914 *Patience Tabernacle*, where we have a glimpse of Saxton and Isobel, from *A Wardour Street Idyll*, working together in their antique shop. Some contemporary authors also feature their characters in later books, as onlookers to another couple's love affair. Essie Summers uses this device quite frequently. The hero of Susan Napier's *True Enchanter* (1987) is the brother of the hero of her *Love in the Valley* (1985), and the main protagonists of the earlier book appear with their child in the later book. Penny Jordan, writing as Frances Roding, used the characters of the Bellaire family of seven children in a series of novels published from 1988 onward.

Marriage does not always mean an end to the heroine's work either. Although in some instances the heroine (for example Patience, in *Patience Tabernacle* and Penelope in *Penelope's Doors*, (Cole, 1913)) is obviously not going to continue work after marriage, in other novels they do. Because Mills & Boon books have always had a work ethic. The society novels, of course, have non-working heroines and heroes, and the heroines of Louise Gerard's West African romances only rarely earn their living. But the heroines of other romances are generally working women, most of whom have little problem in finding a job.

It is generally assumed that the First World War saw the beginning of women's emancipation from the home – for the first time many middle-class women worked in paid labour, as ambulance drivers, nurses, typists in government offices, on the land or in industry. But the Mills & Boon books of the 1910s do not reflect this. In their world the war changed nothing – the heroines were already working before the war as typists, nurses, models, society entertainers, fashion illustrators, shop assistants/managers, authors, editors and, in one case, as the longtime caretaker of Doctor Johnson's house in London (Cole, *A London Posy*, 1917). Of the heroine's friends, some are at home looking after family, but others

train to be dental technicians, are already doctors, become actresses. They have already left the parental home and support themselves. Very few, however, are nurses or teachers, the two main careers open to women in 1911, and none of the main characters are domestic servants. This is consistent with the fantasy element of the novels, which have always shown women in careers that very few women, in reality, could hope to achieve at the time of writing.

In S.C. Nethersole's country novels women are often farmers, as well as shopkeepers and pawnbrokers. In these country novels it is expected that if married the heroine will be partners with the hero in running the farm and, if single, they will run the farm themselves, as in *Mary up at Gaffries* (1909) and *Wilsam* (1913). Husband-and-wife partnership is a constant theme in Mills & Boon romances, and is often used to circumvent a particular period's ideology that married women should not work after marriage. Consequently, it is particularly strong in the 1950s and is used by Essie Summers in her New Zealand farming novels. Present-day authors occasionally use this theme to bypass the problems created when both husband and wife have careers. For example, in Leigh Michaels' *Dreams to Keep* (1985) the architect hero and heroine who are initially antagonistic eventually join forces in starting their own firm. Janet Dailey's *Strange Bedfellow* (1979) presents a slightly different situation. The heroine has been running her husband's firm since he went missing, presumed dead, in the South American jungle. When he unexpectedly returns home, they have to renegotiate the terms of their marriage, as she refuses to give up her career, and he takes back the reins he previously held as head of the company. In this novel, written earlier than *Dreams to Keep*, the couple do not run the firm as partners, instead the heroine becomes the head of their new advertising campaign, and remains so, "directing operations from the maternity ward" (1979:187) after giving birth.

Throughout the decades Mills & Boon novels consistently refute that woman's only sphere is in the home, despite love and marriage being the main subject matter of all their stories. They also assert that a woman who is not with a man and who has to work in order to live is not necessarily unhappy. Isobel, in *A Wardour Street Idyll* is 30 at the start of the book and still friendly

with men whose proposals she has rejected in the past, and is quite content with her life. In Cole's later *In Search of Each Other* (1913) the heroine is a 45-year-old freelance magazine illustrator and writer who is full of enthusiasm for the "little adventures" of life and who is envied by her friends who are at home looking after their parents. It is also implied that she will continue working after marriage.

In the same author's *A Plain Woman's Portrait* (1912) the heroine, reflecting on compliments paid to her writing by another woman, "smiled, and any one looking at her would have imagined she was thinking of a lover" (1912:101). Work and love are linked and, by implication, marriage and family life, in a way that was to become a major theme of all Mills & Boon novels dealing with women's right to work. Although the hero of this romance tells the heroine: "You'd be fool enough to give up your work for a husband, if the right man asked you" (1912:263) the heroine disagrees with him, and because the reader knows that this hero would not ask that of her, the heroine's view is endorsed by the author: the heroine will not marry a man who will expect her to give up work.

These early Mills & Boon heroines, in fact, are similar to Mary Datchett of Virginia Woolf's *Night and Day* who "earned, or intended to earn, her own living and had already lost the look of the irresponsible spectator" (1919:42). According to Beauman the roughly five million working women were ignored by the "middlebrow" novelists of the period between the wars that she is writing about because their novels "were still dominated by the love interest, by the subject of women's lives as, how and when they were rearranged by men" (1983:42). Mills & Boon books of the period, however, do show women working, and *wanting* to work. The heroine of *A Plain Woman's Portrait* (1912) becomes a typist in order to escape from her brother's home after her parents' death: "There was work for girls to be had in London offices. She knew several who had found such . . . Why shouldn't she? Take lessons in book-keeping, typewriting and shorthand" (1912:73–4). Her brother objects: " 'I don't like you going to London. You would be lonely, and I fear your health would suffer.' . . . [but] London called with the call of romance, it stood now for all in her life which was outside the commonplace" (1912:75).

So the heroine ignores his warnings and goes. She has a novel published and is about to start earning her living as a writer when her sister-in-law dies and she "out of duty of love" has to return to her brother's house to look after her nephew. Once her brother has remarried she is once again free to return to London to pursue her own life, becoming a successful novelist and eventually marrying the hero, who has always supported her in her writing career.

The heroine of Louise Gerard's *The Swimmer* (1912), in a letter to the hero about their future life together, has no qualms in saying that she will continue writing and publishing poetry. She knows that he expects this of her. In *The Witch Child* (1916) by the same author, the heroine is a doctor who only agrees to marry the hero on the understanding that she will continue to run her own clinic for the poor.

These novels, however, do not neglect the outside reality of the differences in opportunities for paid employment between men and women. The plot of Gerard's *Life's Shadow Show* (1916) revolves around the lack of work available to a middle-class woman who has been given little education and no training. This novel echoes Ethel Snowden's comment that: "The plain unvarnished truth is that work open to women is not sufficient in amount or sufficiently well-paid to enable them to live in a condition of ordinary comfort and decency." (*The Feminist Movement*, 1913, quoted Adam, 1975:18–19). It depicts a woman who, because of her inability to earn enough to keep herself, is forced to marry a man she does not love and becomes pregnant making her further dependent on him. She later discovers the marriage to be bigamous, a minor theme of Mills & Boon books of the 1920s and 1930s. At the beginning of the book she is a helpless character, but starts to earn money as a writer after the birth of her child and is thus able to leave her lover. She takes her child with her, refusing economic support from him as she can earn a living as an author of children's books. Eventually she becomes a successful playwright and only then does she allow her lover (now a widower) to return to her. She argues that she cannot be his mistress or his wife until she is in a position to support herself.

These independent heroines are nothing like Radway's orphan heroines "away from home and vulnerable". In most Mills & Boon romances it is the heroine who is the hero's succour, not he

her saviour, as other critics have argued. This is particularly evident in the 1910s, when Radway's parent–child analysis is reversed, with the heroine portrayed as the parent figure:

> in all the world there was no one who would understand his loss as Rosalind would. Unconsciously he had been travelling towards the goal of her sympathy, as unconsciously as a child turns to its mother in trouble. (Sophie Cole, *The Loitering Highway*, 1916:299)

In Laura Troubridge's *Body and Soul* (1911), unusually for Mills & Boon novels written in the first person, the hero and heroine are in an arranged marriage. The hero, whose ideas on love differ from the heroine's, leaves her to her own devices while he goes off pursuing his own pleasures, which include having an affair during the heroine's pregnancy. Eventually she falls out of love with him, just as he is beginning to realize he loves her. In the final scene of the novel, he overhears his child, who is named after him, praying: "Bless Mummy and Daddy and make Jim a good boy to-morrow" (1911:309). He comes into the room:

> [R]uddy and bronze but his eyes looked as wide and hopeless as ever, and he stood before me like a beggar, who dares not beg . . .
> "Rosalyn . . . he is not the only one who wants to say his prayers to you."
> . . . The child held out his arms and so did I, and Jim fell on his knees by my side and pillowed his head on my breast where his son had nestled a moment before; and in that moment my love came back to me, not quite the same, but changed and purified, and with something of the mother in it.
> "I love you – I love you!" I said. "If you want me I will never leave you."
> "I want you," he answered, and as he spoke he gave a deep irrepressible sob. "And I too, Rosalyn, want to be good to-morrow!" (1911:311–12)

There is a similar scene towards the end of Sophie Cole's *The Thorn Bush Near the Door* (1912), where the hero has been on trial for a murder he did not commit, but of which he is accused because of his adulterous relationship with the dead woman. After

his acquittal he returns: "robbed of his self-confidence and ease of manner . . . The 'mother' in her yearned over him . . . all her tenderness rising to the succour and defence of the fallen god humbled in the dust . . . He was at her feet, repentant . . ." (1912:335–6). He says he will go abroad because it would not be right for her to be seen to forgive him for his affair and take him back. She refuses to let him go alone on the grounds that morally he is unable to stand on his own two feet. They argue about this, as he says, "I'm not going to make you a keeper of my morals. If I can't stand alone, then let me sink, and the sooner the better."
But she seduces him into agreeing with her:

> Ros, the girl wife [she was 19 when they married], who in the past had contented herself with a passive surrender to the man of her choice, this same Ros was showing herself an adept in the wiles of seduction. The discovery caught him unawares with a provocative surprise that set his heart beating in response. The wisdom of the serpent had dictated the choice of this last weapon, and the woman saw the dawn of her victory in the eyes which met her ardent ones, and stayed in a long look. (1912:338)

In both of these scenes it is the heroine who is quite obviously being portrayed as a mother-figure, and the hero as a child. She could even be seen as a Madonna and the hero a sinner, in need of her help and guidance. This attitude, of course, arises out of the "Edwardian sense of the feminine as symbolising 'higher things'" (Light, 1991:108). It also reflects the women suffrager's argument that men should raise their moral standards to meet women's. Most Mills & Boon novels retain this ideology to the present day, arguing, in effect, that men have to enter the female world of love and domesticity before they can become fully-rounded human beings.

But what is most interesting in *The Thorn Bush Near the Door* is the relationship drawn between the heroine and the other woman. Before the marriage between hero and heroine there are hints that the heroine looks very much like a portrait that the hero had painted called "Daughter of Joy", which was then a common term for prostitute, although it is apparent that the heroine does not know that. However, soon after the marriage she sees this woman

talking to her husband and it is obvious to her that she is "a girl of the streets" as Cole puts it. This link between virgin heroine and sexual other woman is common in Mills & Boon novels of all periods, making part of the underlying theme of these romances the acknowledgement by the heroine of her sisterhood with all women, as, at the end of the novel, she accepts her own sexuality as part of her female nature. In *The Thornbush Near the Door*, this other woman, representing avaricious lust, is killed; a death which symbolizes the repudiation by the hero of sexual intercourse as just a physical act (see p. 59). It is only after this denial by the hero of meaningless sex that the heroine can fully accept him in her life. In later novels this repudiation is represented by the rejection of the other woman by the hero when he meets the heroine and falls in love with her.

But the heroine also has to accept her own sexuality as an active force, represented by the sexual other woman, which she can only do once she is assured that the hero understands the difference between sex as an appetite to be indulged, and sex as an expression of love. The male protagonist, in other words, has to change if he is to become the heroine's hero. In this respect, Mills & Boon romances have more in common with *The Beauty and the Beast* fairytale, than with the story of *Cinderella*. In these books, even if the "Prince" is wealthier and more powerful than the heroine, he still has to undergo a sea-change in order to become worthy of her.

As was noted at the beginning of this chapter, *A Wardour Street Idyll* contains many of the themes that are common to Mills & Boon novels of the period – themes which re-emerge throughout the nearly 90 years during which they have been published. The following chapters take up some of these themes and explore them in more detail, showing how they change with the times, but always remain faithful to the fundamental Mills & Boon philosophy that puts women's needs and viewpoints first.

Hero – *You brought me to life*

Social reality necessarily colours the portrayal of heroes in all popular literature. Thus, in Mills & Boon novels, there are: the imperialistic British hero of the 1910s, the boy hero of the 1920s and 1930s, the British country gentleman of the 1930s, the mature hero of the 1940s, the boy-next-door of the 1950s, the Latin/Arab macho hero of the 1960s, and the dominant hero of the 1970s and 1980s, who can be cruel and sexually aggressive, but also tender and supplicating.

Miles, following Radway (see page 31), claims that in romance fantasy the hero is "an all-powerful parent who is protecting" the heroine (1991). But there are considerable problems with this argument that arise from its historical specificity. It assumes that in all these books the hero is older, richer and more powerful (both physically and socially) than the heroine. As such – and this is important to the argument – he is feared as well as desired, just as a child fears and loves the parent as a figure of authority and caregiving. But this type of hero – known to Mills & Boon editors as the alpha man – makes his first appearance in the 1960s, in a period of student riots, the civil rights movement and demands for both sexual liberation and women's liberation. In other words, as western society went through a period of unrest, romances portrayed a strong authority figure to provide an element of certainty in an uncertain world.

As stated in the preceding chapter, in the early decades it was not always the hero who was the parent figure. In Elizabeth Carfrae's *Payment in Full* (1929), for instance, the hero – who is only a year or so older than the heroine – is off-stage for a major

portion of the novel, and it is the heroine's husband (who she has been forced by penurious circumstances to marry), who is older, richer, and more powerful than her. In this respect he can be said to conform to Radway's "aristocratic" hero, and as such represents the mother-figure (as opposed to a father figure which I will discuss later in this chapter). The heroine and hero have an adulterous affair but, significantly, it is only after the husband's death that the hero, now a Captain in the US Navy, and the heroine, now a wealthy widow, are free to marry and form a lasting and equal partnership. This plot, apart from its obvious Freudian Oedipal references to the supplanting of the father by the son, is more about a woman's fight to free herself of the mother-figure as represented by the husband both literally and psychologically, in order to be able to exercise true freedom of choice, than about the hero taking the place of the mother in her life.

The heroes of the 1910s' romances of Mills & Boon were British, imperialistic, and mature. The heroes of the 1920s and 1930s lost these characteristics, and split into two types – the macho, non-British "god", and the boy, who was occasionally British, but sometimes American, Russian, or Latin. Contemporary Mills & Boon novels sometimes feature a variation of the macho "god", but it is only in the post-First World War period that the hero can be, and often is, younger than the heroine, less well-educated, often with less income and physically inferior: "Seen in the flesh Roy Burney was not imposing; a rickety-looking youth quite two inches less than herself . . . He looked delicate enough, poor boy!" (Louise Gerard, *The Strange Young Man*, 1931:17, 67). These boy heroes are very different from the "clubland heroes" of the 1920s studied by Richard Usborne who "were very rich, belonged to clubs, had servants and fast cars". This "beefy type of hero was a man's man. [And] his club . . . offered him a fortress . . . [from] the distractions of, or obligations to, his womenfolk" (1974:3). This desire for the exclusive company of men is not, in any period, part of the Mills & Boon hero's make-up, as the plot of a romance necessarily revolves around the male desire for the female. In fact, Mills & Boon heroes in the 1920s and 1930s are closer to the detectives featured in the books of Dorothy L. Sayers and Marjorie Allingham, who used physically slim and unprepossessing amateur sleuths "whose personal characteristics are likely to include . . . a

narcissistic delicacy" (Light, 1991:72–3). For, as Jane Miller argues in *Women Writing About Men*, men's heroes, "who would put achievement before love" are not women's heroes, "who would be . . . prepared to love her and to hear her first" (1986:153). After all, "Whether the men in women's novels have been intended as realistic portraits, romantic fantasies or a mixture of both they are . . . men seen, desired and understood by women" (1986:142).

As Violet Winspear put it in the *Radio Times*: "I think all women like to dream about marvellous men." Adding: "I've never met any of them myself, I doubt if anybody has" (quoted in Anderson, 1974:237). However, even if no one has ever met an actual Mills & Boon hero, he is grounded in reality, in that he owes something to the times during which he was created. Thus, although Winspear's 1970s' and 1980s' tough-with-a-heart hero could be construed as representing the mother-figure, the 1920s' and 1930s' hero could not. As already indicated the hero of Louise Gerard's *The Strange Young Man* is no mother-figure in stature, despite his wealth. In this book, if anything, it is the heroine who is the mother-figure – she is the one who takes care of the hero, in this instance being employed by him as his bodyguard. In other books by the same author the heroine takes a more conventional maternal role, as for instance in *The Dancing Boy*: "As Rebel settled himself at his wife's feet, from somewhere she drew out a wide, woolly scarf and wrapped it about his shoulders" (1928:252).

This book has an example of a hero who is the exact reverse of the alpha man – he is poor and not socially powerful, the illegitimate son of a Russian aristocrat and an English dancer, earning his living as a professional dance partner. The heroine, on the other hand, is middle-class, and training to be a doctor on a £1,000 annuity. The plot of this book also emphasizes the reversal of roles when the heroine rescues the hero from his murderous enemies.

Significantly, however, although at no other time apart from the 1920s is the hero depicted as a boy (and younger than the heroine) in nearly all periods, the heroine sees him at some point in the story, as a child or boy.

> Anger and resentment died and she felt tender and maternal. As she felt towards Robin when he was naughty and too proud to admit repentance. Peter [her husband] was such a child.

So big and strong and splendid, but so ludicrously childish. She . . . spoke to him. As she would have spoken to Robin aged two and a bit. (Elizabeth Carfrae, *Blue Heaven*, 1939:117)

"Am I beautiful enough for you?" he whispered in a strangely tremulous voice, and Verna's mind saw a very small boy seeking desperately for reassurance.
"Truly beautiful," she whispered in return, with a light kiss on his fevered brow. "Now go back to sleep". (Victoria Gordon, *Sugar Dragon*, 1981:112)

In other novels the hero is given childish attributes. In Mary Burchell's first novel for Mills & Boon, *Wife to Christopher* (1935), the hero's "sulky melancholy" "profoundly touches" the heroine. This characteristic is also found in Charlotte Lamb's heroes, for instance in *Spellbinding* (1990). Lamb herself maintains that her readers do not find her heroes aggressive but "to some extent, very funny, with their terrible temper" which makes "women feel superior" (telephone interview, 1991). This reaction of the reader infantilizes the hero. The books written in the 1960s and afterwards connect the hero with childhood by showing his interaction with children and their affection for him which alters the heroine's perception of him, as children are portrayed in Mills & Boon books as knowing instinctively whether people are to be trusted or not.

Also in books of the same period, this alpha hero is seen by the heroine, at some point in the novel, standing completely alone and isolated. This also changes her perception of him because for the first time she sees him as vulnerable. In other words, fear may generate desire, as both Miles and Radway argue, but it is the hero's childlike qualities and vulnerability that generates the heroine's love for him. However, in Mills & Boon books from the 1920s and up until the 1940s the heroine has little, if any, fear of the hero. Her desire for him is fuelled by other feelings. The heroes of these decades have other attributes that their heroines find attractive, attributes that emerge from the social background of the period in which their creators are writing.

In post-First World War Britain there was a perception that not only was there a shortage of men after the slaughter of the trenches,

but that there was a shortage of "whole" men. In her article "Soldier's Heart" (1983) Sandra Gilbert argues that during the First Would War young men became increasingly alienated from their pre-war, imperialistic selves. Immured in the mud of No Man's Land, pinned down in the trenches, they felt static, no longer powerful. This was compounded by the men who had returned from the war shell-shocked – "Full of self-doubt, nervy ('neurasthenic' even)" (Light, 1991:170) – and physically disabled. With the open debate of both Havelock Ellis' and Freud's theories of sexuality, both of which included a masculine prototype of super virility who is sexually inexhaustible – Englishmen, unable to achieve this impossible feat, began to see themselves as limp and sexually inadequate: "The Great War was a crisis of masculinity . . . Sexual impotence was a widespread symptom" (Showalter, 1985:170, 172).

As a consequence of the combination of this British male anxiety over the loss of sexual potency and disquietude over Britain's loss of status in the world, men retreated into the home, becoming "pipe-smoking 'little men' " (Light, 1991:211).

Accepting both Gilbert's and Light's arguments that the First World War changed British men's view of themselves, it is also apparent from Mills & Boon romances that British women's view of men also changed, bringing about the boy hero. But it is conceivable that Mills & Boon authors were using this new perception of masculinity more subtly. By emphasizing certain aspects of contemporary masculinity and ignoring others, they were able to argue for the feminist demand for equality between the sexes in sexual and marital relationships.

This is particularly evident in Louise Gerard's *Strange Paths* (1934), where the hero spends half of the book dressed as a woman. He is the same age as the heroine, but from an aristocratic background compared to her middle-class one and, as such, socially more powerful and wealthier than she. But the plot of the book hinges on the heroine helping him escape from his enemies by hiding him in her ship's cabin and later, unknown to him, wiping up his wet footprints so that no one will know he has been secretly ashore and, later still, covering up for him so that he can get safely away. Again, this plot does not present the hero as an all-powerful parent who is protective of the heroine. Rather, both the hero

wearing women's clothing and the heroine coming to his rescue emphasize the equal relationship of the protagonists, showing the hero in the realm of the female.

According to Graham Dawson the legend of Lawrence of Arabia, popularized in 1919 by Lowell Thomas, also emphasized feminine qualities in relation to the British ideal of masculinity of this period: "Lawrence himself is often presented in a distinctly feminine light. Many of his qualities are codable as feminine . . . for example, his boyishness and lack of a beard, his small size, his modesty and shyness" (1991:137). This boyish, feminized male figure was definitely eroticized by Mills & Boon authors of the 1920s. The image is, perhaps, that of Ganymede, cup-bearer to Zeus and generally portrayed in literature as the object of masculine homosexual desire, but here transformed into the sexual fantasy figure of heterosexual women.

But there must also be another reason for the prevalence of this type of hero in the Mills & Boon novels of these two decades, and only these two decades – the memory of the "golden youths" lying dead on the fields of Europe. The youths who would have been the husbands of the women writing a decade later of love and marriage, and who had been the brothers and fiancés of those same women. Last seen as young men, they could only have been portrayed in print as the boys they remained in memory. They were the "lost generation" of men who fell in the war, who would always retain "golden qualities" in the memory of the women they left behind that no living man could ever achieve (Beauman, 1983:36).

Another influence of the Lawrence legend on romance fiction was that authors increasingly abandoned British heroes in favour of Mediterranean heroes. The supreme example of this is *The Sheik*. Published in 1919, E.M. Hull's novel became a bestseller, and boosted the popularity of the desert romance, which continues to this day. But in the 1920s there were few Mills & Boon imitators, as their authors seemed to prefer to concentrate on Latin heroes, not pseudo-Arab heroes who were usually of European descent. These Latin heroes are godlike, but still boys: "Out of the car a big fair *young* man was stepping. As the girl's vision cleared, it seemed to her the gods still walked the earth in strength and beauty" (Louise Gerard, *Following Footsteps*, 1936:63, my emphasis).

This hero, half-boy half-god, echoes the Jungian male archetype of the boy who "is often depicted in early Greek and Egyptian sculpture as a small phallic figure that accompanies an impressive figure of a fertility goddess. In later Greek mythology, the boy appears as a young, beautiful man who is also a sort of consort of the mother" (Greenfield, 1985:194).

Greenfield's article lists Jungian archetypal masculinities as including Don Juan, the Trickster, the Hero, the Father and the Wise Old Man. She argues that, from the standpoint of the psychology of women, the most powerful of these archetypes are the Father and the Trickster, the latter of which "is a son more than a father, and this youthfulness is the basis for much of his appeal" (1985:191–2). The Father is seen as a protector and benefactor in his benign aspect, although his protectiveness can become restrictive. If his power does become overwhelming for the woman, she can turn to the Trickster as liberator. However, she has to be careful of this youthful figure because, while liberating her from the Father's authority, he can also deceive and seduce her. Greenfield concentrates on the effect of male archetypes on a woman during her lifetime but, as has been shown in the change from pre-war to post-war masculine ideology, different archetypes also predominate in different historical periods.

Referring to Britain's *Testament of Youth* (1933) Beauman argues that "one of the most haunting themes of the few novels written by women whose lovers were killed in the war [is that] they may find someone else, but they will never replace what they have lost" (1983:35). This theme of a golden youth, as already noted, is embodied in the Mills & Boon boy heroes of the 1920s and 1930s. However, some books of the 1930s are psychologically significant in that they replace what has been lost with a different hero-figure, nearer to Jung's Father than his Boy/Trickster figure.

For instance, in Sophie Cole's sequel to *The House in Watchman's Alley* (1915), *Passing Footsteps* (1922) the heroine discovers, on the eve of her engagement to the doctor hero, that her husband, presumed dead at the Front, was a deserter and is alive. A drug addict, he eventually dies, freeing her to remarry. This plot is mirrored in Cole's later novel, *The Bridge of Time* (1937), which also replaces the younger boy-husband with an older man

who, in opposition to the boy-husband, offers safety and security after the emotional and social upheavals of the war, reassuring readers that it is possible to replace what has been lost, albeit in a different guise.

The father-hero is particularly evident in two authors of the 1930s, Mary Burchell and Sara Seale. The social ideology of this period emphasized the acceptance of responsibility, of fitting into society, and stressed the community rather than the individual. The country hero of Seale's *Chase the Moon* (1933) and *Summer Spell* (1937), is a solid, mature man, from a long line of landed gentry. His character fits in with this ideology living in the country, though he may work in London.

But even these mature heroes have their moments of childlike vulnerability: "He showed her his collection, telling her how he had acquired each piece ... [H]e was like a little boy, laying his treasures at her feet" (Seale, *The Gentle Prisoner*, 1949:45). Similarly, in Mills & Boon books even fighter pilots during the Second World War experience fear: "'All sorts of things belong to the dark. Fear and despair and loneliness ... you know a bit about darkness if you're a night-bomber pilot, believe me ...'" the hero of Joan Blair's *The Glitter and the Gold* (1941:216) says to his heroine.

In *Hearts of Men* (1983) Barbara Ehrenreich argues that American men retreated in the 1950s, abrogating their responsibilities. This could also be said of the British men who, after the traumas of the Second World War, retreated to the home, and the British, both men and women, became a domesticated people. This domestication of the British male occurs in Mills & Boon novels of the 1940s with the reappearance of a type of boy hero, in the guise of the boy-next-door.

In 1946 Barbara Stanton published *Spring Fever*. This romance begins with the heroine, a child of seven, overhearing the servants gossiping about her father. She learns that he is being prosecuted by Laurence Darrack for the murder of his wife. Her father is found guilty and executed, for which she blames Darrack. She is 17 by the time she meets him, and has lived with her hatred for 10 years. But her feelings for him are thrown into confusion when she discovers that he has been paying for her support, including paying her boarding-school fees since her father's death. Gradually

she comes to accept that he was ensuring that justice was done and she matures into accepting him. There is a twist in the plot when Darrack's son starts to take an interest in her, but she turns her back on the wealth and glamorous life he can offer her and falls in love with the son of the family with whom she is lodging, who are friends of Darrack's. They marry, happy in the knowledge that he will follow in his father's footsteps and become a country solicitor, just as Darrack's son is destined to follow his father to the Bar and become a "star".

This book identifies three masculine types. The Father who, in Jungian theory, is identified with order, power, creation, stability, repression, mastery and, significantly for this novel, lawgiving. He is seen as unable to do wrong, because he is the lawgiver. He can be overturned by the Trickster, represented in this book by his own son, enabling the daughter to escape from him. The Oedipal theme, of the son ousting the father and taking the mother from him, however, is overturned in *Spring Fever*, because the Trickster is a transitional figure for a woman, not a life partner.

The Trickster is a liberator from the Father's repressive laws: an overthrower of the Father in the name of freedom. He enables the woman to assert herself as an independent person and open herself to transformation and growth. A relationship with him forces her into autonomy and to rely on her own strength.

In the tradition of patriarchal literature, for instance, Tolstoy's *Anna Karenina*, the heroine is destroyed by the Trickster/rake. But in, for example, Margaret Atwood's feminist *Lady Oracle*, the woman is strengthened by her affair with a rake, as happens in *Spring Fever*, where the Trickster figure of the Father's son enables the heroine to achieve autonomy and choose the man she loves – the third masculine archetype, the Hero figure.

Mills & Boon authors did not use the "angry young man" figure of 1950s' literature, perhaps because this type of brutal working-class masculinity was too close to reality to fantasize about. Also, as Segal (1990:14–15) points out, with their demands for "freedom and fun", their hostility towards women, and desire to break away from the home, these characters were used to try to re-establish male dominance, which Mills & Boon ideology did not accept. Instead, they developed the Alpha man – a hero placed, not against a background of home, but against the world. The hero of Pamela

Kent's *Flight to the Stars* (1959) jets between Europe and America, pursuing the sports at which he is so adept.

With the appearance of this type of hero, use of the boy hero – both as Ganymede and boy-next-door – died. The hero changed from the non-star boy to the star man – the successful man. This is clearly seen in Roberta Leigh's 1952 *The Vengeful Heart*, where, in contrast to Barbara Stanton's 1946 *Spring Fever*, the hero is the rich and well-known lawyer who sent the heroine's father to gaol, where he died, not the younger man of *Spring Fever*.

This rejection of the younger man becomes a constant in Mills & Boon novels from the 1950s to the present, where the Trickster or Don Juan figure appears frequently as the other man, whose youth is emphasized: "Peter looked so young in his tight trousers. He hadn't really filled out yet into manbood" (Elizabeth Hunter, *Spiced with Cloves*, 1966:71). Even when the other man is the same age as the hero, as in Janet Dailey's *Strange Bedfellow* (1949), he is still associated with youth: "At thirty-six, he was twelve years her senior . . . but there was a boyish air about him that was an integral part of his charm" (1949:6). The hero, who sucessfully runs his own company, says of him later in the book, "He only does what he's told." (1949:138), emphasizing the difference between the hero as "man" and the other man as "boy".

In the 1960s, a time of hippies and male "dedicated followers of fashion" (The Kinks), Mills & Boon authors once again looked abroad specifically to Roman Catholic and Arab countries, where they could find a more traditionally masculine hero to idealize. It is at this point that authors attribute to Latin and Arab men the machismo they can no longer find in British masculinity. In Violet Winspear's *Blue Jasmine* (1969) (her homage to E.M. Hull's 1919 blockbuster, *The Sheik*) the hero is accepted as Arab, but is in fact half-Spanish and half-French. However, in the books that followed, by both Winspear and other authors, heroes are French, Spanish, Italian, Greek and Arab; occasionally Russian, as in Claire Harrison's *One Last Dance* (1984), but never Eastern European, nor are they ever black. Winspear said of her heroes:

> they're lean and hard-muscled and mocking and sardonic and tough and tigerish and single, of course. Oh, and they've got to be rich and then I make it that they're only cynical and

smooth on the surface. But underneath, they're, well, you know, sort of lost and lonely. In need of love but, when aroused, capable of breath-taking passion and potency . . . They frighten but fascinate'. (quoted in Anderson, 1974:237)

It is this type of hero that Miles (1991) is analyzing and the first feminist critics of Mills & Boon books are referring to when they denigrate him as harsh: "Cruelty, callousness, coldness, menace, are all equated with maleness and treated as a necessary part of the package" (Snitow, 1983:260). "The hero of Harlequins . . . is more or less brutal" (Modleski, 1982:40).

In the plots of Mills & Boon novels during the 1970s the hero is the one in command. His power over the heroine is exercised mainly through sexual domination, but he is also the richer and more powerful of the two; often, he is her boss. But, as Daphne Clair points out, this type of hero was "less prevalent than is commonly believed" (questionnaire). Owen quotes Anne Weale as saying that the aggressive hero was historically specific, and that, for instance, Mary Burchell, who started writing in the 1930s and who was still very popular in the 1970s, had "chivalrous and gentlemanly" heroes who were "certainly not dull" (1990:37).

Thurston argues that the power relationship between hero and heroine changed during the 1980s, with the hero becoming a "New Man [who] is sensitive and vulnerable" and "with an ego and masculinity secure enough to seek a relationship based on equality and sharing" (1987:56). However, she bases this on the American lines published by Silhouette and Ballantine, among others, claiming that the Harlequin Mills & Boon books did not change their approach to the hero.

There were, however, many popular Mills & Boon authors who, throughout the 1970s and 1980s, portrayed less aggressive heroes. Both Clair and Weale are cases in point. None of Betty Neels' heroes are violent, nor are Essie Summers' and Jane Donnelly's heroes. Madeleine Ker also has always had gentler heroes.

The hero is, however, always sexual, becoming, in some ways, "the sex" or object of desire in much the same way as men have used this phrase in reference to women. As Creed puts it, "it is clear that the hero is the object of the heroine's erotic gaze" (1984:57). He is sexually virile, with a constant string of mistresses,

is irresistible to women, with "broad shoulders, slim hips and strong thighs", and the heroine distrusts him, precisely because of his aura of potent masculinity. Also his character becomes opaque – the heroine does not understand his motives for seeking her out. And she misreads his character, to his detriment. For, as Modleski states: "The mystery of masculine motives . . . is central to most women's popular romances" (1982:39–40).

This dominant masculinity is particularly evident in warrior heroes. There is an ambiguity apparent in Mills & Boon authors' treatment of servicemen. During periods of war conscientious objectors are condemned as unpatriotic, but servicemen are not automatically glorified. In fact, they are generally shown as wounded men in need of rehabilitation. However, in the relatively peaceful recent decades romances seem to be moving back to Ouida's use of military men as romance heroes. But Mills & Boon heroes are generally independent of the military in that they are agents or ex-servicemen, as in Sally Wentworth's *Man for Hire* (1982). Her hero is a Falkland's veteran, invalided out of the army. These novels, set in real or imagined strife-torn countries, have scenes in which the hero saves the heroine by fighting off an individual attacker, as happens in Charlotte Lamb's *Midnight Lover* (1982) and Lynn Turner's *Forever* (1985), but do not have actual "battle scenes". The heroines of such novels are often wary of their heroes, if not antagonistic towards them, as is the heroine of Mary Lyons' *The Passionate Escape* (1984). They are forced to rely on the heroes' expertise in order to escape from danger themselves and they end up, of course, falling in love with them. Romance authors, it seems, condemn war, while making heroes of the protagonists:

> "War is a rotten business," he went on slowly, "Don't let anyone ever deceive you on that score, infant. If it was looked on a bit more in that light, instead of as a monument to human heroism and glory, there might be more hope for the world."
> "How can people help thinking of it as heroic when people like you behave like heroes?" the child asked. (Nan Sharpe, *From Dusk to Dawn*, 1945:52)

These warrior heroes are father-figures, depicting the protective side of that archetype, as they save the heroine from danger (Violet

Winspear, *Time of the Temptress* (1977), or help her to kidnap her sister from a religious sect (*Man for Hire*, 1982). There are references to the hero as a father in the early books: "In years he was but little in advance of herself, in heart he was old enough to be her father" (Sophie Cole, *Fate Knocks at the Door*, 1924:73). But heroes who reflect Miller's analysis of the father as "protectors, providers of status and money" (1986:58) do not become prevalent until the later years, when the hero-as-guardian plot becomes popular. One of the first of these was Constance M. Evans' *Ward to Andrew*, published in 1957, but it was a plot device still being used by Anne Mather in her 1970 *Moon Witch* and Vanessa James in her 1985 *The Object of the Game*. While not a guardian of the heroine, many of Betty Neels' contemporary heroes can be positioned as father-figures. They are generally large men, Dutch millionnaires, who are older than the heroine, and who rescue her from some sort of problem.

There is a variation on this theme of hero as father-figure when the heroine falls in love with the father of the fiancé who jilts her, as happens in Elizabeth Ashton's *Rendezvous in Venice* (1978). In Carole Mortimer's *The Passionate Winter* (1979), the heroine, an 18-year-old student nurse, is pursued by Gavin, also 18. His father misunderstands their relationship, mistakenly believing it to be sexual, but eventually falls in love with her and she with him.

Sometimes the connection between the hero and a father-figure is made even more explicit, as is shown in the blurb for Janet Dailey's 1976 romance *Valley of the Vapours*:

> If Tisha Caldwell didn't get away from her father soon, he and she were going to come to blows! . . . In desperation Tisha went off to spend a long holiday with her sympathetic Aunt Blanche – and promptly found herself "out of the frying pan and into the fire" when she met Roarke Madison, who was even fonder of telling her what to do than her father had been.

The father-figure has a long history in romantic fiction. Miller (1986) points out that Knightley, in Jane Austen's *Emma*, progresses from father to brother to husband. The hero of Sara Seale's *The Gentle Prisoner* (1949) progresses from stranger, to father to husband:

> A stranger he was, but a stranger who, Shelley sometimes thought, was at times closer to her than her own father . . . She looked up into his face and saw the ugly scar which twisted the muscles so cruelly, and . . . she found in him that strength and tenderness which her father had denied her. There was no one else . . . "I'll marry you . . . No one else wants me," she said. (1949:30, 37)

In Mills & Boon books this theme of the hero as stranger came to the fore with the rise of the Second Wave of feminism and its depiction of men as enemies of women when the heroes suddenly became alien to the heroine. Snitow picks up on this when she suggests that because the books of this period are written from the heroine's point of view, the heroes are seen as "other": "In a sense the usual relationship is reversed: woman is subject, man, object . . . He is the unknowable other" (1984:260). It is a subversion of Simone de Beauvoir's argument that woman in society "is defined and differentiated with reference to man and not he with reference to her; she is the incidental, the inessential as opposed to the essential. He is the Subject, he is the Absolute – she is the Other" (1988:16).

Mills & Boon authors of the 1970s and 1980s create men, that are, in the guise of the hero – "other": sexualized, feared and fought against, the heroine battles to make the hero see her as an autonomous individual, while also fighting to bring him into her sphere, where she has supreme power. Conflict, both between the sexes and between men, in the Mills & Boon world, is necessary to make the hero suffer and thus become, through his suffering, fully human and fit to enter the female world.

As Showalter points out, the female authors of classic romantic novels often maim their heroes in some way (for example, the blinding of Rochester in Charlotte Bronte's *Jane Eyre*), giving them an idea of the feeling of dependency and feebleness that women suffer. Only after this symbolic immersion in the feminine experience does the hero become a fit mate for the heroine:

> Men, these novels are saying, must learn how it feels to be helpless and to be forced unwillingly into dependency. Only then can they understand that women need love but hate to be weak. If he is to be redeemed and rediscover his humanity, the

"woman's man" must find out how it feels to be a woman. (Showalter, 1982:152)

Mills & Boon authors connect the hero with the female world in a variety of ways. During the 1970s the hero often wears silk shirts, a symbol of his wealth. However, as the heroine's skin is often described in these books as being like satin or silk, the wearing of silk by the hero can also be read as linking masculinity with femininity, in particular the femininity of the heroine herself. Occasionally the hero is feminized, as is Rochester, by a disability. For instance, in Susan Napier's *True Enchanter* (1987) the hero limps after a stage accident, although in her preceding novel, *Love in the Valley* (1985), he appears as a secondary character physically whole. But the most obvious immersion of the hero in feminine experience comes from the plot device whereby the heroine runs away from the hero, leaving him alone and helpless. This replicates, for the hero, the heroine's own feelings of dependency and vulnerability that loving him engenders in her, and thus enables him to fully understand her and her emotions. This gives him an equality with her that he could not otherwise obtain, and makes him worthy of her love.

More recent heroes have already gained this knowledge. In Miranda Lee's *Heart-throb for Hire* (1994), the hero is extremely good-looking, and has suffered from being judged solely on his looks all his life – as many women in our western society are. Towards the end of the novel the heroine is looking at a photograph of him:

> Tears filled her eyes as she stared down at the man she loved, seeing again the vulnerability in those beautiful blue eyes, the secret loneliness. There he was, looking as if he should have the world in the palm of his hand, but behind that arrogant macho physique had lain a man just waiting to be loved, aching to be cared for and nurtured as he'd never been nurtured. (1994:187)

De Beauvoir also argues that women are made to seem closer to nature by patriarchal society likening them to nature (1949:190). In Mills & Boon novels, although there are the occasional references linking the heroines to nature, such as referring to her as a

fawn, or by giving them names such as Fleur, it is the *hero* who is constantly compared to an animal: "He had the look of a sleepy feline, a black panther, perhaps" (Carole Mortimer, *The Passionate Winter*, 1979:15). He is also often linked in description to the outdoors. Often the hero is seen riding, an activity the heroine either cannot do, or does not do with his expertise. He is at one in environments that are alien to her. For instance in Charlotte Lamb's *Desert Barbarian* (1978), the hero, despite being a wealthy English businessman, is totally at ease when living in the desert he loves, an environment that is hostile to most westerners. He smells of the outdoors – pine, sea. In Celia Scott's *Starfire* (1984) the heroine nearly drowns in the freezing water of a river in Canada, whereas the hero seems "to be in his element" (1984:109) in the cold vastness of the winter landscape. These references, associating the hero with a nature that is outside civilization, have obvious connections to the Beauty and the Beast fairytale, a strong motif in Mills & Boon novels. Just as Beauty tames the Beast, so does the heroine turn her alien lover into her hero.

There is no one specific type of Mills & Boon hero. He changes over time, from book to book even by the same author, within the same period. He has many attributes, which alter from decade to decade. For as times change, so do women's fantasies of their perfect mate. The Second World War pilot would be a misfit in the domesticated atmosphere of the 1950s. Similarly, the boy hero of the 1920s could never be a hero for the cut-throat 1980s. So, at some periods, he may well be seen as a mother-figure, at other times he is portrayed more as a boy-figure and at others as a father-figure. The only figure-type who embodies the fluidity of the Mills & Boon hero during the last 80 years is the brother – younger, older or twin. Greenfield says of the Jungian Hero of myth:

> he is a figure who is midway between the father and the trickster . . . he has the youth, vitality and audacity of the trickster, but has accepted more of the father's maturity as a result of his travels and exploits . . . We do not, however, receive a very detailed psychological portrait of the hero at this point . . . We do not have pictures of men who are simply the peers of women . . . who [are] . . . neither immature nor rigid, and neither . . . protector nor . . . seducer. (1985:201)

In Mills & Boon novels we get a glimpse of this hero as a woman's fantasy hero, who is "The exception to the rule [which] comes when the man and woman in question are brother and sister (e.g. Apollo and Artemis)" (Greenfield, 1985:201).

This is the archetype Miller (1986) uses when she talks about Charlotte Brontë's "search for the 'semblance', the only man who might ultimately be loved and trusted because he would 'know' her and accept her (1986:79). She continues, "The image of the 'brother' haunts [romance] fiction as the embodiment of all that is forbidden and all that is known, intimate, recognisable from childhood, susceptible to taming and to the acknowledgement of equality between a man and a woman (1986:81).

Throughout the decades there are covert and more obvious references in Mills & Boon romances to the hero as brother to the heroine. There are the romances where the hero and heroine grew up together (Elizabeth Carfrae, *Payment in Full* (1929); Amanda Carpenter, *Waking Up* (1986); Leigh Michaels, *Leaving Home* (1985), and the romances where the heroine marries the elder brother of the man she was originally seeing (Sara Craven, *The Garden of Dreams* (1975); Madeleine Ker, *Impact* (1986); Jane Arbor, *Invisible Wife* (1981); Jayne Bauling, *Thai Triangle* (1985)) or, as in Janet Dailey's *Sentimental Journey* (1979), the man who originally dated her sister. In Sara Craven's *Promise of the Unicorn* (1985) the hero is the heroine's stepcousin. Making the connection even more explicit there are, also, many Mills & Boon novels where the hero is the heroine's stepbrother. Amongst others, Anne Mather uses the device in both her *Living with Adam* (1972) and *Melting Fire* (1979), and Penny Jordan in her *Passionate Relationship* (1987). At a slightly further remove, the hero of Margaret Way's *A Place Called Rambulara* (1984) is the heroine's brother-in-law. In Daphne Clair's *Never Count Tomorrow* (1980) the relationship is also through marriage. The heroine goes to work incognito for the mother who gave her up at birth, and falls in love with the son, by a previous marriage, of the man to whom her mother is now married.

The brother, Miller argues, accepts all of the heroine, as Rochester accepts Jane Eyre's potential madness, her sexuality and vulnerability, and her strengths. There is, in the ending of Charlotte Brontë's books, at last, equality between men and women, at

least as far as feelings go. Such can also be said of Mills & Boon novels: "I do need you, my darling, but when you're the one in need I'll be there, I promise you, for you to lean on," says the hero of *Thai Triangle* to his heroine (Jayne Bauling, 1985:189).

Further than this, through the hero's need for her, the heroine's world, symbolized by the family and the home, is validated:

> Jordan turned to watch out of the window as Grace pulled their son from his face-first dive into the snow ...
> His family.
> His Grace.
> His saving Grace. (Carole Mortimer, *Saving Grace*, 1992:186)

And finally, her power is acknowledged. Echoing the plot of Sophie Cole's much earlier *A Wardour Street Idyll* (1910) (see Chapter Two), the hero of Jane Donnelly's *The Man Outside* tells his heroine: "'You brought me to life'" (1974:184).

Chapter Five

Heroine – *Mirror Image*

It is apparent from the previous chapter that there is more than one Mills & Boon hero. The same applies to the heroines of these romances, as they reflect the different female characteristics that are predominant in certain decades. Also individual authors from the same decade portray different heroines, reflecting the various feminine identities that Bolen (1984) argues women move through during their lifespan.

This idea, that feminine identity is not fixed during a lifetime or even a historical period, but is fluid, allows for a more flexible and interesting analysis of the Mills & Boon heroine than the usual virgin/whore theory, since it allows the tracing of different female characteristics and how they predominate at different periods. For, as Holdsworth points out, each decade has its own style of fashionable woman:

> In the 1920s she pretended to have no breasts or waist and, taking on a tubular appearance, looked much like a young boy. In the 1930s, it was fashionable to look feminine again. In wartime lines were austere and rather masculine. In the 1950s a fashionable woman was almost as curvaceous as her Edwardian grandmother had been, but in the 1960s she was flat-chested and long-legged. Each decade had its own style, dictated by a variety of factors apart from sexual display. (1988:159)

These styles are also reflected in attitudes towards women's role in society. As Adam points out, in the twentieth century women have been asked to 'change their colour, like chameleons, to fit the

81

background of their period" (1975:211), with major changes in their lifestyle taking place within the span of each generation.

Mills & Boon heroines come with different feminine identities. And, although each type can be found in most eras, there is, as with the hero, a definite persona which dominates each decade, though the Mills & Boon heroine does not necessarily directly embody the dominant feminine type in society. For instance, as is well known, the 1920s were dominated by the image of the 'flapper", which originally had sexual connotations, but which also came to reflect social tensions over unemployment, socialism and middle-class fears of workers' revolt (Melman, 1988).

However, apart from Hilary Fane in Louise Gerard's *The Fruit of Eden* (1927), Mills & Boon books of this period rarely portray a flapper as a heroine. This may be precisely because of the social problems the image of the flapper symbolized, problems which authors felt could not be negotiated in a romance, or it may be that the image of the flapper was so rich with symbolism that authors could not use it in any imaginative way. They do, however, occasionally depict these girls, "with their hungry, passionate mouths and their stripped, naked eyes" (Elizabeth Carfrae, *Payment in Full*, 1929:227), as secondary characters. The flapper then becomes a useful shorthand image, already familiar to their readers, of a certain type of femininity that is in direct contrast to the femininity of the heroine.

However, as Light (1991:8) points out, the image of the flapper also portrays a complete reversal of previous expectations of what femininity should be, and on this reading the economically independent heroines that Mills & Boon novels depict reflect the change in the role of the female in society. This is particularly true of Louise Gerard's heroines, who are portrayed as independent travellers, reflecting such women as Freya Stark, Rosita Forbes and Lady Dorothy Mills. In this guise they often save the hero from his pursuers as, for instance, in Gerard's *A Spanish Vendetta* (1920), which has an opening shipboard scene where the heroine hides the hero from his enemies in her bunk.

These travelling heroines are often plain, physically small but clever women who earn their own living, generally as journalists or novelists, and marry Greek god-like heroes, who have little education and no work skills, as in Louise Gerard's *Wild Winds*

(1929) and *Secret Love* (1932). Or they are tall, Amazon-like women, who might act as bodyguards to their smaller heroes, as in Louise Gerard's *The Strange Young Man* (1931), referred to in Chapter Four. These are quite obvious representational changes, reflecting not just the reversals in expectations of both male and female roles, but also the greater opportunities for education, the new opportunities for work and the new equality that middle-class women of the 1920s experienced. These opportunities arose partly as a result of feminist agitation, and partly because, for many middle-class families who had lost the actual or potential income of the male members of the family after the First World War, there was a lack of the financial resources necessary to support women in a life of idleness at home.

It was also partly because many women refused to go home after the war. As Gilbert argues, some women during the First World War gained an "exuberant sense of freedom [from] being at the Front" as, for the first time, they had a socially recognized purpose in the wider world (1989:296–7). Mobilized as drivers they had freedom of movement and were not, as their male counterparts were, stuck in the mud of the trenches. As nurses they also had power over ill male bodies. Having gained a taste of independence, women refused to surrender it. This feeling of female power and efficacy fed into the portrayal of the heroines of the post-First World War Mills & Boon novels.

This is most clearly seen in the advent of a heroine who is richer than her hero. In Elizabeth Carfrae's *The Devil's Jest* (1926) the heroine employs the hero as the overseer of her property in the West Indies after he has been cut out of his uncle's will. In Louise Gerard's *The Fruit of Eden* (1927) it is the heroine's wealth that rescues the hero from his life of poverty on a small farmstead and enables him once again to live in his family castle. In the same author's *The Dancing Boy* (1928) it is by marrying the heroine that the hero is able to become a partner in her brother's farm. In all these books it is because of the female that the male's social status is raised not the other way round, as is more usual in society. This inversion of the *Cinderella* story is most evident in Gerard's earlier romance *The Necklace of Tears* (1922), in which a diamond necklace that the blind heroine has entrusted for safekeeping to the wealthy hero is stolen. Unknown to her, he bankrupts himself

in order to repay her. Her sight restored through his offices, she eventually restores his social status by marrying him.

Light (1991:8) argues that in the inter-war decades, "what had formerly been held as the virtues of the private sphere of middle-class life take on a new public and national significance." She maintains that the 1920s and 1930s saw:

> a move away from formerly heroic and officially masculine public rhetoric of national destiny and from a dynamic and missionary view of the Victorian and Edwardian middle class in "Great Britain" to an Englishness at once less imperial and more inward-looking, more domestic and more private – and, in terms of pre-war standards, more "feminine" (1991:8).

This more domesticated attitude of the wider society is exemplified, in different ways, by two authors who started writing for Mills & Boon in the 1930s. In 1932 Sara Seale published her first novel, *Beggars May Sing*, with Mills & Boon. Three years later, in 1935, Mary Burchell published her first novel, *Wife to Christopher*, with the firm, for which, she claims in her autobiography she got an advance of £30 (Cook, 1976).

Burchell's early novels were quite innovative – in her first novel, a heroine deliberately traps a man into marriage, and in her later *Such is Love* (1939), her heroine has borne an illegitimate child. Burchell's heroines are always capable women, whatever their age, and able to cope with the adversities life throws at them:

> Vicki ... has the sort of face that makes you believe in God ... [She] is one of those foolish people who are always trying to put their arms round the whole world ... it's that urge to protect which gives her a touch of the infinite – that calmness of spirit. (*Wife to Christopher*, 1935:11)

This is the image of the completely composed 1930s' woman whom Light (1991:171) describes as growing up to become older and wiser than their menfolk and consequently to mother them. This is very apparent in the reconciliation scene in *Wife to Christopher*:

> And at that moment he broke down a little, and was suddenly on his knees beside her, clinging to her, his face hidden against her. He felt her arms go round him, and heard her say very

soothingly, "You're all right, my dear. You're quite safe with me." (1935:220)

Like Agatha Christie's heroines, these Mills & Boon heroines are sensible and unassuming, self-reliant and quietly efficient with a muted sexuality which lies in their quality of reserve; they "sacrifice the romantic in favour of the domestic" (Light, 1991:108).

This type of heroine – a domestic manager who makes "the most of the little things of life" (Light, 1991:110) – is a constant of Mills & Boon novels from the beginning, continuing through the decades, sometimes as the dominant heroine type, sometimes not. From the 1960s on she is epitomized by Neels' nursing heroine who is "a small beautiful mouse with a soft voice and lovely eyes and a gentle mouth" as one hero says of her (*The Secret Pool*, 1986:187), and who "ran the home she shared with her three elderly aunts with the same effortless efficiency that she brought to her work" (blurb).

However, in contrast to Burchell's mature heroines, Sara Seale ushered in, for the first time, a new character type of heroine: the orphan. She must have caught the imagination of the readers from the start, as a symbol of all that Britain had lost in the war, and as a reflection of their own feelings of abandonment. Many of Burchell's heroines are, technically, orphans, but it is Seale's heroine who personifies the type. She is young, vulnerable and possesses no work skills. Her parents may not both be dead but, if not, the remaining parent is inadequate, either selling her in marriage to the hero, as the father does in *The Gentle Prisoner* (1949) or, like the mother in *Chase the Moon* (1933), in need of economic and emotional support herself. This heroine sees herself as powerless in a heterosexual relationship and actually becomes the dependent partner. Helpless, she is buffeted by events and not in control of her life. Caught between two men – a younger often manipulative man, living the fast life of London's cocktail set, and an older, more mature man who is generally connected with the country – she eventually chooses the older man and his lifestyle of traditional values. In other words, she chooses between Noel Coward's temporary, jokey, superficial lifestyle and the country home that is the symbol of England as "a safe and solid world" (*Chase the Moon*, 1933:231).

Burchell's and Seale's heroines, in their different ways, personify the cult of domesticity that was part of English ideology during the 1930s. Burchell's heroines by being positioned at the centre of a home; Seale's heroines by choosing a hero who gives them a sense of belonging. This orphan heroine is often dispossessed by wandering parents who, like many male writers of the period, found Britain smothering and defensive, rather than, homely and protective as depicted by Burchell and Seale. According to Light (1991:108) writers like Paul Fussell and D.H. Lawrence constructed Britain after the war "as an anti-romantic and home-oriented nation", and "abroad" became the place of romantic adventure. For these male authors, however, there was no place for the British woman abroad.

But for some Mills & Boon authors in this period, abroad is a place of freedom and adventure for women as well as men. In contrast to the mature heroines of Mary Burchell and the orphan heroines of Sara Seale, those authors who started their writing career in the 1920s continued with their independent heroines into the 1930s. For both Louise Gerard and Elizabeth Carfrae a woman's sexuality is not muted in this period, nor is she simply a wife, but a career woman, who continues earning her living after marriage. Two or three of Carfrae's books depict a heroine who commits adultery, and who, far from being punished for it, is eventually able to marry the man she loves. In Gerard's *Strange Paths* (1934) the usual gender roles are reversed as the hero and heroine travel across Europe to Russia, with the hero being dressed as a woman for most of the book (see p.67).

These perhaps are the escapist fantasies of middle-class women (both writers and readers) who felt hemmed in by the norms and social assumptions about the female role they had internalized and from which they could not break free. In these novels heroines break the rules and have sexual adventures, while safely married, that are denied to most women in society, or they have the sort of thrilling adventures usually reserved for men, as they are chased across continents by the hero's enemies, and are instrumental in his being the victor.

In the 1940s the wealthy heroine of the 1920s reappears, but this time her wealth is portrayed as a problem rather than a helpful tool. This may have been because, during the upheavals and

insecurities of the Second World War, authors wanted to reassure readers with some sort of normality. In some books they ignored the war, and emphasized conformity to gender roles, rather than trying to depict the uncomfortable equality they were actually experiencing as both combatants and civilians came under enemy fire.

For instance, Barbara Stanton in *Give Me Glamour* (1940) chose an ordinary couple for her hero and heroine who separate when the heroine becomes a film star. The boy-next-door hero becomes jealous of her success, afraid that it will change her and her feelings towards him. But when they finally meet again, he realizes he was wrong, and is able to accept her wealth, telling her: "I'm pretty broke at the moment and you may have to lend me the money for the honeymoon, but who cares about a little thing like that?" (1940:248).

The rich heroine of Elizabeth Hoy's *Proud Citadel* (1942) has to run away from home in order to marry the hero, whom her father objects to because he is a poor farmer. She also has to overcome the hero's pride about using her money to help him. This is a theme that reappears in the 1950s, where the rich heroine uses her wealth to help the hero, by enabling him to keep his family estate, as in Phyllis Matthewman's *The Veil Between* (1950) and *Castle to Let* (1953).

The prevalent image of the 1940s' woman is that of the "coper" – as housewife, mother and worker who kept "the home fires burning". As Anderson (1974:219) points out some popular authors of the time (for example, Denise Robins and Ursula Bloom) have heroines who take an active part in the defence of their country, but Mills & Boon authors do not tend to do this, although there are exceptions. In Marjorie M. Price's *Trial By Gunfire* (1941), the secondary heroine realizes that the timetable of the convoys setting out from the island, where the book is set, is signalled to the enemy, by the way washing is set out on the cliff-tops (a detail which gives primacy to the domestic). In Mairi O'Nair's *Husband for Sale* (1942), it is the heroine who ensures that the secret scientific formula on which the hero is working does not fall into enemy hands, and who saves the hero from the villainous other woman.

But for both Margaret Malcolm and Phyllis Matthewman, two major new authors of this period, the primary female role is

domestic. Despite the fact that many heroines work, often in unusual jobs, this is the only period when it is possible to find a large number of Mills & Boon novels, by different authors, where the ideology is thoroughly domestic. Unlike the 1930s, where even the domestic heroines are shown as having a life outside the home, the lives of the heroines of these novels of the late 1940s and early 1950s revolve around their home.

This domestic archetype dominated women's roles in the post-Second World War period. And for the only time in the century Mills & Boon novels, which are generally concerned with how women evolve in becoming wives – rather than their *role* as wives, show heroines who may not be married but are acting out this role of wife. For in this period it was women who were explicitly charged with their traditional role of creating and keeping a sense of community. These heroines embody the "stabilising and civilising influence" that the image of women symbolized immediately after the Second World War; an image that was "particularly important because [Britain] was haunted by the fear of destruction and the end of *all* civilisation" (Wilson, 1980:126).

This is the image of the soft and submissive "happy housewife heroine" retreating into her traditional role that, according to Cecil, is featured in the magazines of the 1950s (1974:12). These women do appear in Mills & Boon novels, enjoying their role of housewife, as the 22-year-old housekeeper heroine of Susan Barrie's *The Gates of Dawn* (1954) does. However, although she is described as "diffident", she is not submissive, and is quite capable of defying her hero-boss on her home ground:

> The master took up his position on the centre of the hearthrug and subjected Melanie to a look which was intended to reduce her to, at least, a semblance of contrition. But apart from the fact she felt awkwardly conscious of the apron tied over her cloudy-grey dinner-dress, and she realised he had some justification for his annoyance, Melanie was unperturbed, and her eyes gazed back at him almost serenely. He suddenly threw back his head and gave vent to a short burst of laughter.
>
> "What a girl!" he exclaimed. "To coolly defy me as if I weren't master in my own home." (1954:88)

The point being, of course, that he is not master in his own home – home is the female sphere where the heroine reigns.

He later says to her: " 'You look so young that I find it difficult to believe that so much uncanny wisdom dwells in that small head of yours' " (1954:97) when, against her advice and at the insistence of the other woman, he takes his delicate sister out into a winter's cold air, causing her to become seriously ill. The wisdom, of course, is domestic, validating the wife's role in opposition to the more public male role.

As Lewis (1992) points out, the role of caring for others has always been bound up with ideas about femininity and caring heroines have always been present in Mills & Boon novels. This role combines "labour and love", joining together activity and identity and is "powerfully linked to the creation of female personality" (1992:89–90). It is not surprising, then, that examples of domestic heroines can be found in all periods. For instance, from the 1970s on, many of Betty Neels' heroines fulfil this role. However, in most periods, these types are not the dominant archetype. The exception is the late 1940s and early 1950s, when some Mills & Boon plots seem to accept a domestic role for their heroines, even glorifying it. As one housekeeper-heroine, in a fit of jealousy over the non-domestic other woman, thinks: "It was very little consolation, at the moment, to tell herself that Elise was stupid and shallow and quite incapable of managing David's household as she herself was doing" (Phyllis Matthewman, *How Could You, Jennifer!*, 1948:85).

There is no sense in Mills & Boon domestic novels of this period of what Betty Friedan called "the problem with no name" for American and British women (1963). Neither do there seem to be present the themes of escape and imprisonment that Wilson found in Hubback's 1957 survey of graduate wives at home with young children (1980:57). But, as in society, Mills & Boon heroines do not stay in the home for long. Jane Arbor's heroines fight for their right to have a career as well as be a wife and mother (*Ladder of Understanding* (1949)); and by the mid-1950s heroines are being portrayed as glamorous career women.

Pamela Kent, a new 1950s author, blows away the cobwebs of domesticity once and for all, in her novels set in Egypt and America,

with *Cinderella*-plots of a secretary marrying her boss, but without sacrificing her career. Kent's heroines are the forerunners of the 1960s' and 1970s' younger heroines. That is, younger in outlook, though not necessarily younger in age, than previous heroines. Freer, the 1960s' heroine is economically independent and emotionally no longer tied to home, with a job she does competently and confidently. The books start to acknowledge more openly that sexual attraction is part of love, although their heroines do not yet have premarital sex. The 1960s' heroine may be a secretary, but she is not a "dolly bird" or a "sex kitten". However, though not a "swinger", she does follow the trend of the day by not modelling herself on her mother.

This more independent heroine continues into the 1970s. Some have seen this heroine as being in a state of passivity, of "not knowing" (Snitow, 1984:263), for whom "travel and work ... are holding patterns while she awaits love" (1984:263). But I would argue these heroines are actually fighting for their independence.

Just as the Doris Day films of the early 1960s can be interpreted as pictures of an adult career-woman protecting her space, instead of being labelled as a virgin protecting her virginity, so can the 1970s' and 1980s' heroine be interpreted as, and admired for, fighting for what *she* wants – even if it is not what feminists think she should want. For instance in Susan Napier's *Love in the Valley* (1985), the heroine, who runs her own catering business, drives through a flood to get to her hero, who tells her, "You know I never would have come to you." (1985:185) She knows that they love each other and refuses to accept his rejection.

1970s' and 1980s' society is dominated by achievement-oriented female archetypes, who fight for what they want, and who see themselves equal to men. Emancipated feminists, are transmuted in Mills & Boon terminology into "feisty" heroines who fight the hero at every turn until he recognizes them as an autonomous individual. They, in fact, refuse the subject position of child, contrary to the argument that they are treated like children by the hero during this period. Assiter asserts their dependency:

> In many a romantic novel ... the heroines are presented as people who swing rapidly from being independent, autonomous beings to being dutiful, passive lovers. Many a heroine

of a 1980s' novel who starts out as a representative of 1980s' progressivism becomes a dutiful wife. (1989:94)

Modleski says: "the heroine of romance ... turns against her own better self, the part of her which feels anger at men" (1982:14). These writers are speaking out of a feminist politics which scorns a purely domestic role for women, and validates a continuous fighting stance towards men. But in Mills & Boon novels the heroine stops fighting, not to become a dutiful wife, but because she has, through her stand against him, turned the hero into the man she wants.

As Cadogan points out: "Romantic and popular fiction of the 70s and 80s was reflecting not only freer attitudes towards sex, but [a] change in thinking about women's place in society" (1994:300). Mills & Boon plots follow this by depicting a heroine who does more than become "a dutiful wife" – she becomes an autonomous being, be that a wife, mother, mistress, career-woman. Within the context of romance ideology, she "has it all" – that is, all that she wants.

The Mills & Boon novels of the Thatcherite 1980s have heroines who are corporate executives, equal in wealth and power to their heroes (such as Carole Mortimer's *Lady Surrender*, 1985), or have heroes who give up their careers for the heroines (for example, Claire Harrison's *Diplomatic Affair*, 1986). Some have heroines who save the hero not, as in the 1920s, from his enemies, but from economic disaster brought about by others' mismanagement of the hero's company (for example, Joanna Mansell's *Sleeping Tiger*, 1987; Liza Manning's *The Garland Girl*, 1985). By doing this both these heroines ensure that the hero does not lose his position in society – his identity.

Thus these heroines reflect their period, in that they are the equal of men in public power, because of their economic wealth. As Thurston says: "In the traditional romance the hero is all-powerful in the public world ... But ... today ... power in the public world is shared by the hero and the heroine" (1987:61).

However, the 1980s incorporate many heroine types – the orphan heroines of Lindsay Armstrong; the misunderstood heroines of Penny Jordan; the professional career women of the majority of Mills & Boon novels of this decade; the homebodies of Betty Neels. All these heroines display some aspect of the multiple

feminine ideals of 1980s' society. In some ways, it is, perhaps, Jordan's misunderstood heroine who is most symbolic of female subjectivity in this period. In Jordan's novels the heroine is often seen by the hero as the complete opposite of what she really is – generally as a selfish gold digger, when she is actually altruistic. He attacks her for her "crimes" and she, for some valid reason, either cannot defend herself, or, in defending herself, manages to reinforce his original, incorrect, impression – leaving her in a no-win situation. This may well reflect the feelings of many women of this period as they defended themselves against men who used their every word against them.

Women have always had to negotiate different subject positions. As Simone de Beauvoir wrote in an article for *Vogue* magazine in 1947:

> ... women are afraid that if they lose [their] feeling of inferiority they will also lose what gives them value in the eyes of men – femininity. The woman who feels feminine does not dare ... to consider herself the equal of men. Yet, conversely, if a woman is stripped of her inferiority complex towards men, if she succeeds with brilliance in business, in social life, in her profession, she often suffers an inferiority complex in comparison to other women. She feels herself less charming, less amiable, less agreeable because she is deprived of her femininity. (quoted Holdsworth, 1988:17)

Mills & Boon novels negotiate these fundamentally oppositional positions by showing, in the *oeuvre* as a whole, different feminine qualities, each one dominating a particular period, but with other feminine qualities also present in other heroines, or in the depiction of the heroine's female friends and rivals. For the figure of the other woman appears throughout these books. In her analysis of *Rebecca*, Light says: "there is always another woman the respectable women would like to be, one whose sexual autonomy would not bring about her social disgrace". She adds: "how to be like, and yet not like, the 'other woman' is at the heart of [du Maurier's] novels" (1991:177–8).

Most commentators on romance fiction, following the patriarchal division of women into Madonnas and whores, have noted the

split of the female character into the sexual other woman, who is vilified, and the virginal heroine, who is rewarded with the prize of the hero. This is both too simplistic, and historically inaccurate. This sexual reading of the texts does not take into account differences between heroines over time, between contemporaneous authors and individual books by the same author.

The other woman is not necessarily a sexual being, nor is she a constant of all the novels. There are as many Mills & Boon books, from all periods, which do not feature the rival other woman character as those that do. Where she does appear, she acts as a foil for the heroine. Thus, a virginal heroine will face a sexual adversary; a domestic heroine a sophisticated woman; a career heroine a homebody; a clever heroine a woman who is just an adornment to hang on the hero's arm (as, for instance the way Charlotte Brontë contrasts Jane Eyre with Blanche).

But the Mills & Boon other woman figure is not always a rival. She is sometimes an older woman who advises the heroine on how to handle the hero, as happens in Alex Stuart's *Queen's Counsel* (1957), or a friend who tells the hero that the heroine loves him, thus making possible the happy ending, as happens in Janet Fraser's *Young Bar* (1949). In many of Barbara Stanton's books of the 1940s it is the other woman who sorts out the misunderstandings the hero and heroine are encountering; or, as in *Every Woman's Dream* (1946) and *Serena's Silver Lining* (1944), recognizing that the hero loves the heroine, breaks off her own engagement to him.

For in Mills & Boon novels the other woman's primary role is not as a negative of, or an alternative to, the heroine. She may represent, where the heroine does not, an aspect of their contemporary society, but she always represents some feminine aspect that the heroine has to acknowledge as being part of herself. As Brownstein writes in reference to Jane Austen's heroines: "[she] must separate from other women in order to realize her self, but on the other hand she must also learn that she is like her sisters and her mother" (1982:99). In other words, the other woman is a twin or mirror image of the heroine (and through her, by implication, the reader). Connected, but distanced, the same yet different, the other woman depicts aspects of femininity the heroine must incorporate in order to become fully female. This is most evident when the other woman is a relative of the heroine.

She is, for instance, occasionally the heroine's aunt as in Sara Craven's, *Unguarded Moment* (1982), or mother. In Burchell's *Little Sister* (1939) the heroine has to pretend that her diva mother is her elder sister, because her mother cannot face up to her age nor her maternal responsibilities. But the heroine learns to accept her mother for what she is. In the much later *The Flame of Desire* (1981) by Carole Mortimer, the heroine believes, erroneously, that the hero is having an affair with her stepmother. In these books, the mother/aunt is glamorous, sophisticated, wealthy, talented and beautiful, in contrast to the heroine's own feelings about herself as unassuming and less than attractive. This plot-type does not represent the whore/virgin dichotomy, but is an investigation of the mother/daughter relationship, where the heroine has to over-come her feelings of inadequacy in relation to her mother and then accept her mother as part of herself. Accept, that is, all that female-ness entails – motherhood, lover, worker, wife, daughter.

Sometimes the heroine and other woman are more distant relat-ives as in Sally Wentworth's *The Wings of Love* (1985), where the two women are cousins. But in many they are sisters and show sibling rivalry. From Eleanor Farnes 1930s' romances *Tangled Harmonies* (1936) and *Hesitation Waltz* (1939) to Sally Went-worth's double romance *Twin Torment* and *Ghost of the Past* (1991), sisters vie with each other for the hero, sometimes acrimo-niously and sometimes not.

The most interesting of these romances, however, are the "twin" books, where the twin of the heroine is portrayed as the sexual other woman, and where often the heroine is asked to imperson-ate her sister for some reason that she cannot refuse. Kay Thorpe's *Double Deception* (1985) is a prime example of this, with the heroine first of all impersonating her sister, and then being herself when the sister returns. The heroines of these books are continu-ally struggling to be autonomous individuals. They fight to make the hero see them as separate from their twins – not just as "Woman" or "the Sex", but as people in their own right. In Jane Donnelly's *No Way Out* (1980) the heroine impersonates her married twin sister, Celia, who had a brief fling with the hero while on holiday, and is terrified her husband will find out. The hero tells the heroine, near the end of the book after he has seen through the deception:

"I'd have been back."
"To see Celia?"
"To see you." (1980:157)

With these words he reassures her that it is her, as an individual and not just as a female body, that he wants.

In 1987 and 1991 Mills & Boon published, respectively, Emma Darcy's *The Wrong Mirror* and Miranda Cross' *Mirror Image*. Darcy's romance opens with the death of the "mirror image" twin of the heroine, who is physically her opposite: one is left-handed, one right, and so on. They are also opposite in temperament. The dead twin was an extrovert, who loved travelling and had a career in television; the heroine is more of a homebody. The hero has had an affair with the twin who has died and, unknown to him, has fathered a son whom the heroine is bringing up. When he discovers this, he forces the heroine to marry him. From the start he thinks she is as deceitful as he believes her twin was, and the heroine has to fight to make him see her as an autonomous individual.

In Cross's *Mirror Image*, however, the mirror image of the heroine is herself. A certified investigator for an insurance company from Boston, she is sent into the country to investigate a fire that has killed half a million dollars' worth of cattle. Inappropriately dressed, she finds herself helping the local vet, which spoils her expensive image. Gradually, under his influence, she changes her appearance – freeing her hair from its bun and replacing her designer suits with jeans and tartan shirts – and starts to revise her memories of her childhood, spent in a poor neighbourhood of the city – a background she has spent her adult life denying. She comes to accept Frannie, her childhood persona, and incorporate her into Frances, her adult persona, and leaves the city behind her to start again in the country with the hero; another example of the country as a place of, in this case, psychological healing and love.

It is evident in the analysis of these two books that Modleski's "second enigma, usually but not always implicit, concern[ing] how the hero will come to see that the heroine is different from all other women" (1982:39) does not always hold true. In Darcy's *The Wrong Mirror* the heroine does have to fight to establish her own individuality, over and against her twin's, in the hero's sight, but in Cross's *Mirror Image*, the hero has already seen the heroine's

other self, and has to wait for her to recognize that part of her femininity and incorporate it into her own female identity. This heroine type does hide her self and her desire, but most heroines do not, although they may deny certain aspects of their femininity until forced to confront them in the person of the other woman.

Talbot (1995), following Radway and Miles, talks about the heroine having her identity restored through loving the hero, but as has been shown, this is not always the case. It is often through her interaction with the other woman that the heroine moves "towards completing the ideal of herself" (Brownstein, 1982:96) which is the goal of all romantic heroines. But what that ideal is and how she completes it depends on her character and her period.

The Mills & Boon heroine is more than a static stereotype. She is of her era, and any analysis must take that period's ideology of femininity into account. By using the foil of the other woman, by portraying different types of heroines in the same period, by depicting heroines against the backgrounds of home and work, and by changing their vision of "ideal" femininity, sometimes in sympathy with, and sometimes in opposition to, the social ideal, Mills & Boon novels show the multitudinous possibilities of women's positions in society.

Chapter Six

War and Aftermath – *You give me redemption*

It may seem surprising that most Mills & Boon books published during periods of war do not mention the hostilities, even fewer use the war as a backdrop for the action of the book and fewer still use it as a mainspring of the plot. There are several reasons for this. Romances in general rarely portray current events, partly in order not to date the books too rapidly and thus prevent reprints. This is especially true in wartime. According to John Boon, " 'We couldn't really publish a reprint of a book [in which] guns and bombs were falling all over the place' " (quoted in McAleer, 1992:126). However, it was eventually accepted, as the Second World War continued for longer than the general populace had expected, that it was unrealistic not to include the war as a backdrop.

Even then, war is not depicted in these books to any great degree, for Mills & Boon novels were written for women who wanted some relief from the anxieties of the war surrounding them. In this respect, like films during the Second World War, they helped to boost morale, a fact recognized by the rest of the industry, if not by the government. McAleer quotes John Boon's story of what happened when the Ministry of Supply refused to give Mills & Boon its paper allocation during the Second World War: " 'The Publisher's Association protested on our behalf, saying quite rightly that these were the sort of books which were read by the women in factories and all that. They gave way.' " (1992:105).

Another reason lies in the way Mills & Boon authors view war. Unlike previous romance authors' total support for war, the few twentieth-century descriptions of war by romance writers are

97

mitigated by despair, as in this account of a parade of men marching off to the Front soon after the beginning of the First World War:

> And so he passed, and his passing brought home to those watching him, more vividly than anything else in the world could have done, the sinister realities lying under the brave show made by those boys in the glory of their youth. . . .
> John and his party were strangely silent and in Delia's and Dora's eyes were tears. . . . The pageant was over, the excitement had fizzled out. It was the moment when those who had danced thought of the piper who had to be paid. (Sophie Cole, *The House in Watchman's Alley*, 1915:360–4)

Earlier in the same book there is the following comment:

> Boys, young men, and middle-aged men all gravitated in one direction becoming part of a huge machine . . . which absorbed these willing victims by the hundred thousand . . . The victims left their homes, their mothers, wives and sweethearts, they sacrificed their individuality they gave their life blood, some in unspeakable torture. . . (1915:175)

The same pride and grief is shown in the opening scenes of Nan Sharpe's *From Dusk to Dawn* (published immediately after the end of the Second World War in 1945):

> The dawn of the brave new world! . . .
> Peace! The moment for which countless millions the world over had sweated and toiled, had spilt their blood, and counted not the cost of their tears. The moment for which all women had been on their knees since the first bugle call had sounded to summon their men to war . . .
> Victory over the powers of darkness, liberation for the oppressed, peace – for the sons of the brave.
> Unashamedly now the tears rolled down Midge's cheeks. So much sacrifice and suffering, so much broken human metal that could never be repaired. (1945:5–6)

Both these passages emphasize the ambiguity of the authors' feelings about war. They are not overtly anti-war, yet they cannot help writing of the pain and anguish war causes, and consequently do not just describe its "glory".

Patriarchal mythology of war regards war as a game which is both the ultimate testing ground of individual male power, and a symbol of society's power. Each war also carries with it a myth of how it was experienced, either formed during it, or in later memory. According to Philip Beidler, the reality of war lies in the "collective mythic imagining" as much as in the "experience of battle" (1982). In Britain the First World War is remembered as a war of slaughter and sacrifice, in which a whole British generation – "the flower of British youth" – was lost; the Second World War is thought of as a "just war" against the evils of Hitler in which the whole nation was involved, civilians as well as service personnel, and is called "the people's war". Vietnam, with which America is still trying to come to terms, is seen as a shameful waste of youth.

These myths of specific wars are part of national ideology, accepted at all levels of society, and by both sexes, though not necessarily recognized by other nations. There is, for instance, a paucity of Mills & Boon Vietnam novels, partly due to a cultural bias. As one British editor explained, "We got fed up with books about Vietnam, and turned many of them down" (private communication), indicating that for British women Vietnam is not a national myth, and therefore not an event with which British editors thought their nation's readers would connect. However, the American Silhouette line still, in the 1990s, has plots which feature heroes damaged by their experiences in Vietnam, and these books sell well in Britain. For there are myths of war which do cross national boundaries; myths which belong in particular to women – not the glory of war, but the grief – not the fury of battle, but the patient wait for the casualty's return. It is this aspect of war that is portrayed in twentieth-century romances. Romances are not "about" a specific war, but are concerned with the idea of war and its effect on women who love men who are, or who have been, caught up in war.

This view of war follows feminist lines of argument. In 1915 C.K. Ogden and Mary Sargant Florence published their *Militarism versus Feminism*. It linked militarism with an anti-woman philosophy: "in war man alone rules; when war is over man does not surrender his privileges" (1915:56). The authors argued that war and violence stop men from thinking about and dealing with social affairs, in particular the condition of women. The militaristic

view creates slavery, a double standard of morality, sees woman as property and debases "love to physical enjoyment", with a woman's chief duty being "to exhaust all her faculties in the ceaseless production of children [so] that nations might have the warriors needed for aggression or defence" (1915:57).

There is a strong pacifist ideology in present-day feminism also. The Feminism and Nonviolence Study Group's *Piecing it Together: Feminism and Nonviolence* (1983), states that: "It has become clear to us that resistance to war and to the use of nuclear weapons is impossible without resistance to sexism, to racism, to imperialism and to violence as an everyday pervasive reality" (1983:5). Mills & Boon authors do not state their philosophy as directly as that, although at least one author thinks of war as the outcome of men's insanity: "Peace and war ... Would it ever end, the eternal conflict? Was it fantastic to hope, to believe that man's sanity and wisdom could prevail?" (Nan Sharpe, *From Dusk to Dawn*, 1945:6) and Sophie Cole calls war not "a pageant" but "a Moloch" referring to the ancient Canaanite God to whose image children were sacrificed (*The House in Watchman's Alley*, 1915:364, 175).

However, the pacifist argument is really made in these novels' concentration on events that happens *after* war, to the women who must pick up the pieces of men's shattered lives. In these books the Mills & Boon war myth is developed. The romance writers of this century argue that war traumatizes men to such an extent that they can only be healed, and thus reintegrated into society (a peaceful secure society where women matter as individuals, rather than producers of children) through the power of a woman's love. Thus most Mills & Boon "war" books are published some ten years after the event. This viewpoint is not specific to Mills & Boon novels for, as Nicola Beauman argues in her book on women's fiction between 1914 and 1939, "at the time of the war most writers lacked the necessary detachment to see it as anything other than a background to individual behaviour" (1983:26).

Consequently, S.C. Nethersole's *Take Joy Home* (1919) is dedicated to her brother, who died at the Front, but does not mention the war, and her one book to be published during the war, *The Game of the Tangled Web* (1916), is set before the outbreak of war which is made clear as, unusually for Mills & Boon books, it opens with a date. None of Louise Gerard's books mention

the war, even though she had five published between 1914 and 1917.

Many of the romances published during the Second World War also ignore the hostilities. Nearly all of Margaret Malcolm's 12 novels published between 1940 and 1945 do not mention the war. Sophie Cole's *Lilac Time in Westminster* (1941) has a warless setting. Juliet Armstrong's *The Pride You Trampled* (1942) is about the heroine's attempts to deny the hero's accusation of fortune-hunting and does not mention the war.

Neither world war affects the plots of these stories or the characters' lifestyles. According to Mirabel Cecil in magazine fiction:

> First World War heroines were found doing men's jobs at home: they were chauffeuses and mechanics, and they met their heroes by the side of the road where they were mending their cars, or out driving ambulances, or on the farm: and they fell in love despite their dishevelled curls and work-roughened hands. (1974:148)

But this is not so in the book fiction of the day, again, not only romances. As Nicola Beauman says: "war work may have expanded middle-class women's horizons, but it provided relatively few themes for novelists." (1983:19)

This is not to say that there are not exceptions. Sophie Cole published five books during the First World War which mention the war. These are *Skirts of Straw* (1915), where the heroine decides at the end of the book to go to the Front as a nurse; *The House in Watchman's Alley* (1915), where part of the plot revolves round the heroine's belief that the hero is a coward as he has not joined up, for which she despises him; *The Loitering Highway* (1916), where the hero is sent to the Front on his wedding day, but returns; *A London Posy* (1917), where one of the heroes stands duty as an air-raid warden and where one of the children dies in an air raid; and *The Gate of Opportunity* (1918), where the hero returns from the war shell-shocked.

However, as I have indicated, Cole is unusual among Mills & Boon authors of the period in writing about the First World War. The same is true of the Second World War period, when again only a few authors used the war as a part of the plot.

Mills & Boon authors were not ignorant of current affairs. From the mid-1930s Mills & Boon writers were aware of what was happening in Europe. For instance Mary Burchell, aided by her sister, was instrumental in saving 29 Jews from Germany immediately prior to the war, because they "were simply moved by a sense of furious revolt against the brutality and injustice of it all" (Cook, 1976:124). And Sara Seale, in 1937, in *Summer Spell*, a novel partly set in Munich, shows Hitler's anti-Semitism. The heroine's stepfather, a German Jew,

> looked at her with eyes that were a little afraid and said: "You shall see, Lee, you shall see. My father always said the Führer will drive the Jews from the country. There will be a new persecution, my father said, greater than any in living memory." (1937:62)

He is proved right when he is killed by an anti-Jewish mob. However, Seale does not mention the Second World War in the 23 novels she published during that period.

Other non-Mills & Boon romance authors use the Second World War as a plot device, giving their heroine a major role to play in helping the war effort, as happens in Denise Robins' *This One Night* (1942), where the heroine is a British agent. Mills & Boon authors tend not to do this, although there are exceptions. As mentioned in Chapter Five, in Mairi O'Nair's *Husband for Sale* (1942), it is the heroine who ensures that the secret scientific formula the hero is working on does not fall into enemy hands, and who saves the hero from the villainous other woman. In Marjorie M. Price's *Trial By Gunfire* (1941) the secondary heroine realizes that the timetable of the convoys setting out from the island where the book is set is being signalled to the enemy by the way washing is set out on the cliff-tops. In another romance, Elizabeth Hoy's *Give Me New Wings* (1944) the first part of the book is set in Spanish Morocco, where the heroine, a doctor, is living. She discovers a wounded British airman, hides him from the authorities, nurses him back to health and then escapes with him via Algiers to England. The second part of the book traces their separate lives until they meet up again. The book ends with their honeymoon, of which the author says:

It didn't occur to them that it was tragic . . . Two short months snatched from the cauldron of war . . . But they didn't think of it like that. Lovers never do . . . When he took her in his arms and kissed her that autumn night the war and all it might yet mean to them was very unimportant indeed. (1944:194–5)

These are the last words of the novel, where the author is giving as much hope for the future as she can, while still acknowledging reality. However, as this particular hero is training fighter pilots, and not actively involved in battle, the hope may be justified.

Although they acknowledge the war, none of these books depict battle scenes. In Mills & Boon novels, where war is seen as a sinister reality, such descriptions of violence are avoided. However, in Joan Sutherland's pre-war books set in India, with a hero serving in the Indian army, there are some descriptions of border skirmishes. But it is only some years after the First World War that, in *Wings of the Morning*, published in 1929, she partly sets a romance at the Front, where the hero is a volunteer ambulance driver and encounters quite gruesome conditions which are vividly described.

In the same book the source of the secondary plot is the gang rape of the second hero's sister by a group of German soldiers. When the hero discovers her, she is alone except for a German officer, who has been castrated by six of his men because he tried to defend her. He dies in the hero's arms, after asking him to remember that there are some honourable Germans. A book which depicts an enemy who acts in a praiseworthy manner could only have been published some years after a war.

A few books published during the Second World War use service personnel as their protagonists. For instance, Barbara Stanton's *WAAF into Wife* (1943) has a WAAF heroine who falls in love with a Polish Freedom Fighter, but the war is distanced by the plot's concentration on the relationship and not the setting against which it is being played out. Unusually, Joan Blair's *The Glitter and the Gold* (1941) does have a scene in which the pilot-hero is in danger when his plane catches fire. He orders the crew to bale out and his own experience is then described:

At the word of command they stepped forward to the hatch. As they went, the machine rocked at the change of weight; she

was lurching now, threatening every second to dive into a spin . . . the fire was spreading far too rapidly for there to be any hope of controlling it. Already the heat was strong on his face and the fumes were choking him . . .

He held his breath as he let himself through the hatch, to fall like a stone for the regulation time before pulling the rip cord. He was not actually afraid – fear seemed a small emotion by comparison with the immeasurable horror of that drop into the grey mists which hid what? Sea, or land? Wild, inimical country or friendly fields? Then he pulled the cord . . . and began to drift gently earthward while the great machine, blazing horribly, shot past him. (1941:248–9)

He lands safely in an English field, near to his base. But the main point of the book, as with all the romances mentioned, is the romance between the hero and heroine. After the crash he asks her: " 'Tell me, darling . . . has last night's show put you off being an Air Force wife?' "

" 'Nothing will put me off that,' said Jo" (1941:250) thus bringing the romance to the expected happy, and patriotic, ending.

But this type of scene is rare in Second World War Mills & Boon novels, where the war is generally distanced by setting the story in a never-never land, which is hardly touched by the war. For instance, Betty Stafford Robinson's *The Crooked Stick* (1940), where the heroine helps the hero to recover from an injury sustained in battle, is set in the Highlands of Scotland.

The major part of Joan Blair's *The Glitter and the Gold* (1941) is set in the New Forest where, despite the scene just quoted, the majority of the protagonists remain untouched by the war. As already stated, Marjorie M. Price's *Trial By Gunfire* is set on an island in the Middle East, apparently isolated from the fighting. She follows what seems to have been the convention of saving the hero from battle at the end of the book by sending him to South Africa. Elizabeth Hoy does the same in *Give Me New Wings* when she gives her hero the job of training men at an army camp in Britain. The hero of Jean S. MacLeod's *The Rowan Tree* (1943) (also set in Scotland) sustains an injury which, though not serious, allows him to leave the army.

This distancing of war has not always been the case in the romance genre, as Rachel Anderson points out:

> In the [nineteenth] century, war, soldiering and death had been romantic and glorious, the very meat of romantic fiction ... for Ouida, even the actual bloodthirsty details of her imaginative battles, with decapitations, and slain corpses piling up, were portrayed as a magnificently colourful spectacle. There was still glory in war – and in death.
>
> But with the real mass horrors of the First World War ... war lost this kind of glamour. Too many real heroes were killed, and frequently were not able to die nobly. (1974:173–4)

So romance writers faced a dilemma as war was brought nearer home and could no longer be distanced, either figuratively or in actual geographical location, and began to affect every family in the land. War was no longer glorious and, therefore, no longer romantic. In a world where uncertainty about loved ones' whereabouts, indeed their very lives, is a constant, ever-present anxiety, a romance reader cannot read about a missing hero with equanimity, safe in the knowledge that he will return.

It was not until the Second World War that the war affected the civilian population of Britain both directly and continually. During the First World War the battles were fought abroad, and the civilian population, as Vera Britain says, didn't understand what was happening in the trenches:

> From a world in which life or death, victory or defeat, national survival or national extinction, had been the sole issues, I returned to a society where no one discussed anything but the price of butter and the incompetence of the latest "temporary". (quoted Beauman, 1983:20)

Britain is here talking about the upper-middle classes, those women who could afford servants, and who did little, if any work. But the incomprehensibility of trench warfare to civilians pervaded all classes. Life had to go on. So it is the fact that life, for the majority of women, continued as usual, that Mills & Boon novels depict.

The war becomes essential to Mills & Boon plots when the hero is so deeply marked by his experiences that he cannot fully

rejoin society without the heroine's loving help. These books emphasize the healing and reintegration of men into society through the love of women. This is a theme of much fiction, including Rebecca West's *The Return of the Soldier*, which was published in 1918.

One of the first Mills & Boon romances to use this plot is Sophie Cole's *The Gate of Opportunity*, published in the same year as West's novel. The book opens pre-war and is different from Cole's other books, in that the hero is a happy-go-lucky individual, who leaves the events of his life to chance. Thus, despite the fact that the heroine loves him and tries to stay in touch, many of their meetings are accidental, with no sense of the hero actively pursuing a relationship with the heroine. Indeed, at one point she has a long correspondence with a friend of the hero at the Front, only to discover that she has been writing to the hero himself. It is only by using this device that he can be open with her. Even so, when he is sent home because of a nervous breakdown due to shell-shock, he avoids her. However, before leaving for the East Coast, where he is now to be stationed, he throws a note through her window suggesting she joins him. She does so, and lives with him, platonically, until he proposes as a result of someone else thinking they are married.

It is made quite clear in the plot development of this romance that the heroine is the hero's anchor, and that her love for him is instrumental in helping him to overcome his breakdown, a fact which he acknowledges when he says of her, on their wedding night, "she lays my ghosts" as, through her love, he is made whole.

Cole returns to this plot device again in *The Toy Maker* (1925). In this romance the actor-hero, a blatantly unfaithful husband, goes off to the Front to entertain the troops and is captured by the Bolsheviks in Estonia and tortured by them. He is eventually rescued and returns to London, but with total amnesia. He makes toys for a living, and thus comes back into contact with his wife, Anna, who during his absence has got a job in a toyshop, and who has also borne his child, Billy. She recognizes him, but doesn't say anything, as she no longer loves him and is quite happy with her life as it is. But both she and he gradually start to fall in love. This gives new purpose to the hero, who has only been going through the motions of living until then:

He wanted to take care of Anna and Billy – to work for them and cherish them – to bear their burdens and share in their joys. He wanted to get back into that world of strenuous living from which his affliction had cut him off. He no longer craved for the peace of stagnation; he wanted life with its passionate joys and its sharp pains . . . Could he do it? He might – for Anna. In the upliftedness of this moment of revelation he felt new powers were being given him. (1925:203–4)

Thus, through his love for his wife and child he is reintegrated into society as he starts a happy married life.

There is a similar theme running through the post-Second World War romances. For instance, in Phyllis Matthewman's *Utility Wedding* (1946) the hero, who has been told by his doctor that he must not do any strenuous physical work, is encouraged to start writing through his love for the heroine. He tells her: " 'You've done so much for me that I can't repay you . . . everything I am likely to do in the future I owe to you' " (1946:165). The theme recurs in Jane Arbor's *Memory Serves My Love* (1952), where the hero has been rejected by the woman he thought he loved because of his war-injury. He is made bitter by this, and it is only through the heroine's love that he is once again able to experience life as being worth living.

Nan Sharpe's *From Dusk to Dawn* (1945) is more explicit in describing the effects of war on combatants. It explores the consequences of the war on one family. The heroine, Midge, is the stepmother of an adult family of five. Her husband, who was a wealthy middle-class newspaper editor, and two of her stepchildren have died in the war, and the youngest, Neil, has come back embittered and disillusioned. Midge thinks of him:

Eighteen months after joining up he'd been in Africa, and it was then, reading between the lines of his letters to his father, that she had begun to suspect something amiss. The sight of war at close quarters was stripping the scales from his eyes, and doing something rather terrible, it seemed, to his still very young soul. (1945:7)

Neil's own disillusionment about the war is expressed when he tells Midge:

> "It was the whole futile, ghastly, tragic *stupidity* of it; the misery and horror and utter desolation of it all," he broke out violently. "The never-ending killing, killing, *killing*. And all to what purpose? To preserve civilisation, we're told. Grand sounding words, but what is it when you get down to brass tacks? A world in which other men with less simple minds may grow fat once again on the fruits of youth's sacrifice. A world in which nations will quibble as violently as ever over the length and breadth of their frontiers; a woman takes fresh lovers before the ink is dry on their widows' pension . . . I don't believe in fairy-tales any more. I've lost my appetite."
> "What you have lost," answered Midge in a sudden rush of uncontrollable anger, "is your soul." (1945:8–9)

Neil is saved from this despair through his friendship with Penny, a 12-year-old who has been crippled for life by infantile paralysis. Towards the end of the book he tells her:

> "You've got to believe this because it's terribly important. There's not a soul on earth I've talked to as I've sometimes talked to you . . . I've told you things that would have been better left unsaid, but I've done it because something in you has drawn them out and made me feel better for the telling . . . I've made a pal of you because I wanted to, and I wanted to because somehow I need you, I can't get along without you . . . I guess deep down where I really live I know I love you." (1945:185)

He is, at last, through his love for Penny, significantly a little girl, reintegrated into the new, post-war society.

This aspect of war-romances is particularly evident in the American post-Vietnam novels, all of which concentrate on the reintegration of the hero into society through the healing power of love. Doris Rangel's *Legacy* (1985) has a hero who is "racked with the legacy of nightmare memories of his time at war" (blurb):

> Carolyn knew there was a world of horror he had left unspoken. It had been in his face – in the grim set of his jaw and bitter twist of his mouth. Most of all, it had been in his eyes, haunted with remembrance. Mike had not spoken of reprisals for his unsuccessful escape attempts but Carolyn had seen for

herself the scars at his neck and wrists and the smaller ones on his upper torso . . .

These were the scars of the body but the nightmares showed that the scarring was equally deep on the mind. Would he also carry the nightmares with him for the rest of his life – or would peace eventually come to his sleep as time and events created new layers of healing? With all her heart Carolyn prayed that it would. (1985:87–8)

But it is not just time that heals him. The heroine persuades him to continue with the pills that he has to take daily in order to keep at bay the fever he picked up while a prisoner, and without which he will die, and she soothes his nightmares:

The familiar tossing and turning was coming from Mike's pallet as it had every night since he had been here. She squatted down and took the hand that was pulling restlessly at the blankets, beginning to talk softly and soothingly as she did so. As it had every night, the hand held hers in strong, firm desperation as though clinging through a storm-tossed sea . . . (1985:113)

Until finally he accepts their love for each other and is then able to sleep the night through: "In the dim light, her eyes had roamed lovingly over his sleeping face. The lines had smoothed out of it, giving him the look of being at peace" (1985:186). He has at last, through the heroine's love, become a whole person, at peace with himself and his past.

In Quinn Wilder's *That Man from Texas* (1986) the hero has been emotionally scarred by his experiences in Vietnam, and is estranged from his family, who disowned him after he was court-martialled for hitting an officer, though they have since tried to contact him. The heroine pleads with the hero to make it up with his family:

"How many pounds of flesh are you going to demand before you're satisfied? Or maybe you're never going to be satisfied! . . ."

"Forgive them. And if you can't do it for yourself, do it for me and our children . . ."

> "Don't you see what this hatred has done to you, and will keep doing? You told me that you were a cripple . . . and you were right." (1986:168)

He takes this as a sign that she no longer loves him and leaves.

When he returns a few weeks later, he has made peace with his family, telling the heroine:

> "I started to think about some of the things you'd said. Especially about what hate was doing to me, and I knew, then, that I could never love you the way you deserved to be loved with the hate living and growing inside me like a cancer." (1986:180)

Through the heroine's intervention, he is reconciled with his family and thus able to take his place in society again.

It is, however, in Amanda Carpenter's *Flashback* (1984) (dedicated to the hope that ". . . Maybe one day there will be no more war") that the healing power of love is made most explicit. This is the most extraordinary war-romance to be published by Mills & Boon, as Carpenter adds another dimension to the story of a Vietnam veteran by including a telepathic heroine. This romance emphasizes the unreality many experienced in Vietnam and by using different layers of reality: the reality of Vietnam as it was, the reality of the remembering of it, and the reality of telepathy which forces the heroine, against her will, to live in the hero's mind as he remembers the torture and killing he witnessed in Vietnam as he struggles to come to terms with what happened to him.

David, the hero, has blocked all his memories of his experiences of the war, but the pressure of his suppressed memories has finally become too much for him and he has come to the heroine's village to have a "nice little crisis, all by yourself, all alone" (1984:151) as she accuses him of doing.

But because the telepathic heroine cannot block out other people's thoughts, she cannot block the horrors he experienced from her mind. Consequently, he has to accept responsibility for her mental well-being as well as his own. She forces him to stop denying what happened, believing that only then will he find peace: " 'You can't cut [it] out of you. Vietnam is part of you, and it's a part of me now . . . It may be in the past, but it's there, and you may try to

block it all you like. It's there'" (1984:152). Eventually, he accepts that she is right. Admitting his love for her he says: "'I was breaking myself with my rigidity...'" He continues:

> "The one essential thing that you gave me and that you still give me every night with your sweet, warm body and your eager loving, and every day with your peaceful tranquillity – the one thing that I drink from you constantly and always come away refreshed – is," he turned his head and looked into her eyes, "redemption". (1984:187–8)

There is, it seems, an unconscious taboo on a plot device in which the woman, suffering from the after-effects of war, needs to be reintegrated into society through a man's love: there are very few Mills & Boon novels which describe the effect of war on women. There is one Silhouette romance published in Britain – Kathleen Korbel's *A Soldier's Heart* (1994) – that honours the nurses of Vietnam, by taking an ex-nurse as its heroine and showing that she, too, needs the same sort of help as ex-combatants. But post-First World War Mills & Boon novels do not depict war-wounded heroines, nor do the romances published during or after the Second World War.

However, Elizabeth Wilson quotes a doctor who wrote to the *Daily Telegraph* in November 1945 commenting on the physical strain housewives had suffered as a result of the war: "Many are strained to breaking point by long hours of work without assistance and standing in queues in all weathers to serve food of sorts for those dependent on their patient exertions" (1980:20).

Margaret Malcolm, although not mentioning the war in many of her books published in the 1940s, portrays this "breaking point" in two of her books – *One Stopped At Home* (1941) and *Listen to Me!* (1949) – both of which feature heroines who have nervous breakdowns. In the books this is brought on by overwork, worry and poverty, and the consequent constant stress of having to do the housework and manage a family's affairs on little money and with no emotional support. It is not attributed to the stressful effects of the war on women, but it seems likely that Malcolm is using her heroines' circumstances to point out the sufferings of women both during and after the war, for this plot type is prevalent only in this period.

Mills & Boon authors believe that "'Most women have an instinct that leads them to protect, and to denounce war,'" as the heroine's stepmother says in Penny Jordan's *The Inward Storm* (1984:167). They tend to ignore periods of war while enduring it, but remake war after the fact, out of a literary myth of war heroes, whom they see as flawed, some of them perhaps scarred physically, but more importantly, all of them scarred emotionally, unable to form deep relationships with other people, and therefore unable to contribute fully to society. It is only through love that the combatant can be healed and fully reintegrated into society. War, according to the Mills & Boon myth, is a necessary evil, fought by men. But, even after a peace treaty is signed, the war is not over, not until all the participants have come to accept the primacy of love in human relationships. Then they can be rehabilitated into a society in which, women, through their greater capacity to both give and receive love, have power.

Chapter Seven

Work – *The smothering of the creative spark . . . could be a sort of murder*

Mills & Boon heroines have always worked; the romances have consistently had a work-ethic for both male and female characters, even during those periods when such an ideology for women was unacceptable. As Sophie Cole puts it, "The man or woman who is content with all play has never learnt how to get the most out of life" (*Money isn't Everything*, 1923:122).

In every decade authors have depicted working heroines, although there are exceptions. Laura Troubridge's society novels of 1909–14 have non-working heroines and heroes. Sara Seale's heroines do not, generally, have a job, having no qualifications:

> [Though he] recognised that in these days it was nothing un-usual for a girl to find some means of earning her own living, he hated the idea of Gina working when he could still afford to keep her, added to which she was not fitted for anything that would help very materially. (*Beggars May Sing*, 1932:203)

Authors, such as Sophie Cole (1909–1941), Margaret Malcolm (1940–1972), Jane Arbor (1948–1980s) and Anne Weale (1955–1990s) sometimes depict gainfully employed heroines and sometimes do not. Whether they do so depends not so much on the ethos of the time as on the storyline of the book. Thus, in the 1910s, most of the heroines of the city and country novels work, though those of the society and exotic novels do not. But during periods when it is the norm for women to work, there is still the domestic heroine who is not in gainful employment (for example, many of Betty Neels' heroines of the 1970s and after in a marriage of convenience, do not work outside the home).

As well as presenting a work ethic for their single heroines, Mills & Boon books have also argued that married women have a right to work if they so choose, even during periods when this went agains the ethos of the time.

Echoing Lewis's comment that it has repeatedly been shown that there are three important components in women's view of work: "a means to self-fulfilment . . . companionship at work and a feeling of self-worth derived from a measure of financial independence" (1992:69), Mills & Boon books have argued throughout the decades that work is part of a woman's identity:

> "When I can bring myself to living with Selby, physically, and yet being able to live a spiritual life of my own as well, so that just being with him won't interfere with my own work as it does now – I'll go back to him . . ."
>
> "*My job is to justify my own existence.* Until I've done that I can't go back. And I won't. When I've written the book everyone's expected me to write, I can afford to let the trivial round get hold of me." (Elizabeth Carfrae, *The Trivial Rounds*, 1930:140, 166 my emphasis)

> "I loved you, Adam . . . But you – you were taking over my life. I felt suffocated . . . I had a career too, but that was just ignored . . . I was being crushed . . . and I knew that if I gave in and let it happen, *I would cease to exist as an individual.* For the rest of my life I would be somebody's daughter, somebody's wife, and somebody's mother." (Dana James, *Heart of Glass*, 1987:92–3 my emphasis)

Mills & Boon novels also stress the need to domesticate the workplace. As Rabine argues of Mills & Boon heroines:

> Not content with Helen Gurley Brown's rationalistic advice to "have it all", they don't want it the way it is now; they want the world of labor to change so that women can find happiness there, and they want men to change so that men will just as much find *their* happiness with women. (1985:256)

These three themes of the right of married women to work, that work is just as much part of a woman's identity as it is of a man's, and that the workplace should be made more accommodating to

women's needs, wind their way through the decades of Mills & Boon romances, sometimes one to the fore, sometimes another, but always embedded in the reality of women's actual experience of the world of work.

In 1918 women stepped down from the jobs they had been doing during the First World War. There was a split in the feminist ranks between the middle classes who did not want to lose the ground won from men during the war and the working-class women who accepted that, in a period when there were nearly one million unemployed, it was the men (who were, after all, their own fathers, brothers and husbands) who needed the available jobs. Consequently, by the 1921 Census, working-class women were once again to be found in their traditional workplaces. As Nicola Beauman (1983) points out it was the middle-class woman whose life was really changed by the "new" opportunities to work.

As a result of the Sex Disqualification (Removal) Act of December 1919 women could in theory now assume or carry on any civil profession or vocation, and by 1921 there were about 40 women training as solicitors, and other women became architects, dentists, veterinary surgeons, dieticians and pharmacists. Many spheres of work were not covered by the Act, but women now had both more choice of a professional career and more chance of entering a profession than they had had before the war. However, as Pugh points out, there was a "ruthless removal of women from their wartime role" (1992:81) and the proportion of numbers of women among teachers, nurses and manual workers, declined. However, "they improved their position slightly among higher professionals" and "made major gains in clerical and related work" in the interwar period (1992:92).

The 1920s were, therefore, a period when the working middle-class woman came into her own for the first time. According to Reincourt (1974) increased work opportunities for women were brought about by the rapid growth of urbanization, an increasing division within and specialization of the workplace, the invention of the typewriter and the increase in business offices, the rapid development of department stores and a shift towards service industries.

This emancipation into the workforce is endorsed by the Mills & Boon romances of this period, with most heroines working before marriage and some, for example, nearly all of Louise

Gerard's heroines, keeping their jobs after marriage, often as the breadwinner of the family. This acceptance of married women having careers was not a majority attitude at this time, as Lewis points out:

> Census statistics showed only 10 per cent of married women in the work-force from the early twentieth century to the mid twentieth century. Only in the post-[Second World] war world has the idea of the working wife and mother gained in credibility. (1992:68)

So it is not surprising that occasionally Mills & Boon authors of this period feel it necessary to provide an excuse for a married woman working. For instance, the heroine of Sophie Coles' *The Speaking Silence* (1921) keeps on her job as owner-manager of a dress shop in order to help the hero clear his debts. By 1931 the number of unemployed had crept up to nearly three million. Even so, 37 per cent of the female population between the ages of 14 and 65 were working for money. But they seemed to have left paid employment on marriage (Lewis, 1992), no doubt partly because of the marriage bar. Even the BBC, which in the 1920s had accepted married women, was dismissing them in 1932 on the grounds that they were taking jobs from single women who had no other means of support.

A few of the romances of the 1920s and 1930s use this reason for the married heroine's non-employment. In Sophie Cole's *Money Isn't Everything*, published in 1923, the hero wins the £60,000 first prize of the Calcutta Sweepstakes, enabling him to marry, but his wife soon becomes bored with a life of idleness: "Jim had his studio and his work, but she had nothing. There had been hours during the last few weeks when she had even regretted those old days of poverty and office work" (1923:100).

In the same author's *Bill and Patricia* (1933), one of the few Mills & Boon novels to actually show the effect of unemployment on a working-class family, the heroine, who is supported by her wealthy uncle, tells the hero: " 'If I went out and got a job I should feel I was taking the bread out of the mouth of some girl who had nothing but what she earned' " (1933:11).

In Cole's 1937 novel, *The Bridge of Time*, the heroine cannot work because "To do so would have been to deprive some other

woman, who might otherwise starve, of a living", but Cole then comments that she is therefore "Drifting into the neurotic state of the unemployed woman who is too imaginative to settle down to the life of a vegetable" (1937:79).

In Elizabeth Carfrae's *The Radiant Years* (1931), the effect of low salaries and lack of job opportunities for untrained middle-class women is shown when the heroine is thrown out of her home by her wealthy and autocratic grandfather when she refuses to marry the man of his choice. She eventually gets a job as a shop mannequin with a salary on which she can barely live. After this experience she tells the hero:

> "You don't tell me that girls go on the streets because they want to. Or let men keep them. Not the average girl, that is. There are girls who do it, of course, but I'm willing to bet my last sixpence that out of all the prostitutes and kept women in London, only a tenth of them do it because they want to. The rest of them do it because they're hungry and broke. If you're hungry you'll do any damned thing for a meal." (1931:127)

The marriage bar which, as Lewis (1984) says, chiefly applied to professional women, reinforced the ideology that married (middle-class) women belonged at home. It was, throughout the 1930s, the subject of an on-going debate, which Mills & Boon books join, arguing against the prevailing view. Holdsworth comments: "A surprising number of women confessed to us that they had kept their marriages a secret," (1988:73) and Mills & Boon romances use this device to show both the economic and psychological effects of the rule that sacked women on marriage.

In Mary Burchell's *After Office Hours* (1939) the heroine, in conversation with another woman, starts by arguing for the marriage bar, claiming that: " 'Lots of firms do make it a rule that you must leave on marriage' " adding: " 'I suppose really most girls would prefer to leave when they marry.' " Her friend points out that: " 'Circumstances don't always allow it ...' ", to which the heroine replies:

> "No, that's true. But in that case, quite frankly, I think I'll be thoroughly commonsensical and stick to the job ... I can't imagine being greatly attracted by a man who couldn't even

make enough to support a wife very simply. There's somehow a suggestion of failure about that." (1939:14–15)

This rather smug attitiude is knocked on the head when she meets a struggling artist, with whom she quickly falls in love and marries. But when he breaks his wrist, thus rendering him unable to work, she has to become the breadwinner. The only way she can do this is by keeping her marriage a secret.

In Barbara Stanton's *Orange Blossom Fades*, published in the same year (1939), the heroine leaves her job on marriage, but has to go back to work when the firm her husband works for goes bankrupt. She is much happier at work than at home:

> Secretly she had missed her job more than she had admitted, even to herself. As for confessing as much to Jimmy, the idea had never occurred to her, for she knew how hurt and unhappy it would have made him. Had it not been for his bad luck with Browning and Clerk, the chances were that she would have gradually reconciled herself to the leisure and – only whisper it! – occasional boredom of the young married woman in a modern labour-saving flat . . .
>
> Indeed, she couldn't help feeling an occasional twinge of guilt when she thought how much happier she was now than during those early days, after the honeymoon when she had sat in the flat not knowing how to pass the time. (1939:99, 148)

In order to work she has had to claim to be a single woman. However, when her boss discovers that she is married, he allows her to continue working, bringing in her husband as her boss. This ending, based in the external reality (*she* isn't the boss), allows the heroine to keep her independence, doing a job she enjoys and can do well, unlike running a home: "The truth of it is, I'm not really cut out for domestic work, she told herself. Now that she could afford a daily woman the running of the flat was delightfully smooth" (1939:148). (Mills & Boon heroines never have problems with servants, as Anderson says: "There is available in the world of romantic fiction a far higher proportion per household of wise, servile, loyal dailies and housekeepers than one finds in real life" (1974:106).

Despite the Depression, by the beginning of the Second World War single women were supporting themselves as a matter of course and most women agreed that they should do war work, but it was more through a sense of duty than enthusiasm for the new horizons that different types of jobs had offered in the First World War. Magazines encouraged war work with both features and "stalwart fiction" (Cecil, 1974:171), and most Mills & Boon heroines of this period work – though generally it is in jobs that they had had before the war started, not war work as such. Margaret Malcolm is an exception, with very few of her heroines working outside the home.

Traditionally, at least since Florence Nightingale's time in Scutari, war has demanded that men become fighters and women nurses. Mills & Boon claim that "the injured heroes of the Second World War set the scene for their Doctor/Nurse romances" (*The Changing Face of Romance*, 1983:3). Nevertheless, there seem to have been few romances of this period with injured war heroes and nursing heroines, although in Jean MacLeod's *This Much to Give* (1945) the heroine is a nurse and the hero a surgeon at a military hospital in Scotland. This may be because, although in the First World War nursing was one of the few jobs whereby women could be directly involved with the war, in the Second World War there were many other jobs open to them. Accordingly, Second World War romances which have a war background occasionally have heroines who are in the Services. However, as Rachel Anderson (1974) points out in her book on romances, their jobs are not even sketchily described.

In *WAAF into Wife* (Barbara Stanton, 1943) the heroine joins the WAAFs out of loneliness and boredom, and after training is "booked for 'special duties'" at an aerodrome (1943:15). Here she meets, and eventually marries, Alexei, a Polish Count who is the Leader of the Polish Squadron stationed nearby. The author happily admits that:

we haven't told you much about [her job] for two reasons.

First, Security (Remember how we mentioned that her job was of the hush-hush variety). Second because we thought, rightly or wrongly, that you'd be more interested to know how she spent her time *after* the day's (or night's) work was over. (1943:105)

She adds the further reason: "who wants to read about work; it's bad enough having to *do* it" (1943:105).

These are arguments to which Mills & Boon writers would still subscribe, although the heroine's work is occasionally sketched in in more detail, and is sometimes integral to the plot. For instance, in Daphne Clair's *Frozen Heart* (1980) the hero is the leader of an expedition to the Antarctic and the heroine the person doing the psychiatric evaluations on the members of the team, and in Leigh Michaels' *Dreams to Keep* (1985) both the hero and heroine are architects who set themselves a competition to see who is the best.

Despite the fact that 58 per cent of the women surveyed in 1943 did not believe that women should work after marriage (Lewis, 1992:76), from the late 1940s on there was a mass movement of women into the labour market (Weeks, 1989:257), although it was mainly as part-time workers:

> What emerged from the wartime experience was . . . the con-
> viction of policy makers that it was possible for women to
> combine work, marriage and motherhood without their home
> responsibilities being seriously undermined. Both government
> and industry saw the extension of part-time work for women
> as an ideal means of ensuring that women would be able to
> fulfil their responsibilities as both workers and wives and
> mothers. (Lewis, 1984:153)

Mills & Boon heroines do not follow this trend of part-time work. Despite (or perhaps precisely because of) industry's need of women as workers, this was the beginning of the period of the ideology of domesticity, and the majority of the heroines of the late 1940s to the mid-1950s are either full-time homemakers or full-time workers, though neither choice depends on their marital status.

According to Niamh Baker there are working heroines in the novels of the women writers of the post-war period "and in some cases this work does provide gratification . . . [but] generally the work was of less importance in the novel than the personal rela-tionships" (1989:142). Post-second World War Mills & Boon ro-mances, on the other hand, emphasize the importance of gainful employment to women, following the interwar feminist ideology of equality, and argue passionately for a woman's right to work in

a job she enjoys. In Nan Sharpe's *From Dusk to Dawn* there is sympathy for one of the secondary heroines' frustration in not being able to obtain a job flying planes, despite having been a pilot in the Air Ferry Service during the war. Jane Arbor, who was still with Mills & Boon in the 1980s, started writing for them in 1944. Her novel *Ladder of Understanding* (1949) depicts a heroine who insists, that she has the right to work in a job she loves:

> Was her undoubted talent for her own chosen career to be buried henceforward beneath a welter of ministering-angel work for the estate? Didn't it ever occur to him that if she satisfied her own creative instinct in the work which she did best, she could still spare time and interest for other people? Whereas, she had only to stay idling here for a while longer and she felt she could manufacture many a 'mostly trivial' problem of her own – and grow grey and dull-witted in the solving of a succession of them! (1949:47)

Her husband objects saying:

> "You want one thing – your right to work and to take a share in the money getting. I want another – my right to work *for* you and for this place, because you are both *my* responsibility, *my* heritage, *my* – loves. Yes, I know . . . it's "archaic", "impractical", "wooden-head obstinacy" – you've called it all that on occasion – but it's *male*, and it's *me*! (1949:161)

Arbor's heroine thinks later: "the smothering of the creative spark which she expressed in her work could be a sort of murder . . ." (1949:163).

In this particular romance the heroine continues working, even though she loses her child when he drowns while in the care of his nurse. But many of the books, such as Barbara Stanton's *Spring Fever* (1946), compromise, with the married heroine working until she has her first baby.

By having these heroines, however, Mills & Boon were fighting the ideology of the times. As Elizabeth Wilson points out, women may have been welcomed into the labour force as temporary workers in a period of crisis, and as part-time workers, and so long as they did not disturb the traditional gender-division of labour in industry,

but the dominant view was still "that married women would not naturally wish to work" (1980:43–4).

Mills & Boon novels constantly argue that married women do wish to work, in direct opposition to the cult of women as home-makers that the women's magazines upheld:

"Women's magazines played their part in . . . putting across post-war social policies such as those enshrined in the Beveridge Report of 1942 . . . which firmly re-located women back in the home" (Ferguson, 1983:20–1).

This refusal to completely domesticate women is evident in Margaret Malcolm's *No Cure for Love* (1946) where the heroine, Caroline, is a 40-year-old woman who is the owner of a boot and shoe factory. This is one of the few Mills & Boon novels where the heroine is presented unsympathetically. She is a widow with two daughters, whom she tries to rule autocratically, expecting them to marry the men she picks out for them. She uses the hero as a convenient social partner, but refuses to acknowledge her feelings for him. For the major part of the book she is presented as a hard businesswoman, who completely disregards the feelings of others. Eventually she has a breakdown, and when she is recovering from this, the hero explains the reason for it: "Your husband made you assume what ought to have been his responsibility, and instead of living your own life you had to live your husband's, so to speak" (1946:188). But the denouement is not, as one would then expect, of her surrendering to him and giving up her work. Instead, she marries the hero, but only cuts down on her commitments, placing her female secretary and male factory head jointly in charge of the day-to-day running of the business, while she herself acts as director. Instead of following the argument through to its logical conclusion that women should not work, Malcolm depicts a woman denying an essential part of herself. It is only when she has accepted both her private emotional self, and her public working self, that she becomes a "whole" person, and thus is able to, in current jargon, "have it all".

In another novel, Malcolm has a minor female character tell the hero: "Of course I shall go on working [after marriage]. These are days when extra money coming into the house is useful" (*That Eagle's Fate*, 1949:16). In this particular novel, the heroine is also a widow with a young child to support. She owns an antique

shop, and one of the impediments to her relationship with the hero is her fear of losing her financial, and thus her emotional, independence.

The marriage bar had been lifted during the war, and the post-war economic boom needed married women in the new industries. For "from the beginning, the Attlee government was attempting a weird juggling feat, trying to promote ideals of family life while simultaneously desperately in need of labour for the work of peace-time reconstruction" (Wilson, 1980:43). This meant using women, as they formed the only large reserve of labour left.

But the majority of jobs were part-time and at the lower end of the job scale. Mills & Boon novels, however, argue for full-time careers for women, not for a job market where women are expected to work or not at the whim of the government of the day. For instance, the heroine of Barbara Stanton's *Lonely Heart* (1951) keeps her job as a florist after marrying the hero, a freelance journalist. He is not happy about it, but admits that they need the money. The heroine, who is not at all domesticated, is relieved to leave the running of their home to his spinster sister, a job the sister enjoys, while the heroine has a job she enjoys.

However, Mills & Boon romances also acknowledged that women often did need to be able to work at times to suit them, if they had family commitments. In Stanton's earlier *Every Woman's Dream* (1946) the hero says to the heroine,

"Naturally you'll give up your job when we're married."

"Naturally, my foot!" was on the tip of Carol's tongue, but she was far too sensible to let it slip. Masculine vanity, she knew, was a highly sensitive plant that had to be treated with the utmost delicacy ... All the same, just because love had come in at the front door was no excuse for letting common sense fly out of the window.

And so, in her most wheedling tones, she pointed out all the advantages to be gained from carrying on with her job for a year or two and not starting a family in the meantime. (1946:192)

Wilson comments of Hubback's 1957 survey of *Wives Who Went to College* that the author herself "observed that 'many of the correspondents were obviously being very careful not to

complain' ... Only five per cent said they regarded marriage as a career" (1980:56, 57). The solution offered to these women by Viola Klein and Alva Myrdal in their book *Women's Two Roles*, published in 1956, was one of part-time work in order to combine both careers of marriage and paid employment, a solution that was popular with both women and their male supervisors, as it was flexible, supplemented the women's family income and saved their supervisors money.

However, Mills & Boon romances combine the cult of domesticity with women's need to work by joining the home and the workplace in various ways such as working from home, as do Louise Gerard's writer and artist heroines of the 1920s and 1930s. Another solution is sharing your husband's job, a fantasy solution which overcomes what Baker argues was "the real dilemma for ambitious women in this period: that the sort of work available for women tended to be repetitive and dull, with little chance of turning into a satisfying career" (1989:143), by combining an interesting career, in which the heroine has a personal stake, with marriage.

At the end of Barbara Stanton's *Too Precious to Love* (1954) the heroine takes over the financial side of her husband's car-hire firm after he has got into debt through mismanagement. She will, it is implied, use her business skills to help him turn it around. In Marjorie Lewty's *Never Call It Loving* (1958) the hero farms roses and the heroine is his secretary. The implication at the end of the book is that she will continue to work with him after their wedding. In Pamela Kent's *Flight to the Stars* (1959) the heroine is again the hero's secretary. He is the playboy son of an international hotel-chain owner, but she forces him to take his responsibilities as the manager of the London hotel seriously. Discussing their marriage he says to her: "if you really feel you can be happy here in the Nonpareil we'll make a success of it somehow together" (1959:181).

These plots contradict Cecil's (1974) comment that the magazines of the 1950s and early 1960s saw a career as a threat to the heroine's chances of getting married and to having children afterwards. They also, to some extent, underline Wilson's comment that, despite the popular explanation in the 1950s that married women worked for luxuries, they actually wanted economic inde-

pendence from their husbands – "an independent income was more satisfactory than waiting on a husband's generosity" (1980:32).

This acceptance of married women's right to paid employment is underscored by Margaret Malcolm's *Sweeter than My Dreams* (1955). The heroine is engaged to a man who was previously engaged to a woman who is now a world-famous singer. He tells her:

"She sang at a charity concert and the very next day she received an offer which was obviously that first step on a ladder which could easily lead to real fame. She was tremendously excited about it when she told me. I, on the other hand, was considerably annoyed that she would even contemplate accepting the offer. You see, I regarded her gift only as a pleasant little talent acceptable in my future wife! . . . And I told her so without mincing matters. At first she could not believe I meant it. I remember she said: *'But surely you, of all people, understand, Riley! For years you've worked so hard – and now you have earned a well-deserved recognition of your ability. It is just the same for me!'* But I would not admit it. To me, my work was so important that every other consideration must give way to it. At least, so I told myself. Actually, of course, it was my own importance, my pride in my ability to dominate a situation that was at stake!" (1955:180)

This attitude was echoed 31 years later by the lawyer-hero of Emma Darcy's *Woman of Honour* (1986):

"I was engaged to be married once. Perhaps it would have worked out, given the chance." His mouth curled into a self-mocking smile. "But I was a young man then with a young man's ego . . ."

"I was unreasonable. She was in law, too. We were both very keen to make names for ourselves. It annoyed me whenever she put her job ahead of any arrangement we'd make to see each other . . .

"She pointed out that I did exactly the same thing. And I did. I argued that since I was going to be the provider my work was more important than hers. She replied that if that was my attitude, she was not going to marry a male chauvinist

pig. My pride and her pride cemented the break." He sighed and his eyes held a hard-learnt wisdom.

"The years have taught me that pride is a very cold bed-fellow. I don't intend that it ever get in the way again." (1986:82–3)

The heroine of this romance will continue her job as a freelance caterer, running her business from home, after marriage, just as the heroine of *Sweeter Than My Dreams*, after being jilted by her fiancé, marries the hero, a vet, and learns bookkeeping so that she can help him run his practice. Her fiancé returns to his first love, who retires, telling him that her success meant nothing because she "had turned her back on all the things that would have made life worth living" (1955:181). Significantly, it is the other woman, here, who acts out the ideologically expected lifestyle of the time for a married woman.

But the same authors also have heroines who stop working on marriage. In Marjorie Lewty's *The Million Stars* (1959) the hero is a brilliant geologist and the heroine has had her nursing training interrupted through illness. At the end of the book she agrees not to work after their marriage, though she warns: "if I'd once started training again, I might not have wanted to give it up" (1959:186). In Pamela Kent's *Meet Me In Istanbul* (1958) the typist-heroine stops working once married to the wealthy archaeologist-hero.

Berger and Maizels, writing in 1962, argue that there was little change in society's attitude between the 1950s and 1960s toward women working. In both periods:

work is seen more as a matter of personal choice than as a contribution to the national effort, and they [women] were regarded as marginal in the labour force rather than a stable factor within it. (1962:30)

Women, they said, were regarded as important to the economy as consumers, not producers. They pointed out that eight million women in Britain were in paid employment; "One in three of all those who work for a living are women." This represents the same number as 50 years previously, but now over half the 8 million were married; one in three of all married women worked (1962:81). Despite this, they pointed out that society did not accept the mass

of women exercising the right to work and have a family, but only "charwomen, actresses and Royalty" (1962:81, 97). But the 1960s was a decade of fast-moving change: "There was a restlessness in the time that communicated itself everywhere and to everyone" (Bernard Levin, quoted in Holdsworth, 1988).

It was a period of youth:

> "The Sixties" exists today primarily as a powerful metaphor for current ideological contests between progressives and conservatives over economic, political and moral agendas. Yet at the time it was simply the emergence of a wave of Western youth desperate to flee domestic, suburban comfort for inner-city stimulation and squalor. (Segal, 1994:2)

There were many items on the agenda. Freedom – from domesticity, from sexual inhibition, from authoritarianism. All the 1960s' movements, in their various ways, challenged traditional values, and all the different movements were intertwined. From the civil rights movement came the Women's Liberation Movement, which was tied to the sexual liberation movement. Above all, these were movements of the young. 1968 was the "year of revolt and reaction through the world" which suggested that "anything was possible" (Weeks, 1989:276). A year later, in 1969, at the Ruskin History Conference, a call went out for papers on women's history and in 1970, at what is now known as the Ruskin Conference, women's liberation burst onto the British scene. Three of the first four demands of the Women's Liberation Movement made at that conference concerned women's paid employment: equal pay for equal work, equal opportunities and education, free 24-hour child care and free contraception and abortion on demand.

In the same year the Equal Pay Act became law, which meant that by 29 December 1975 a woman doing the same job as a man had to be paid the same salary as him. In 1975 the Sex Discrimination Act banned the practice of refusing a job to an applicant on grounds of gender. This extended the horizons of female school-leavers; the Employment Protection Act of the same year gave women paid maternity leave and the right to return to her job within 29 weeks of giving birth.

This mingling of sex, work and female equality in the name of "freedom" – labelled by its detractors as "permissiveness" – is

127

evident in Mills & Boon novels from this period on. It is difficult to untangle them into separate strands, as the Latin hero ushers in a more sexual book, and heroines move out of the home and into the workplace and try to change that workplace to meet their needs, while simultaneously trying to change the hero's view of sex as meaningless recreation:

> "When did you last go to bed with a woman?"
> ... "It – I – four days ago," he admitted ...
> "And the time before that?"
> ... "About a week before that ... I'm not making excuses!"
> "And why should you, any healthy male would feel proud to have bedded two different women in as many weeks. Now let's see, there are fifty-two weeks in a year, and I would say you've been sexually active ... probably twenty-two years of your life –"
> ... "Okay we'll give you the benefit of the doubt and say twenty-six times twenty-one ... That's a total of five hundred and fifty-six ... That isn't bad for an unmarried man." (Carole Mortimer, *A Rogue and a Pirate*, 1987:63–4)

As Thurston says, from the late 1970s on,

> The New Heroine is not only intent on both social and economic equality with the man with whom she forms a sexual relationship, but it is a rare heroine who is not also gainfully employed, usually in a non-traditional job or career, and intends to remain so. (1987:185)

This can be seen in the 1960s' romances. Society expected single women to work, though generally in a service capacity – nurse, hairdresser, shop assistant or secretary. However, the "dolly-bird" secretary of the 1960s' culture, with her bright clothes and mini-skirts, flitting from temporary job to temporary job, is not a feature of the Mills & Boon novels of the period. Their heroines work in permanent jobs, often as secretaries, sometimes not, but it is generally through their work that they meet their heroes.

This had begun earlier, in the 1950s, with some of Eleanor Farnes' novels, and by 1959 Mills & Boon were publishing books where the heroine will not give up her job on marriage. The ending of Rachel Lindsay's *House of Lorraine* (1959), for instance,

implies not only that the heroine, a fashion designer, will continue working after her marriage to the hero, a textile manufacturer who works in close collaboration with the firm the heroine runs, but also that her career may continue even if they have children. Lindsay repeats this ideology in the next year's *Business Affair* (1960).

In the 1970s and 1980s, against the background of demands for equality, women's work became an issue for Mills & Boon authors, who concentrated on women working in "male" jobs, and the fight to turn the workplace into an environment in which women are comfortable, and in which their needs and views are taken seriously. These heroines are actively pursuing careers, often in jobs that they have no intention of giving up once they are married.

In one of the earliest of these novels, Kay Thorpe's *Not Wanted on Voyage* (1972), the heroine is a doctor on board a whaler. The hero, the captain of the ship, is a woman-hater and resents her presence: " 'You represent a distraction the crew can do without,' " he tells her (1972:27). But by the end of the novel she has proved herself to him, not only as a doctor but also as a woman he can trust. After she has accepted his marriage proposal, he offers to give up his job, but she refuses, saying they can work together, until the children come along and then: " 'I'd have a part of you always with me – and we'd have the summers together. Six whole months! That's more than most can count on' " (1972:189).

As in this book, many of the heroines of the 1970s and early 1980s are in constant battle with their heroes, often physically as well as emotionally, as they try to prove their capability. At the same time this particular type of heroine denies, both to the hero and herself, her feelings for the hero, believing that they weaken her in her battle with him as he seems not to feel the same and, if told, would only use them against her.

Leslie Rabine (1985) points out that in these romances the hero is generally the boss of, or has economic or professional power over, the heroine. She argues that:

> Two themes of revolt and fantasy escape that run most strongly through the romances concern the depersonalization of the cybernetic world and the powerlessness of the feminine individual within it.

The force of Harlequin [the North American publishers of Mills & Boon novels] comes from its ability to combine, often in the same image, the heroine's fantasy escape from these restraints and her idealized, romanticized and eroticized compliance with them. (1985:254)

She points out that the heroine has a respected (generally professional) job, over which, albeit with a fight, she gets control and within which she has a great deal of freedom, being part of the decision-making process of the firm.

Rabine's view may be contrasted with that of other feminist critics of the genre, such as Valverde, who argues that: "the reader of Harlequins is expected . . . to interpret sexual coercion by a man in a superior position as permissible", and that in these books the heroine is seen not as the victim of an unjust economic system, but "as a trembling female body yearning to be engulfed by the power of the male" (1985:85, 137). Rabine, on the other hand, argues that the personalized relationships between the hero and the heroine are actually condemning the unjust economic system:

These working heroines . . . seek more than simply to succeed in the man's world. An analysis of the romances will show that on an implicit level they seek not so much an improved life within the possibilities of the existing social structure, but a different social structure. The very facts that the hero is both boss and lover, that the world of work and business is romanticized and eroticized, and that in it love flourishes suggest that the Harlequin heroines seek an end to the division between the domestic world of love and sentiment and the public world of work and business. (1985:250)

These heroines are also still fighting for the hero to recognize their identity as someone other than just a "wife".

I know you think my job is a sort of stop-gap, like the other things I tried and tired of, but it isn't. This is important to me. For the first time in my life I feel like a real person in my own right, someone who's doing something productive and creative in more than just a biological sense. (Daphne Clair, *Marriage Under Fire*, 1983:179)

In Ann Cooper's *Maelstrom* (1984), although the hero objects to the heroine's job as a petroleum engineer in the oil fields of Dubai, expecting her to give it up when they get married, she stands firm:

> It was her job – her identity. It was as much a part of her as Max's career was to him. *She* wouldn't have dreamed of asking him to give up his job. What right had he to ask her to give up hers? If she wasn't always there when he got back home, what about all the days – weeks – when he could be flying off anywhere in the Middle East – how was she supposed to do without him? (1984:176)

In this romance, hero and heroine talk, reaching a compromise whereby he accepts her right and need to work, and she agrees to look for a job with a company that takes fewer risks than her current employers. In Victoria Gordon's *Wolf at the Door* (1981), the hero and heroine clash over her ability to stand in for her father as administrator and cook at a boom-town camp. In the end they become equal partners in the camp. There is a similar plot line in Sara Craven's *Outsider* (1987), where the heroine's ill father brings the hero in as a partner at his training stables, despite the heroine's capable single-handed running of the business. After a forced marriage the book ends with hero and heroine as equal partners in marriage and the running of the stables.

As society is accepting women's right to work, Mills & Boon novels have begun to put forward solutions to the problems caused by two-career families. Occasionally the hero gives up his job to be with the heroine. For instance, in Claire Harrison's *Diplomatic Affair* (1986) the hero resigns from the Foreign Service after refusing a promotion to the US embassy in Rome, when he realizes that the heroine would be unable to practise her job as a paedatrician if he remains a diplomat. He tells her: " 'I need you far more than I need anything else. Rome would be nothing without you. My job would be worthless if you weren't there . . . I don't think I can live without you' " (1986:184).

In Elzabeth Oldfield's *Close Proximity* (1987) the hero changes from being a foreign correspondent for a TV company to concentrate on in-depth political interviews so that he can spend more time with her and their child. He tells the heroine:

> "Reporting has too many drawbacks . . . I have a horror of a
> white knight appearing while I'm in distant lands and gallop-
> ing off with my lady. I'm fed up with being so damn celibate
> I could give lessons to monks . . . I want to be around to watch
> [our child] . . . grow up . . . I want to share your life, and I want
> to be fully involved in bringing up our child." (1987:174–8)

Other solutions offered by the novels include the parents being
wealthy enough to afford servants; or the father using modern
technology to work at home and look after the children, as in
Emma Darcy's *The Positive Approach* (1987) – which ends the
division between the public and private spheres with a vengeance
– or the mother working from home, as in Daphne Clair's *A
Ruling Passion* (1984), which reflects a trend in present-day soci-
ety, where one tenth of the workforce works from home.

From the 1960s onwards the boss-heroes of Mills & Boon
books owned their own companies. By the Thatcherite 1980s, so
do many heroines, and they are thus able to organize their time to
suit themselves and their family commitments, as do the heroines
of Carole Mortimer's *Fantasy Girl* (1983) and *Lady Surrender*
(1985).

With Robyn Donald's *Country of the Heart* (1987) a new trend
is evident in Mills & Boon novels that involves both hero and
heroine giving up the corporate ratrace for a slower life in the
country, where the demands and pressures of the job are not so
great and they can both share in providing economic and emo-
tional support for their family.

Although not ignoring those women who preferred to stay at
home, Mills & Boon novels have argued throughout this century
for women's right to work, before and during marriage, and after
having children. Additionaly they have had a more radical sub-
text – that of changing the workplace to suit women's needs.

This is evident in those books where the heroine works from
home, in those where the job and marriage are combined in the
same physical space and in those where the heroine fights to in-
clude the emotional world of interpersonal relationships in the
workplace. This means engaging their heroes in battle, often in the
sexual arena.

Chapter Eight

Sex – *We got all the damned foreplay over with months ago*

Despite their reputation for "stopping at the bedroom door", Mills & Boon romances have always been sexual. In the 1920s, when the hero and heroine, although not married, make love for the first time, "The fact of his love was a spar she clung to when strange wild seas engulfed her" (Louise Gerard, *The Dancing Boy*, 1928:180). In the 1930s when the other man starts to seduce the heroine

> [he] began to kiss her in that fierce possessive way that left her excited and unsettled and utterly bewildered . . . his experienced fingers began their insidious work, and she lay very still against him, the teddy bear still clasped against her breast."
> (Sara Seale, *Grace Before Meat*, 1938:168)

In the 1940s:

> Slowly his arms closed round her, ignoring her puny resistance. His tall head bent until his lips met hers.
> And now she was quite still in his arms, for, against her will, the flame of passion that burnt in that first kiss kindled an answering flame in Susan. Perhaps she could have killed that, for something of that strange, almost fanatical strength that can deny heart's desire had always been hers. But stronger than that flame, wonder and awe possessed her. For here was she, a prisoner in his arms, helpless to free herself and yet, though he could so master her, he was at her mercy, as a lover must always be at the mercy of the beloved. (Margaret Malcolm, *One Stopped at Home*, 1941:224)

And in the 1950s, when the married protagonists declare their mutual love:

> His lips hungry and demanding as they closed over hers. For perhaps five seconds Jan was passive in his arms. Then all the love and yearning of past months welled up inside her and, flinging her arms round his neck, she eagerly returned his kiss. (Anne Weale, *Hope for Tomorrow*, 1959:183)

As can be seen from the above quotes, Thurston's (1987) argument that romances only became sexual in the 1970s is incorrect. Sex has always been a part of Mills & Boon romances, to a greater or lesser degree, depending on the era, the author and the type of plot. There is also a consistency of viewpoint. It is the emotions of sex that the authors concentrate on, not the physical aspects.

> The actual intensity of her own experience, her own fulfilment was so overwhelming that she cried out almost in panic at the sheer awe-inspiring power of it, her body trembling so much in its aftermath that she felt as physically incapable of movement as though she had lost complete control of her nervous system. (Penny Jordan, *Second-best Husband*, 1991:168)

From the beginning, Mills & Boon novels make explicit the link between love, marriage and sex. This does not mean, as some commentators have assumed, that the books condemn sex outside marriage. On the contrary, there exist many instances, from most decades, of the heroine having premarital or adulterous sex, which is not condemned in the novels. The heroine of Mary Burchell's *Such is Love* (1939) bears an illegitimate child. The heroine of Elizabeth Carfrae's *Payment in Full* (1929) has an adulterous two-week affair with the hero. In most of the later novels the hero and heroine have sex before marriage. Amanda Carpenter's *Rage* (1985) and Michelle Reid's *Passion Becomes You* (1994) and *Slave to Love* (1995) have heroines who are living with the hero when the book opens. Both these heroines enjoy "orgasmic sex", which refutes Snitow's (1984) argument that a Mills & Boon heroine can achieve orgasmic sex only once she has obtained a commitment – that is, a declaration of love and a marriage proposal – from her hero.

Many of the "meet again" plots have heroes and heroines who had affairs before the book opens. This plot-type is prevalent in the 1920s and again in the late 1940s, after both world wars. In Sophie Cole's *The Other Gate* (1921) the hero and heroine were lovers before the war, an affair of which the heroine is ashamed. She meets another ex-mistress of the hero, who has borne him a child. However, she is not ashamed of this, saying:

> "The thought that he loved me, and that I once belonged to him, makes me proud and glad to be myself. It has been a safeguard through more temptation than you could ever imagine. What does it matter that people call it 'sin'? To me it is all that is opposite to such a thing." (1921:32)

When the mother of the child dies, the hero and heroine marry in order to provide her child with a home, each believing the other is doing it for practical purposes. Eventually, the heroine tells the hero she loves him, and he reciprocates. They kiss:

> It was the old Andrew and the old Josephine – the two who had answered the call of passion in those days when youth goes to youth in the glamour of adolescence – only now they entered that past again, through another gate. (1921:252)

After the Second World War it is more often married protagonists who meet up again after a period of separation. In Fay Chandos' *Lost Summer* (1948) the British heroine married the American hero during the war, but was so miserable with his family in America, where she went to wait for him, that she divorced him and returned to Britian. When she discovers that he was tortured by the Japanese she returns to him. They find that the divorce is invalid, and the heroine spends the summer convincing the hero that she still loves him, which he eventually accepts and then admits his love for her.

However, this meet-again plot is most predominant in the 1970s and 1980s. Robyn Donald's *Bride at Whangatapu* (1978) has a hero who forces the heroine into marriage because she has borne him a child from their earlier affair. In Carole Mortimer's *Forgotten Lover* (1982) the heroine has previously had an affair with the hero, who was married (though separated) at the time.

Affairs, however, are not always with the hero. Claire Harrison's *One Last Dance* (1984) opens with the morning after the heroine's one-night stand with a stranger, who is not the hero. The heroine of Pippa Clarke's *Heat Stroke* (1985) embarks on a series of one-night stands after she thinks the hero has rejected her.

In Daphne Clair's *Marriage Under Fire* (1983) the married heroine has a one-night stand which is discovered and brings about a better understanding between her and her hero-husband. Readers wrote in about this, complaining, not about the sexual immorality, but about the heroine leaving her ill children in the capable hands of her parents-in-law.

In fact, where adultery is concerned, if the heroine strays, she is portrayed sympathetically. It is the (possible) straying of the hero, or the actual straying of the non-hero husband that is condemned. In these instances, it shows a lack of love on the hero's part, or is indicative of a weak character on the non-hero's part. It is, however, still the case that the hero is more sexually experienced than the heroine. There are a few exceptions – Amanda Carpenter's 24-year-old hero shocks the heroine of *Waking Up* (1986) when he tells her that he, like her, is still a virgin. The hero of Daphne Clair's *Never Count Tomorrow* (1980) is a virgin, having been brought up by his father and stepmother to disapprove of sex outside marriage – for both sexes.

This is an essential part of the plot as her knowledge of this makes the heroine run away when she realizes she cannot reveal that she is the illegitimate daughter of the hero's stepmother, without, as she believes, ruining her mother's marriage. It is only when her mother comes to see her and, via a photograph, recognizes the heroine as the daughter she gave up at birth, that the denouement of marriage is able to take place.

Although Elizabeth Carfrae's *The Radiant Years* (1931) has a hero with a "clean sheet" because "That sort of paid affection has always seemed to me repulsive" (1931:135), in the past male virginity was applied mainly to men other than the hero, as in Joan Sutherland's 1929 novel set during and immediately after the First World War, *Wings of the Morning*. Here the 29-year-old secondary hero tells the mother of the 16-year-old girl he loves, when declaring his intention to marry her: "I will go to her as she comes to me" (1929:198). This perhaps reflects Christabel Pankhurst's

"chastity for men" slogan, but it is not an argument to which Mills & Boon romances usually subscribe as, on the whole, they have, throughout their history, preferred sexually experienced heroes. The exception is the 1940s' boy-next-door hero, whose sexual experience is not clarified. However, the boy heroes of the 1920s are sexually experienced and the other older heroes throughout the decades obviously have a sexual history. For, as an editor explained in the 1980s. "Readers don't like virgin heroes, and neither do I" (private communication).

With the awareness of AIDS, this attitude has changed somewhat. Penny Jordan said that she had to be conscious of AIDS, and now makes it clear that her heroes "haven't had lots of previous affairs because the readers wouldn't like it, if they thought they might have AIDS". Condoms are now shown in use, partly as protection against sexually transmitted diseases and partly as protection against an unwanted pregnancy. This is not to say that contraceptives were not referred to previously. There is, for instance, in Anne Mather's *A Haunting Compulsion* (1981), a reference to the Pill and the problems caused if it is not suitable.

Many Mills & Boon novels throughout the decades, have included descriptions of sexual intercourse, and have portrayed sexual attraction as a motivating force in a male–female relationship. The early twentieth-century feminists were deeply divided over the issue of sexuality, with one side pointing out the pleasures gained from heterosexual intercourse, and the other that many women feared and loathed sex, gaining no pleasure from it at all. This, they argued, was partly due to the socialized nature of male sexuality, which led to "large differences of interest between men and women over the issue of sexuality" (Jeffreys, 1985:100). Mills & Boon books were also divided. The early society and exotic novels show heroines gaining pleasure from their sexual encounters with their heroes, while the city and country novels emphasize the companionship element of marriage, not its sexual component. Further than this, however, Mills & Boon novels agree with the argument that men and women have different interests bound up in sex and argue for a change in men's attitude towards sex, wanting sex to be part of a loving relationship.

The 1920s saw the rise of the bestseller "sex novel". There were various factors that made this possible. The topic of female sexuality

"was promoted from the domain of the esoteric, the outlawed and the subversive to the area of respectability" (Melman, 1988:3). The sexologists used a language of sex that the media picked up, thus giving the reading and writing public a repository of words that could be used as a shorthand for certain images, including E.M. Hull's "Sheik", a word which came to denote a masculine lover, with loads of sex appeal.

Following this, Mills & Boon novels of the 1920s and 1930s are sexual, while still retaining the idea that love is based on more than sex. For instance, in *Fate Knocks at the Door* (1924), Sophie Cole has a plot which revolves around a hero and heroine who fall in love with each other, but who cannot marry because the hero already has a wife. At one point they contemplate having an affair, but do not do so, and the heroine, the hero and his wife remain friends until the wife dies.

This careful negotiation of friendship and sex can also be seen in Louise Gerard's *The Dancing Boy* (1928), quoted at the beginning of this chapter. In this book the hero and heroine are living together as flatmates, with the heroine totally unaware of his desire for her. Once she does recognize it, she has sex with him, before marriage, because she loves him and so wants to assuage his needs. It is only later that she starts experiencing sexual desire and enjoying sex. In fact, living together platonically becomes a theme in Mills & Boon romances of this time, as a way of introducing sexual tension into the novels, while at the same time giving the protagonists the time and the proximity to get to know each other.

But there were at least two Mills & Boon romances, both by Gerard, which followed *The Sheik* by including a hero/heroine rape scene. These, however, do not take place in the desert, but in France. These rape scenes are specifically about male power and revenge. In *The Fruit of Eden* (1927) the hero thinks the heroine has been patronizing him and so rapes her as a show of his power. In *The Shadow of the Palm* (1925), the hero thinks that the heroine is the sister of the man who seduced and then abandoned his own sister and rapes her on a *quid pro quo* basis.

Both these rapes precipitate a forced marriage between the protagonists, in the case of the *Fruit of Eden* because the heroine thinks she is pregnant and, in the *Shadow of the Palm*, because of the heroine's actual pregnancy. Ironically, once married, the woman's

right to say "no" is upheld, with sex between the heroine and hero not taking place again until the heroine desires it, a desire she only acknowledges once she is assured of the hero's love. This plot line may be a portrayal of "anger at male inconsideration of female sexual needs and pleasure" (Bland, 1983:18) that was a prevalent part of feminist post-First World War politics. For, with its description of the effects of rape on a woman (after the rape the heroine of *The Shadow of the Palm* "creeps down the stairs" of her hotel to the lobby, feeling that "her shame must be written on her face for all to read" (1925:95)) and, in the consequent development of the story and the reversing of sexual power roles, this plot line demands that male sexuality should be feminized.

In other Mills & Boon novels of the period, it is the mutuality of sex as an essential part of love that is described. In Elizabeth Carfrae's 1929 novel *Payment in Full* the hero and married heroine indulge in an adulterous 14-day affair, with the hero remembering:

> the passionate, breathless glory of those moments when Elizabeth, waking, would creep into his arms for his morning kiss . . . The wonder of the nights when, holding her in his arms, she'd gone to sleep . . . The marvel of Elizabeth's selfless glad surrender . . . The mystery of the love they found together in those miracle-laden fourteen days. (1929:137)

Because they love each other, this adulterous affair is condoned in the book, quite specifically, with the birth of a child. The heroine, who has been unable to carry her husband's child to full term, knows that her lover's child will survive because she was conceived out of love. Her husband thinks the baby is his and raises her accordingly until his death, when the hero and heroine meet up again and marry.

Ten years later, the case is slightly different. Illicit sex is being dealt with more carefully, so in Mary Burchell's 1939 novel *Such is Love* the heroine has actually had an adulterous affair when she was 17, although she had believed she was married to the man. This bigamous marriage resulted in a child, which her mother told her died at birth. Thinking about the affair later, the heroine remembers:

she was fascinated by the ripple of muscle under the brown skin of his bare arm. Indeed, she was distinctly aware of a desire to put out her hand and touch his warm, tanned arm, just where the sleeve of his shirt was rolled above his elbow . . .

Poor silly little girl that she had been! There was not really much chance for her, of course, with every sense awakened and quivering, every fibre of her – body and soul – crying out for this wonderful lover who had come into her life . . . She loved him of course . . . But there were some things about Terry's love-making which shocked and even horrified her. (1939:13–16)

Light (1991) argues that in Daphne du Maurier's novels of this period sexuality is seen as an elementary part of a person's individuality, and "a thing so personal and so intimate" (*Frenchman's Creek*, 1941:113) that to bestow it indiscriminately results not just in the loss of reputation but also the loss of "a unique and superior selfhood" (1991:177). It also leads to "being banished from respectability to join the ranks of those sexual women who must be members of another class" (1991:177). This attitude is reflected in *Such is Love*, where the heroine thinks of a servant: "He wouldn't have thought her a real lady if he knew she had been fooled by a bigamist at 17 . . . But he didn't know . . . So she remained a real lady" (Burchell, 1939:29). She never loses her status as a "lady", because her husband, loving her, accepts her past and agrees to adopt her son when he is discovered alive and still in the orphanage where his grandmother had placed him at birth.

The bigamous marriage theme is also part of the plot of Sophie Cole's *The Bridge of Time* (1937) where the heroine discovers she is bigamously married to the hero, when her first husband, presumed dead, reappears. The hero, chivalrously then decides to stop having sex with her, but their sex life is resumed later in order to save the heroine from "dementia". This implies, of course, that sex is part of marriage, and that women have sexual desires that need to be met. This is still being said in the 1940s. In Phyllis Matthewman's 1946 novel, *Utility Wedding*, the heroine, loving the hero but knowing he does not love her spends: " 'White' nights, when she lay awake, tossing and turning and longing, with an intensity that sometimes almost frightened her, for Giles' love" (1946:89).

In the domesticated 1950s sexual desire stops at kissing. "Pleasurable, non-reproductive sex" may have "stepped in as the 'cement' of the marital relationship" (Bland, 1983:25) in society, but Mills & Boon romances concentrate on the courtship period, during which sex is forbidden – both in the books and in reality. The heroines even become wary of kissing, as in Susan Barrie's *The Gates of Dawn* (1954), where the heroine feels "suddenly panic-stricken at the idea that he should kiss her – casually, under the mistletoe in the hall" (1954:76).

> For she could no longer think calmly of such a thing as the cool, faintly cynical, intensely masculine lips of Richard Trenchard, succesful playwright, approaching hers, even under the mistletoe, without being conscious that it was the one thing in life she wanted more than anything else. And it was the one thing in life she must school herself to do without . . . (1954:80)

Mills & Boon romances took a decade or so to catch up with the permissive society, because they never relinquished the idea that while "Passion isn't always the ugly thing many well-meaning people make it out to be" it doesn't "unless it has something a great deal more stable blended with it, form a very solid foundation for married happiness" (Elizabeth Carfrae, *Guarded Heights*, 1929:71–2).

But the books of the 1960s did at least acknowledge passion:

> And suddenly he was so unbearable in his mockery that she had to find relief in a hard smack across his clefted cheek.
> "That had to happen sometime, eh?"
> "Well, I'm darned if you or anyone else will play paddy-whack on my face!"
> The moon was directly overhead, and then it was out of sight and the cry on Jill's lips was lost under the punishing warmth of Erik's mouth . . . (Violet Winspear, *The Viking Stranger*, 1966:150)

Later, the hero says to the heroine:

> "I suppose you've realised what we were doing down on the beach the other night," he said, his voice grating in his throat.

> "We were quarrelling – but not like friends. And we were kissing – like lovers." (1966:188)

In the 1970s, with the advent of Janet Dailey and Charlotte Lamb, and the eroticization, by Violet Winspear, of the Latin and Arab hero, the books become more sexual and more violent. According to Lewis (1992:104) wife abuse was rediscovered as a social problem in the mid-1970s, and in 1988 Frenier, basing her argument on 1970s' Mills & Boon novels, was contending that: "Harlequins tell wives that if they behave like battered women they will obtain and keep a good marriage" (1981:39).

In some respects this is true of the sexual politics expressed in some of the books. For instance, "'Unless he's one of those sick men who go around beating women up ... a man doesn't spank a girl unless he feels reponsible for her'" (1978:165) the heroine of Elizabeth Graham's *New Man at Cedar Hills* is told after the hero has picked her up:

> sat down and bent her over his knees ... The pain of his well-aimed slaps was nothing compared to the injury to her dignity as she struggled impotently against the steel band of his arm holding her across his knees. When at last he released her and stood her on her feet, the tears sparkling in her eyes were composed of molten fury.
> He tells her, "I'm sorry if I hurt you ... but its something you've been asking for and I make no apology for doing it." (1978:162)

This is an example of a spirited heroine being "brought back into line when you were getting beyond reason" that a few authors occasionally used in the 1970s, with the spanking being described in terms that leave no doubt that the hero is enforcing his will on the heroine through brute force.

In later books the spanking becomes more sexual when it is made clear that it is used instead of forced sex. The hero of Kay Thorpe's *Win or Lose* tells the heroine after spanking her into submission during a quarrel, "You asked for worse, and on balance I thought you'd prefer the hiding" (1986:88). But other authors of the 1980s make a specific link between spanking and abuse. In Sandra K. Rhoades' *Bitter Legacy* (1986), when the hero spanks the heroine, she recoils:

Like a frayed anchor rope, something inside snapped and she felt herself being swept away on a growing nightmare. She turned to her mother, tears flowing unchecked down her cheeks. "Why do you let him do this to me? Why don't you take me away from him? Why won't you understand when I tell you he hurts me? I'm not being naughty. I'm not lying. Why won't you stop him? Why, Mommy, why?" she shrieked. (1986:170)

And the story of the physical abuse she was subjected to as a child by her grandfather comes out.

Owen's (1990) British readers, of the late 1980s, objected to aggressive heroes and violent sex, claiming that they were an American phenomenon. Frenier (1988), however, states that they are a British phenomenon, and that, for instance, Janet Dailey (an American author) only writes like that for her Mills & Boon romances and not for her American publishers. However, violent sex scenes are time-specific. It is not the cultural background of the authors that seems to be relevant but rather the period in which they are writing that is important.

The Mills & Boon view of sex is very specific. Sexual intercourse is always better, for both hero and heroine, when there is a mutual feeling of love and desire and both protagonists surrender to that feeling, with body and mind in harmony. However, in the 1970s and 1980s, in certain circumstances, the hero forcefully seduces the heroine, against her mind's will, though not against her body's desire, in an effort to force her to acknowledge her feelings for him and to show her his feelings for her. As Liz Fielding put it when questioned on this point:

I would have sworn I was totally innocent of this, but I can see from your viewpoint I might well be as guilty as the next. The problem may be that the author knows the heroine is madly attracted to the hero, even if she would deny it with her last breath. By putting her in a position where the hero is in control, dominant if you like, the writer is being her *friend* by forcing her to confront her feelings. The heroine might fight the hero's kisses, but she still longs for them and he knows it – they both do; the reader understands that and knows that the heroine is never forced to have sex, even though afterwards she might regret it. (letter:1996)

But, until the heroine knows, through words, that the hero loves her, she, while enjoying the sex, finds it a matter for shame afterwards. In other words, in this type of Mills & Boon novel, sex can be pleasurable – even orgasmic – without love, but is only truly acceptable for the heroine when it is part of an expression of an already acknowledged love – whether mutually declared or the heroine's recognition of her own feelings. For, with the acknowledgement of love which, according to Mills & Boon philsophy is the arena where the female is more powerful than the male, the heroine becomes the one in control.

Belsey (1994:28–30) argues that romance literature (in which she includes romances other than Mills & Boon romances) promises that true love unifies mind and body, but fails to deliver, because "the engulfing tidal wave of sexual feeling" that the books portray, while being necessary to true love is not a guarantee that love is present. Therefore, the hero has to speak, "to tell the heroine that he loves her and wants to marry her". This means that mind and body remain separate. Hodge does not agree with this analysis, arguing that in the final scene words and bodies combine, at last, to make "a complete transaction, after all the incomplete ones" (1990:198).

This unification can never take place between non-loving actors, and it is only when sex takes place in situations where such a union is impossible that it is called "rape" in the books. In Mills & Boon ideology, in most instances, rape can only take place between the heroine and a man who is not, and who could never be, a romance hero.

The subsequent plot of this type of Mills & Boon is based on the heroine's fear of sex (and sometimes men) and the hero's finally successful attempts to overcome her fears in relation to him and his lovemaking, as in Carole Mortimer's *Living Together* (1981) and Charlotte Lamb's *Stranger in the Night* (1980).

Many women – especially feminists – have objected to this division of forced sex into two, calling both "rape" and arguing that the books thus reinforce the idea that violence from a man towards a woman is an indication of his love for her. But the linking of sex with violence and rape in the books of the 1970s reflects, not a validation of violent male sexuality, but Brownmiller's (1975) argument that all men are co-conspirators in using the threat of

rape as a conscious process of intimidation to keep all women in a state of fear.

This can be clearly seen in Daphne Clair's *The Loving Trap* (1981) where the heroine was raped by a gang of youths as a teenager. The hero, not knowing this, initiates sex between them against her will, stopping when she starts to tell him about her past. In the later reconciliation scene, when she tells him she knows she disgusts him because of her past, he replies: " 'I was disgusted, all right – sick with it. But never with you. I despised myself – [because] it dawned on me that I'd just damn near raped you myself' " (1981:184).

Valverde draws a distinction between power and domination and then argues that Mills & Boon novels eroticize male domination (1985:136). But, if anything, it is power not domination that these particular plot-type books eroticize. This is made quite clear in the portrayal of the heroine's feelings when sex is used by the hero as a weapon. She feels shame, which, in the language of Mills & Boon novels, shows an awareness of the sexual politics involved. For instance, in Kay Thorpe's *Not Wanted on Voyage* (1972), when angered by a remark of the heroine's during an argument with him, the hero kisses her into silence:

> Tracy found herself caught and drawn up by two arms which were like steel bands across her back, felt the bruising force of his mouth pressing back her head until she thought her neck would break. Then, as abruptly as he had seized her, he let her go, standing back to regard her with anger still glinting in his eyes . . .
>
> She reached her cabin two minutes later, shut the door and leaned her back against it and closed her eyes, feeling the humiliation reaching down inside her as her mind relived the scene enacted a few short minutes ago. (1972:94–5)

Here the hero is attempting to dominate the heroine, using sex as a weapon. The fact that the heroine is shamed by such domineering sexual advances indicates that it is not domination she finds erotic, although the books may eroticize, in certain periods, the physical, economic and social power of the male in other spheres of life. The plots of this type of book are depicting, not "domination . . . as inherently sexy" (Valverde, 1985:137) but the battle of

the heroine to make the hero see her as an individual, played out in the sexual arena. This is a battle which she wins, for in this type of book, the hero eventually breaks down and begs the heroine for her love, so that it ends on a note of female power, not male domination. In other words, sex is seen as symbolizing male power, love as symbolic of female power. The hero of Jayne Bauling's *Rage to Possess* (1985) tells his heroine:

> "I'm sorry, I am so sorry, though I know there's no sort of apology I can make for the terrible damage I've done, and nothing will mend it. I'm just no good to you, I never have been, but I wish, I wish, I'd handled it all differently . . . I wish you weren't going . . . I love you so much . . . And God knows, it's killing me. I've been existing in a sort of hell since the first time I saw you." (1985:181)

This enables her to tell him she loves him, and they make love again, though "it was shatteringly new". The book ends with his promising to give up his war reporter's job: "I don't want to be parted from you . . . My life has become too precious, with you in it" (1985:187).

This reversal of power roles is particularly evident in the forced marriage plots of some Mills & Boon novels, where the heroine, in a powerless position, has to fight against the hero's sexual advances until she is sure that he loves her. In Rosemary Hammond's *Loser Take All* (1986) the heroine, having agreed to marry the hero to save her father's fishing livelihood, which the hero has won from him in a poker game, is initially so repulsed by sex that she is physically sick when the hero tries to make love to her. Once she realizes she loves him, she sets out to seduce him.

But as soon as "she stroked downward towards his loose waistband" (1986:162) he stiffens, loses control and throws

> himself on to her without a word or any attempt at lovemaking, taking her roughly, uncaring of the pain of that first deep thrust into her inexperienced body, again and again and again." (1986:165)

She thinks: "he'd used her body as he would a prostitute's, worse, without the slightest concern for her pleasure or feelings, merely as a form of revenge" (1986:169). In thinking this the heroine is,

in fact, wrong. The hero is not seeking revenge. However, he has lost control after months of living celibately with a woman he loves and desires, giving her the impression that he does not care for her. It is only after the heroine realises that he loves her and tells him that she loves him that he is able to be "gentle" with her, "murmurs softly" to her and makes love to her "slowly", giving her a "glorious climax" (1986:186). The balance of power has shifted: "This time, she decided a little smugly, it was the loser who took all" (1986:187).

These quotes make it clear that what the heroine of a Mills & Boon novel objects to is sex without love, or without any acknowledgement of her, as she thinks, as an individual. This is one reason why so many heroines are virgins – her virginity is bound up with her autonomy as an individual.

This is not to say that heroines are always sexually inexperienced. Following social trends, by the 1980s heroines have often had one or two previous sexual affairs – usually in a long-term relationship, often a marriage which has ended through death or divorce. Authors are now making a distinction between chastity and virginity: "I don't regard virginity as a prerequisite of a 'virtuous woman' but I think that chastity meaning sexually moderate is a characteristic which is admirable" (Kate Walker, 1995).

Snitow argued that the sex in the books of 1977–8 she read was "diffuse" and not "enacted" (1984), but as Treacher points out:

> in private, the heroine's thoughts are actually highly erotic, active and full of more or less explicit hints as to her wishes . . .
> It is on her own, in her wandering erotic daydreams and thoughts, that the heroine can be active and powerful, and can express what she wants in terms of sex, and her male lover. (1988:85)

Later books have scenes in which the heroine, far from daydreaming about sex, instigates it. In Carole Mortimer's *Cherish Tomorrow* (1985) the heroine sets out to seduce the hero:

> "Oh, Lucas . . . Kiss me, darling," she urged . . . "I ache for you."
> "Dear God, I can't fight you when you are like this," he groaned.

> "Why should you want to?" she rained fevered kisses along his jaw . . . Her lips travelled slowly down his chest, lingering on the hard nubs nestled among the dark hair, her tongue flicking across the taut flesh as Lucas gasped in reaction. (1985:124–5)

In Susan Napier's *Love in the Valley* (1984), the heroine initiates the final sex scene. In this book the hero thinks he is condemned to a life without love because he is afraid that he is like his father, who battered both his wife and son. The heroine, in the final scene, chases after him in order to convince him otherwise by taunting him into hitting her. He cannot do it, putting his fist through the wall behind her, instead. Freed of his fear, he is released into "impassioned lovemaking".

Susan Napier is one of the mid-1980s group of authors who never used violent sex in her novels, building on the earlier non-violent, though sexual, romances that were being published at the same time that sexually violent Mills & Boon romances were being issued. These non-violent Mills & Boon novels were written by such popular authors as Charlotte Lamb, Jane Donnelly, Carole Mortimer, Essie Summers, Betty Neels, Daphne Clair, Anne Weale and Anne Mather whose *An All-consuming Passion* (1986), has a hero who does not satisfy the heroine in their first sexual encounter because he ejaculates prematurely. This is significant when reading the underlying sexual rhythm of the books.

Boone points out that many male commentators on "love-plot" books evoke a "pattern of desire" that "follows a linear model of sexual excitation and final discharge most often associated, in both psychological and physiological terms, with men". Therefore, he argues, the narrative rhythm of all romances, because they follow the male pattern of sexual action, foster "the illusion that all pleasure (of reading or of sex) is ejaculatory" (1987:72).

But Mills & Boon novels follow a different "erotic dynamic", which is a female rhythm of small climaxes building to the final ecstatic orgasm. This is made explicit when the hero says to the heroine of Napier's *Love in the Valley* (1984) as he starts making love to her at the end of the book: " 'We got all the damned foreplay over with months ago' " (1984:184).

This rhythm is part of the sexual plot of the novels, a subtext that shows the transmutation of sex as rape/lust to sex as passion/

love, symbolic of the underlying ideology of nearly all Mills &
Boon novels – the fight by the heroine to make the hero see her as
an individual, not a sex object. That is, the sex scenes in a Mills &
Boon romance move from a description of lust, depicted as a way
in which men exert power over women, through desire, to love, at
which point the positions are reversed and it is the woman who
holds the power.

This is very apparent in Robyn Donald's *Captives of the Past*,
published in 1986. The heroine, Jennet, is divorced from a man who
physically abused her. She has learnt that her half-sister is now
engaged to him, and so she has returned to her stepbrother's home
in order to prevent the marriage. For various reasons her stepbrother,
Rafe, regards her with contempt and does not trust her, so Jennet
cannot bring herself to tell him the truth about her ex-husband.

From the beginning Rafe uses their sexual attraction for each
other to try and discover her real reasons for returning home.

> His mouth invaded hers in a kiss totally without subtlety or
> tenderness. He wanted her and he didn't care if he hurt
> her . . . She went rigid beneath him, her whole being suffused
> with outrage.
>
> Then, as if his ferocity had breached some hidden barrier, a
> great wave of heat surged through her body . . . Her lashes
> fluttered down as she was stricken by a kind of sensory over-
> load. The warm male scent of him, the rapid heating of his
> skin against hers made her groan. Circles of sparks danced
> behind her eyelids, and her mouth was filled with the taste of
> him, erotic, stimulating . . .
>
> "Why did you come back?" he asked against her throat.
>
> She froze, every process in her body suspended.
>
> . . . As her eyes stared blindly over his dark hair she realised
> with bleak comprehension that he had baited a trap for her,
> using the heated sexuality of their desire for each other to
> strip her bare of lies and evasions. (1986:82–3)

This scene combines a description of sex being used as a male
weapon against women, with the first foreplay scene, where both
participants are exploring their mutual sexual attraction, with nei-
ther of them willing to risk admitting their feelings. The descrip-
tion here uses the language and imagery of war ("invaded",

"ferocity", "sparks") to underscore the fact that this is a battle between male and female, with the male dominant. He is, in Snitow's (1984) words, "too hard" for the heroine to be able to respond fully.

In the second scene Jennet has nearly died in a truck that exploded, and Rafe admits to wanting her.

> "You are so beautiful," he whispered as if it hurt him to speak, "you make me ache just to think of you . . ."
>
> "I'm sick of fighting it. God knows, I've given sanity and pride and discrimination a fair trial and they've only brought me this craving that tears at me until I can't sleep, can't think of anything but the need to lose myself in you."
>
> The hot tumbled words fell out as though he could not repress them, each stark syllable thick with desire's ugly brother, lust, but as they died away his mouth was urgently searching the full curve of her breast and she stiffened in anticipation, her breath choking in her throat.
>
> When at last his lips reached their destination she groaned harshly, . . . She welcomed the smothering intensity of his kiss, straining to meet and match it, her body shaking with the kind of untramelled, uncontrolled passion only he knew how to arouse. (1986:106–7)

At which point they are interrupted and Jennet, afraid of the feelings Rafe arouses in her, and aware of his contempt for her, despite his desire, tells him that she is not going to have sex with him.

This is a "little climax", Snitow's "breathless anticipation", where both participants are jockeying for position, only able to go so far in revealing their feelings. The language of war has gone, but it is "lust" not "desire" that drives the hero, so the heroine retreats, aware she is in a powerless position.

However, a few pages later Jennet realizes she loves Rafe, and has done so since she was 16. This alters her response to him even though, in this scene when he feeds her fruit, he is still being manipulative:

> Slowly . . . Jennet's tongue curved on to his finger, working slowly around it so that the juice of the mandarin was removed.

Her lashes flickered. She could feel a familiar pressure in her throat, in her breasts, a familiar hunger in the pit of her stomach . . .

Only this man, she thought bemusedly. It had never been like this . . . not with anyone. There had never been this conviction of absolute rightness, of – fulfilment.

What was between them was love. Passion and hatred and suspicion – and love. She should have realised much sooner . . . And although Rafe would never admit it, he too must know, for that was why he had to hate her. She was dangerous, a threat to that splendid self-sufficiency of his . . .

He closed her eyes with kisses before his warm, demanding mouth moved to her temple. Almost soothed by the persuasive touch of his lips she leaned into him, a soft sight escaping through lips which stung with the need for his lovemaking . . .

His head lowered and his mouth took hers.

This time, freed from the fear of understanding her emotions, she allowed herself the freedom to respond fully . . .

His mouth . . . was gentle, but determined, seducingly sweet, summoning such intense excitement that she was overcome by it, she didn't know how to cope and she went under completely . . .

Like calling to like, she thought dazedly, holding on to his shoulders as if she was drowning . . .

"Is this how your ex-husband makes you feel?" he [asked] in a voice dead and devoid of emotion.

Slowly, like a woman in the grip of a nightmare, she awoke to her actions – and his. Held in that grip . . . able to feel every inch of his body and its wild response . . . she knew that he wanted her and that yet again he had rejected her. (1986:117–22)

This scene is more complex. The language, in relation to the sex act, has changed to one of persuasion, not force, ("gentle", "sweet", "warm") as the heroine acknowledges to herself that more is happening here than sex, but also realizing that the hero will always see her as "dangerous" because she is a "threat" to his "self-sufficiency". The language of battle, again, but this time on the emotional, not the sexual, level. The ground is beginning to shift

in the female's favour, making the conditions right for the larger climax. But the male is still refusing to acknowledge his emotions, is still standing out against the siege, alone.

Finally, Jennet's ex-husband is revealed for the violent man he is, and she explains her reasons for coming home. She goes to bed and, freed by the truth, dreams that she seduces Rafe.

> He said . . . "I love you."
>
> Of course he did. That was what dreams were for. To give you the momentary illusion of happiness.
>
> "Then kiss me properly," she begged.
>
> So he did and it was joy and ecstasy for this time there was no anger, no contempt, no driving need to conquer. His kiss was sweet. He coaxed her lips apart to taste the soft depths revealed to him yet she was not frightened or repelled, not even when he slid an arm across her back and pulled her close to him and she realised that, like her, he was naked, and, like her, he was very, very aroused . . .
>
> His mouth fastened on to her breast, closed over the erect nub, warm and moist and fantastically exciting. The gentle tugging made Jennet groan in anticipation and frustration, her body in flames, as her hand pulled at the smooth hardness of his shoulders, urging him silently to take her with the strength and power she had craved for so long.
>
> "Please," she pleaded, barely able to form the word because she was shivering with fever, forlorn, empty, racked by desire.
>
> "Yes, now!" he said triumphantly. Then at last she felt the weight of his body and knew the fierce rapture of his possession. She was overwhelmed by sensation yet it was fulfilment, soaring ecstasy which tore his name from her lips in an agony of supplication until her body convulsed beneath and about him and she went sobbing over the edge into darkness, his muffled groan echoing in her ears as his body trembled in ecstasy.
>
> For of course it wasn't a dream. And she had known . . . She had just seduced him and it had been like a foretaste of heaven. (1986:173–5)

This is the final climax, when the language of force has completely disappeared, and both protagonists are able to have orgasmic sex, *which is initiated by the heroine*. She is finally free to reveal her

feelings, and to demand what she wants in a sexual relationship, both symbolically represented as a "dream", which also enables the hero to "relent", declare his love and respond sexually in a manner that enables them both to share the "ecstasy" of mutual orgasmic sex.

In Mills & Boon romances sex is symbolic of male power and is used to describe the battle between the sexes for the heroine to be recognized by the hero as an individual. Once the heroine has "tamed" her hero's sexuality, it is love, where the female has power, that is important, not sex. As the ending of Jayne Bauling's *Rage to Possess* (1985) puts it: "Love had defeated bitterness and suspicion, bringing wisdom and trust in their place – love, the only victor" (1985:188).

Love and Marriage – *Harbour of desire*

In his analysis of what he describes as love-plot books Boone defines three types of storylines: courtship, where "lovers are sundered by various obstacles . . . all of which must be removed to facilitate a successful alliance"; seduction, where the "would-be lovers are revealed as sexual antagonists"; and wedlock, which focuses either on "the tribulations of the long-suffering wife caught in an adulterous triangle" or "on the impasse of the totally mismatched union" (1987:80, 100, 114).

Mills & Boon novels include all these plot types. However, the marriage plot differs slightly, in that if the heroine is married to the hero, although she suspects that he is being unfaithful to her, in fact he is not. There are two types of marriage plot in Mills & Boon romances – marriages of convenience and forced marriages, where the storyline revolves around two people coming together as strangers and gradually learning to live with each other in harmony and falling in love in the process. In books of the 1920s the forced marriages are a result of the hero's rape of the heroine; from the 1960s on, they occur because of the economic circumstances of the heroine (for example, Sara Craven's *A High Price to Pay* (1986)). These marriages are a battleground throughout the book, as the heroine, desperate to hang on to her autonomy, fights the hero at every turn until, at the end, he admits his love for her. " 'Something happened, and left me completely winded, like a callow youth in his first love affair . . . I realised that I loved you,' he said simply. '. . . I couldn't handle it. I didn't know what to do' " (Robyn Donald, *Bride at Whagatapu*, 1978:186–7).

The marriage of convenience plots depict a calmer relationship, as the couple marry in order to gain mutual benefits so that the tension only arises when the heroine realizes she loves the hero and reflects her anxiety over this in her awkward behaviour in his presence. For instance, in Margery Hilton's *Snow Bride* (1979) the hero needs a mother for his child and the heroine needs someone to run the family business after her father's incapacitating stroke. But the denouement is the same as the hero declares, " 'I love you so desperately that I dare not imagine my life without you' " (1979:187). The marriage of convenience is a favoured plot line of Betty Neels, who ends her books with the hero telling the heroine: " 'I've been in love with you since the day we met' " (*When May Follows*, 1981:183).

Frenier (1988) argues that in the 1950s "in a world in which women and men were not only socialized to be as different as possible from each other, but also have very different expectations of marriage" (1988:24), people's experience of marriage was the joining of two strangers. This, she argues, is the basic plot of current romances, as they all hark back to the 1950s' ideal of marriage.

The 1950s was the "golden decade" for marriage in Britain. Divorce was not prevalent and, as the longevity of the population increased, marriage lasted a long time. It was a time of high (male) employment and general economic prosperity. Also, the break-up of families through death, evacuation, separation and the loss of homes during the war, "inevitably engendered a conservative reaction in favour of family and home" in the post-war country (Pugh, 1992:264).

This "all embracing conservative consensus" (Segal, 1990:28) and the emphasis on the home as the centre of marriage is reflected in Mills & Boon romances, where nearly all the books are set amongst a middle class that, seemingly, never leaves its home.

Contrary to Frenier's argument, however, many Mills & Boon novels of the 1950s show marriage as the joining of two friends, not strangers. For instance, in Jane Arbor's 1948 *This Second Spring*, it is the husband who has become a stranger (which happened to many couples after the war) and his fellow officer (the hero) who becomes a friend to the heroine. During the war the protagonists of this novel had dreamt of "being real country people . . . and raising a family", but after the war the husband

announces that he intends to remain a serving soldier. The heroine is hurt that he has not discussed this decision with her: "And because she was a woman, it was her dreams which must be broken into a thousand pieces [because of] the man's determination to live his life as he wished" (1948:14).

It is the friend who seems to understand her feelings, and sympathizes with her when she discovers that her husband is going to serve abroad. It is also the friend, not her husband, who helps her adjust to a different way of life when she joins them in India. As the plot develops she tries to keep her marriage alive in the face of her husband's indifference to her feelings and his eventual adultery, and her own growing love for the husband's friend, who acts as her confidant. In the final pages, after an attempted reconciliation, the husband dies, leaving the heroine free to marry the man she loves and who loves her; a man she *knows*, who understands her and who is willing to form a marriage partnership in which the keynote is "sharing", in which both people make necessary compromises, not only the woman.

This emphasis on the heroine marrying a man she already knows, who therefore provides an element of security, must have been of psychological importance to many women during and after the upheavals and uncertainties of the war. It is used as a plot device in many of Margaret Malcolm's romances of this period, as in her *No 4 Victoria Terrace* (1944), where the hero and heroine are next-door neighbours.

Another plot device highlighting the importance of the heroine marrying a man she already knows also appears in books of this period which revolve around the problems faced by a widow with young children to support. The heroine of Barbara Stanton's *If Today Be Sweet* (1945) is such a woman, who has difficulty in finding a job which pays enough to finance a home for herself and her children. She becomes a housekeeper, and then forms a marriage of convenience with her boss, which leads to love. Again, the heroine is marrying and falling in love with a man she already knows.

This plot type, where the heroine's job as a housekeeper leads to a career as a wife, echoes the theme of "the housewife's home is her factory" which was "*part* of the broader theme of 'homemaking as a career' so popular after the war" (Wilson, 1980:21–2).

Given this ideology, it is not surprising that it is during the post-war period that housework starts to be shown as a skilled job.

As Niamh Baker (1989) comments of post-war feminist novels:

> Although confinement to the home was regarded critically, women writers did not neglect what is often dismissively referred to as "women's work". As women themselves with domestic commitments, they knew perfectly well that running a home requires a whole battery of skills which can in themselves provide occasion for celebration and achievement. Confined to the home, women can and do take pride in their ability to master these skills. (1989:159)

Echoing this sentiment, running the house is described in Susan Barrie's *The Gates of Dawn* (1954) as a job in which the woman is the boss:

> Melanie assured her she did not find it dull at all, and Eve sounded a little astonished. She would have found it very difficult to accept the fact that whereas with her Melanie had certainly seen many more faces, and enjoyed more actual variety in her daily life, she had always been a little out of the picture . . . She had never been more than an employee. But here . . . she was the next-best-thing to being her own mistress, with no instruction from anyone – not even Richard Trenchard . . . [It] made her feel that she was doing a really useful job. (1954:64)

Again the heroine, when she marries the man to whom she was housekeeper, is marrying a man she knows.

Mills & Boon novels never belittle domesticity, which remains important in these romances to this day. In Anne Weale's *Hope for Tomorrow* (1959), the heroine tells her aunt:

> "I love running the house. It's the only thing I can do at all well."
>
> "And a great deal more use than all this artistic nonsense," her aunt retorted, with feeling . . . "A man expects his wife to be more than an animated fashion plate, my dear." (1959:5–6)

In 1979 Anne Weale is still arguing for the acknowledgement of the skills needed to run a home well. In her *Separate Bedrooms* the heroine tells the other woman that:

"Fanny Rankin has seven children and a large house to run, and she's one of the most well-read and interesting women I've met since I came to England. She makes being a wife into an art, and by the time they're all grown up she'll have sent seven very civilised young people into the world. If that's not an achievement, I don't know what is." (1979:149)

This reflects Weale's own philosophy:

I think it would be nice to think that we have arrived at the stage where if a woman wanted to be a full-time wife she could without being denigrated by people. Because I do think that running a house, and a garden and children, and all these things, is an enormously complex job, far more skilful and complex than a lot of these rather mundane jobs. (interview, 1994)

Betty Neels who, in the 1990s, remains a popular author, still describes the daily domestic round of her heroines. In her novels, at least, she takes the view that " '[A man] wants a wife . . . someone who'll sit on the opposite side of the fireplace and knit while he reads the papers, listen when he wants to talk, and love his children' " (*A Gentle Awakening*, 1988:35). This separate sphere ideology, however, is undercut later in the book when, during a domestic crisis, the hero, an eminent consultant, takes over some of the domestic chores – vacuuming, scraping potatoes at the kitchen sink and making the tea.

Neels' romances are based on the marriage of convenience plot. However, many Mills & Boon novels do not involve marriage plots but courtship plots, in which the protagonists get to know each other before marriage. As with the earlier housekeeper plots, this is often brought about through circumstances which force them to share a home, as happens in Anne Mather's *Living With Adam* (1972), where the heroine goes to live platonically with her older stepbrother in order to escape from the confines of her family. In Leigh Michaels' later *Come Next Summer* (1985) the hero and heroine decide to share an apartment as they have left it too near to term-time to be able to find separate accommodation in a university town. In a more domestic version, in Sara Craven's *A Nanny for Christmas* (1997) the heroine is employed as a nanny

to the hero's daughter. These novels chart the progress of the protagonists' journey to love and marriage.

In a more recent version of this, however, some novels open with the hero and heroine already lovers, and the plot follows their journey towards marriage, as in Amanda Carpenter's *Rage* (1984) and Michelle Reid's *Slave to Love* (1995).

In these courtship romances the obstacle to the protagonists' eventual union, referred to by Boone (1987), is often the existence of another man or woman. But in some Mills & Boon novels it is the mother of either the hero or the heroine who is the impediment. In the post-Second World War period, where couples were often forced to live with in-laws due to the housing shortage, the novels reflect the problem of living with parents by depicting marriage as a fight between the heroine and her mother-in-law for the control of the hero and the children. In *Katherine* by Jean S. MacLeod (1950) the heroine is so unhappy because of her mother-in-law's bullying that she eventually runs away. It is only then that the hero gradually begins to realize that his mother has never liked his wife, and he starts to build a home for the heroine, himself and their child, thus choosing her over his parents. Again, in Roberta Leigh's *Beloved Ballerina* (1953), the hero's mother, about whom he is "blind and obstinately loyal" (1953:191) constantly interferes in their marriage, forcing a separation between them. They only become reconciled once he gives up his obsession with his mother.

In the books in which it is the heroine's mother who is an impediment to a happy marriage, much is made of the emotional ties the heroine has to her older parents. With the arrival of the hero, the plot becomes a tug-of-war between her duty to her parents and her duty to herself. These heroines are trapped by their acceptance of the belief that daughters should look after elderly parents, if necessary sacrificing their own lives to them. Mills & Boon novels do not agree with this philosophy, arguing, in contrast that women's caring role should be primarily in relation to a husband and children. As the hero of Margaret Malcolm's *One Stopped at Home* (1941) puts it, " 'If the three of us were always together, it would be impossible for you to be shared by two very possessive people so that both are satisfied' " (1941:221).

This theme of a tug-of-war between mother and hero over the heroine still occurs in current Mills & Boon novels, but, with the

rise of sexual liberation, it is the seduction plot that becomes most prevalent from the 1970s on. In these romances the hero and heroine fight each other to a standstill, with the heroine resisting the hero's sexual advances until he admits he loves her.

Cranny-Francis (1990) referring to these later novels with their socially and economically powerful heroes argues that romances' fundamental preoccupation is with money and status, which they displace on to fetishized gender relations. This argument, however, fails to take into account that all Mills & Boon novels deliberately deny that good marriages are founded on an economic basis. This is made clear in the romances of the 1970s and 1980s by the fact that it is the other woman who wants to marry the hero for money and/or status. The heroine does not. But wants to marry him for himself. As one of Betty Neels' heroines explains to her hero:

> "You don't think that I am marrying you for your money, Rijk? . . . Because I'm not. Money's nice to have, isn't it? But it isn't as important as other things. If – if I say I'll marry you it wouldn't make any difference to – me if you were on the dole." (*The Awakening Heart*, 1993:103)

This need for the heroine to let the hero know that she wants to marry him for himself not money is the reverse side of her need for him to recognize her as an autonomous being. "Each discovers the other's uniqueness," as Batsleer (1985:103) puts it. This is the only possible reading of those early novels where both the hero and the heroine are from a struggling middle-class background. For instance, in Sophie Cole's *Money Isn't Everything* (1923) the protagonists can only afford to get married when the hero wins the Calcutta Sweepstakes. But their marriage is unhappy, as the heroine has nothing to do, and she leaves him. It is only after he has lost the money in a failed business venture that they find happiness together.

In the novels of the 1940s and 1950s either the heroine turns down the wealthy man for the boy-next-door, or she is the one with the wealth, as happens again in the 1980s. In fact, the wealth of the hero only becomes a factor from the late 1960s on in these books, reflecting society's own concerns with fame and fortune. It is not the power of male wealth that Mills & Boon novels

emphasize, but the power of female love. This has two conse-
quences: the disparagement of homosexuality, and the books' stance
on divorce.

Homosexuality is rarely mentioned in the early novels, although
there is an interesting plot line in Sophie Cole's 1910 *Blue-grey
Magic*, where the heroine thinks she is corresponding with a male
doctor, whom she loves, but is in fact writing to a woman. When
the anonymous penfriend, who has, through her letters, been edu-
cating the heroine in art, music and literature, finally reveals her-
self, the heroine is horrified:

> Hester paled, and with a quick, shrinking movement turned
> her head. Trouble, vague, yet significant in a way she dared
> not try to fathom, had seized her. If only the Doctor would
> appear and put an end to the little scene which had, all at
> once, developed something of the terror of a nightmare! . . .
>
> Hester looked at the self-possessed figure seated beside her,
> at the masculine ease of attitude coupled with the feminine
> perfection of detail in dress . . .
>
> "Oh, why did you mislead me by writing me love letters?"
> she wailed.
>
> "Because I took you for something better than the average
> coarse-minded girl who has no conception of any love but
> that which ends in marriage." (1910:180–2)

Seventy years later it is male homosexuality to which the heroine
reacts with horror. In Emma Darcy's *Fantasy* (1985) the heroine
has just discovered her fiancé in bed with another man, and run
away in her car to the beach: "Every thought brought a bitter
sickness. As another shudder of revulsion cramped her stomach,
she thrust the door open and almost fell out of the car (1985:5)."
The hero rescues her from drowning, and she tells him that her
fiancé: "Doesn't want a woman. Not a real woman" (1985:16).
He starts to make love to her, reassuring her that: "You are very
much a woman, a beautiful, desirable, totally feminine woman"
(1985:19).

Other authors take a different slant, although still a homophobic
one. In many of Sally Wentworth's romances the heroine flings the
accusation of homosexuality at the hero. This is meant as, and he
takes it to be, an insult, the truth of which he disproves by for-

cibly kissing her. Mary Wibberley, in *Gold To Remember*, has a heroine who is dressed as a boy at the beginning of the book. When the hero eventually discovers her true gender, he is relieved, explaining that:

> "I knew there was something wrong, but I never guessed what it was. I thought you were effeminate, heaven help me – I wondered what I had got myself into . . . I thought that – I – was –" He seemed to be having difficulty finding the right words. "I was beginning to think there was something wrong with *me*." (1981:52, original emphasis)

Other authors are more sympathetic to homosexuality. In Vanessa James' *The Object of the Game* (1985) the other man is in love with the hero. When he realizes this at the denouement of the novel, the hero says to the heroine:

> "I shouldn't have said those things, and I shouldn't have hit him. But I hadn't realised. It was stupid of me – I should have known . . ."
>
> "I wish I hadn't done that. It was cruel and uncharitable and I should have known better . . ." (1985:182–3)

Homosexuality, however, is a side issue in Mills & Boon novels, because even though a homosexual relationship would fit with their belief that love should be the mainspring of human action, it would not fit with the books' ideology that men have to be socialized through a love relationship into the female sphere.

Divorce, however, is a prevalent issue in many decades. Despite, or perhaps because of, a total adherence and commitment to the ideology that love should be present in all marriages, Mills & Boon novels are strongly pro-divorce. They have always argued, along with some feminists and often against prevailing ideology, for no-fault divorce. From 1912, with Laura Troubridge's *Stormlight* (see Chapter Three) through to the present day, Mills & Boon authors have been on the cutting-edge of divorce reform. They express their views in two ways – through the plot and through voicing the protagonists' ideas:

> "Divorce isn't so very awful. It's better, anyway, than staying on with a man you've married whom you despise, merely

because he can provide you with clothes and food which other-
wise you'd have to work for. That's my idea of prostitution."
(Elizabeth Carfrae, *Troubled Waters*, 1925:40)

One plot-type prevalent in the 1920s and 1930s is that of the
heroine refusing to marry the hero because of the social stigma of
her position as the child of divorced parents. These books always
end with their marriage, and their acceptance by his family, thus
arguing against society's view of divorce.

In making their pro-divorce arguments, though, some authors go
to extremes. For instance, in the plot of Elizabeth Carfrae's *Guarded
Heights* (1929) the heroine is married to an Anglican priest who is
rabidly anti-divorce. When he realizes that his wife is in love with
another man, and is bitterly unhappy at the situation she finds
herself in, he commits suicide in order to set her free, rather than
divorce her.

After the 1930s divorce as a theme in Mills & Boon novels
virtually disappeared until the 1960s, when once again there was
agitation in society for divorce reform, which was achieved with
the 1969 Act. By this time, divorce was no longer a social stigma,
although Mills & Boon authors of the 1960s are reluctant to show
a heroine committing sexual adultery, unlike the authors of earlier
decades. This continues into the 1980s with, for instance, Char-
lotte Lamb's *A Frozen Fire* (1980), where the heroine refuses the
sexual advances of the hero, although they both admit their love
for each other, because she is married, albeit to a blatantly un-
faithful husband.

As always, there are exceptions. In 1982 Carole Mortimer's
Forgotten Lover has a hero who has an affair with the heroine
after his separation from his wife but before his divorce is abso-
lute. This, however, takes place before the opening of the book,
and it is more common for the plot to depict a heroine refusing
sex because she believes the hero is married; a charge which he
vehemently denies, with the significant words: "Do you think I'm
that sort of man?"

Mills & Boon claim Nan Asquith's 1967 *The Garden of Per-
sephone* as an adultery novel. But the heroine is a widow and the
Greek hero is only engaged, not married to, the other woman, for
dynastic reasons. The plot is developed in such a way that all three

protagonists find love – the hero and heroine with each other, and the other woman with another man.

However, the married heroine of Daphne Clair's *Marriage Under Fire* (1983) does have a one-night stand with a co-worker. In fact, in this novel, the heroine's adultery brings the husband and wife back together again because he realizes how much he has been neglecting her.

In a much earlier version of this rare plot type, Elizabeth Carfrae's *The Trivial Rounds* (1930), the wife-heroine leaves her hero-husband and embarks on a series of one-night stands because she finds she cannot combine her career as a novelist with marriage because " '(Love) monopolizes you so that you can't think alone or be alone any more' " (1929:219). Marriage, she finds, strips her of all autonomy. She wants the freedom to live and work as she pleases. She only returns to her husband when she is able to find the balance between loving someone else and working for herself. She originally sees marriage as a trap that does not allow her to be herself, as do the heroines of Elizabeth Oldfield's *Take It or Leave It* (1984) and Dana James' *Heart of Glass* (1987). " 'I'm ambitious. I want to have a successful career, and not just live life through my husband,' " (1987:144) says the heroine of *Take It or Leave It*, as an explanation of why she has refused the hero's marriage proposal.

In other books, where the heroine may not work, it is accepted that she needs her own interests. In Penny Jordan's *The Inward Storm* (1984) Kate, the heroine, reflecting on her marriage, remembers how problems surfaced when the hero, who then worked at "Greenham airbase, using his knowledge to perfect [nuclear] missiles" (1987:11), found her studying anti-nuclear literature:

His anger had chilled her, as had his insistence that she throw the stuff away. It was almost as though he wouldn't allow her to have any views that weren't his; as though she were a mechanical doll designed purely for his pleasure and nothing else. (1987:12)

Rebelling against this dictatorship she joins the Peace Movement and the hero leaves her. In the reconciliation scene, he admits to her that he has come to realize that during their marriage: " 'I

wasn't letting you grow up to be an individual. I got so mad when you kept on rejecting me. I couldn't see that I wasn't allowing you to think for yourself'" (1987:184). In fact, he changes his job to accommodate her and save their marriage, in contrast to, for instance, the adulterous heroine of Daphne Claire's *Marriage Under Fire* (1983) who refuses to choose between her marriage and her job and insists on having both.

Thurston argues that the historical romances of the 1970s changed the contemporary 1980s romances' view of love from: "a simple case of love overcoming all problems and obstacles, as John Cawelti (1976:41) described the moral fantasy of romance" to: "a specific kind of love, one that frees respect and the right of self-determination from gender" (1987:86).

But, as is apparent in the storyline of those novels where the heroine resists marriage, outlined above, this has always been the case in Mills & Boon romances to a greater or lesser degree. It is only when these heroines have found the ability to combine marriage and work – not to lose themselves in the hero's needs but to assert their own – that they accept the role of wife, which, of course, they have now changed to suit their needs.

This reflects the description of feminism by Dora Russell: "It means men meeting our standards of nurturing. It does not mean that we [women] should deny our nurturing, our strengths as mothers, to meet theirs!" (quoted Spender, 1983:94).

Other heroines do not fight against marriage *per se*, but they do change its parameters to suit them. In Daphne Clair's *A Ruling Passion* (1984), for instance, the hero and heroine marry but do not live together year round, as neither can fit in for long with the other's lifestyle. So they spend weekends together, and occasionally longer periods of time either in the city (where he lives) or in the country (where she lives). Something similar happens in Rosemary Hammond's *All My Tomorrows* (1986), where the doctor-heroine and the journalist-hero agree that they will both continue with their respective careers, even though this means that he, as a war correspondent, will often be away from her and they will lead separate lives a lot of the time. In other books, for instance Emma Darcy's *The Positive Approach* (1987), the husband works from home and the heroine leaves the children in his care as she pursues her career in the workplace.

166

This, of course, is an example of the reversal of roles that Jones (1986) argues takes place in all Mills & Boon novels in their depiction of the power structure within marriage, even those where the hero is much older than the heroine. Such reversal is particularly evident in the guardian-ward plots which appear in the novels from the 1930s on. This incestuous theme, with the child-woman gaining power over the father-man, is reversed in a few of the novels of the 1980s, where the Oedipal story is reworked from the woman's point of view. The plots of these romances revolve around mother–son relationships, as in Lindsay Armstrong's *Surrender, My Heart* (1986), where the heroine falls in love with her stepson after his father's death. She "had been a loving and faithful wife" (blurb), but after experiencing sex with the hero, she realizes how much had been missing from her marriage. Thus, in Mills & Boon's version of the myth, the emphasis is on the heroine's readiness to move from the father's protection to a more equal relationship with the hero, not on the son's appropriation of the husband's dominion.

At the same time this plot-type reveals a difference between the law which forbids marriage between step-relations, and romance ideology, which endorses it. For in romance fiction it is the female law of love that is paramount over *man*-made laws.

In Mills & Boon ideology love is the *raison d'être* of life. It does not necessarily sweep all before it; it can be a warm breeze, rather than a hurricane, but without it one is only existing, not living. Referring to his love for the heroine the hero of Jane Donnelly's *The Man Outside* tells her: " 'I have to take care of the breath in my body' " (1974:186). As this quote implies, heterosexual love, in these books, is often described using language evocative of the Christian ideology of divine love. This mingling of religious and secular love has always been present in romance literature, especially in the turn-of-the-century novels of Florence Barclay, Elinor Glyn, Ethel M. Dell and Marie Corelli. In these novels, however, the religious theme is explicit: "The trail of the heroine's religious doubts runs a parallel course to her difficulties and sufferings of mortal love," as Anderson (1974:143) puts it. Some of the early Mills & Boon novels do have an explicit religious element. When the heroine of Laura Troubridge's *Body and Soul* (1911) falls out of love with her hero-husband she turns to religion as one of the

philosophies that might help her. Sophie Cole uses both religion and the supernatural in her early books as part of the plot – the first love of the heroine of her *A Plain Woman's Portrait* (1912) is a Baptist minister; Isobel in *A Wardour Street Idyll* (1910) sees the ghost of the previous owner of the antique shop she works in – but by the end of the First World War both Cole and other authors have dropped explicit references to religion. Love, however, is still described in terms of religious salvation. In Louise Gerard's *The Fruit of Eden* (1927) after the hero has raped the heroine, she thinks, "He had now fallen so low that *even love* could not pick him out of the mire and cleanse him" (1927:115, my emphasis).

In Elizabeth Carfrae's *Barbed Wire* (1925) the hero stands trial for murder. He refuses to tell the authorities that he was stranded in a car with the heroine during the night that the murder took place, as this would ruin her reputation. Returning from abroad, she goes to court to give evidence on his behalf. After his acquittal, he proposes, and they leave the court "together through the sunlight into the Promised Land, which was theirs at last" (1925:318). This religious elements is still evident in some contemporary Mills & Boon books such as in the final words of Carole Mortimer's *Saving Grace* (1992) (a pun on the heroines name) when the hero, calls her "His saving Grace" (1992:186).

Other critics have seen the expression of love in Mills & Boon books in different terms. Batsleer argues that

> Love operates as a code-word for sex, and sexual attraction is conversely a sign that love is present. The major characteristic of this sex-love is that it overpowers man and woman alike. It has the intransitive, irresistible character of a natural force, heat or electricity. It lights fires. (1985:101)

This, however, is only the case in the Mills & Boon novels of the latter half of the century for, as Jackson (1995) points out, love is a social construct and culturally and temporally specific. So, although through the decades some elements are constants in Mills & Boon books' ideology of love, the *depiction* of love changes according to the period when it is written. In Sophie Cole's 1940 *The Valiant Spinster*, for instance, the heroine is married to a disabled man she cannot leave. In other Mills & Boon novels of

this or other periods the plot would have resolved this by his death. Cole, whose view of love is "good comradeship, companionship in the work of life as well as in its play" (*Bill and Patricia*, 1933:242), ends the book with a platonic triangle. The heroine remains married and the hero the faithful friend of both of them. The final words are: "No incident which happened to the one or the other was too small to be of mutual interest, and the things they didn't say were things which speech couldn't voice" (1933:252).

This non-marital ending is rare in Mills & Boon books, although some later novels do have a type of open ending, with no promise of marriage. In Charlotte Lamb's *Man's World* (1980) the heroine's antipathy towards men is the result of her previous marriage to a brutal man. The hero understands her fear of marriage, and when he proposes says:

"I want a commitment . . . But I realise you're still wary. Marriage may be out of the question for the moment, but I want you to keep it in mind. I won't rush you, I promise. I'll give you every chance to find out what sort of man you'd be getting." (1980:186)

Other authors have similar open endings. When discussing her own books, which generally feature aggressively brutal heroes and spirited heroines, Kay Thorpe has said: "In real life I'd give their marriage two months" (private communication). At least one of her books ends abruptly, on the wedding night, after a warring relationship between hero and heroine where the hero has refused to believe the heroine's protestations of innocence and her virginity. The book ends with the words:

He either found proof or he didn't. That was with the gods, too . . . Jaime gave herself willingly into his hands – that big, domineering, brute of a husband she would love all the days of her life. (*Bitter Alliance*, 1978:186–7)

In fact, the ending was so abrupt, finishing coincidentally at the end of a page, that readers wrote in saying they were missing the final pages. Too open an ending obviously does not work for Mills & Boon readers, who need an offer of hope for the future. This hope comes from the protestation of love for the heroine from the hero, followed by his abject apology for not believing her. A book

with a similar plot, where the hero has not believed the heroine's protestations of virginity, Carole Mortimer's *Love's Duel* (1982), also ends on the wedding night of the couple, after they have made love for the first time:

> She woke to find the dawn just breaking over the rooftops of Paris . . .
> She sat up, searching the gloom for him . . .
> "Giles!" she cried her concern.
> He looked down at her, the tears still wet on his cheeks. "I didn't know," he choked.
> "It doesn't matter," Leonie soothed him . . .
> "Now, are you going to come back to bed with me?"
> "Tonight and every other night." His words were in the form of a vow. (1982:187–8)

This "inward grovelling" of the hero, as Modleski (1982) puts it, is the romance's literary device to show men changing to "fit" women, both emotionally and sexually. Mills & Boon plots make the same demand for a transformation in men that feminism makes. This demand is indicated by the type of marriage which Mills & Boon novels advocate. In these books, marriage is for life, but *only* if the husband accepts his integration into the female world that is symbolized by the act of marriage in this literary genre. In Mills & Boon romances it is the man who has to work at the marriage, not the woman. As the hero of Amanda Carpenter's *Caprice* (1986) tells the heroine when she is worried about whether they can sustain a marriage: " 'I'm not so careless as to let my affection and love for you fade' "(1986:187).

As Miller says of Jane Austen's romances, "The good marriage . . . must start with a man's concessions, his acknowledgement of his own dependence and brotherly admission of equality" (1986:81). It is this equality for which the heroine fights, not just by making her hero see her as an autonomous human being in the public sphere, but also by bringing him into the private sphere through encouraging him to express his emotions. Most Mills & Boon books promote the feminist argument that the majority of men are unable to articulate their feelings to any great degree, and have difficulty caring for others. As Valverde puts it:

... in heterosexual relationships the emotional depth is often limited by men's tendency to steer clear of "heavy" emotions, and by the woman's knowledge that men will seldom be able to take good care of an emotionally vulnerable partner. (1987:90)

Mills & Boon romances are about making the hero "emotional", breaking down his barriers and bringing him into the female world of love.

There are three types of love that Mills & Boon plots recognize: the *coup de foudre*, which includes passionate desire; loving friendship, which is built up gradually as protagonists get to know each other; and an immediate bond with the other half of one's self, which goes beyond the physical.

Treacher argues that, "Within this genre love is represented as a powerful and consuming force which stands over and above the lovers, a power in the face of which they have no control and even less responsibility" (1988:77–8). This type of love, expressed in the phrase "a clap of thunder and a lightning flash", first used in Flaubert's *Madame Bovary* in 1857 (Belsey, 1994:27), is historically specific, however. With the increased sexuality of the books from the late 1960s on, the concept of *coup de foudre* was useful in expressing the suddenness of sexual attraction, and was a phrase often used by Mills & Boon authors in the 1970s. It is no longer used today, even though love and sexual passion are still portrayed as inextricably linked. Nor was it used in the 1920s, even though this was also a period of more explicit sexuality in the books.

In direct opposition to this portrayal of love as a sexual force that overwhelms the protagonists is Sophie Cole's portrayal of love as friendship (see above), a depiction to which many other authors have also subscribed. It is implicit in many Mills & Boon romances that the protagonists fall in love with the other half of themselves, occasionally explicitly expressed as the instant recognition of each other as soul mates:

"I knew who you were, Ruth, the first moment I saw you . . . It was like recognising someone you had only seen in paintings, or photographs; someone you always hoped existed, but

171

never really believed in. That was what it was like, seeing you
for the first time. And I knew you were that person, before
you spoke a single word . . . I knew in that instant that for the
rest of my life, you would be a part of me."

She nodded . . . because she felt the same way (Melinda Cross,
What's Right, 1986:59).

All of these aspects of love, of course, have elements of one
another within them, but individual authors tend to emphasize
one element more than the other. To some extent this depends
on the decade in which they are writing, but not entirely. Sophie
Cole was writing at the same time as Louise Gerard and Eliza-
beth Carfrae, who portray love in a more sexually-based way than
Cole. And beginning in the 1960s, when sexual attraction began
to be depicted as the initial magnetism drawing the protagonists
together, there are authors, such as Mary Burchell, who do not
follow the trend. This is still the case, with some authors down-
playing its importance, and concentrating on other aspects of love.
Examples include Jane Donnelly, who sees love as the recognition
of one's other half; Betty Neels, who emphasizes the growth of
love over time and Leigh Michaels, who stresses the friendship
aspect of love.

However, the main trend from the 1970s onwards was to depict
sexual passion as being of major importance. With this came the
aggressive hero. This is the period when "male brutality comes to
be seen as a manifestation, not of contempt, but of love" as
Modleski (1982) argues. But as Jackson says, "the concept of love
. . . in its passionate romantic form is . . . often characterised as
violent, even ruthless" (1995:54). That is to say that, in some
instances, where there is desire, hate and love are two sides of the
same coin.

It has to be pointed out that the heroine does not respond to
this male coercion, except against her will, until she sees the hero
as a person who is isolated and alone, or until he admits his love
for her:

Just once she looked at Nicholas, and instantly her pleasure
died to be replaced by a deep aching pain . . . there was such a
look of aloneness in his eyes that she ached to reach out and

touch him, to take the bleakness from his eyes and replace it with warmth . . . with love.

In that instant, blindingly, totally she knew, and her whole world seemed to turn slowly over, leaving her heart incapable of beating . . . She loved him. (Frances Roding, *Open to Influence*, 1987:115)

In Sally Wentworth's *Shattered Dreams* (1979), the hero tries to get the truth from the heroine about her relationship with another man through threats and force. She refuses to tell him, until he admits that he loves her and begs for another chance. She then tells him she loves him and that the other man is her half-brother. "He had got the surrender he'd wanted with such anger and bitterness. But there was no anger in him now, only passion and tenderness and an immeasurable joy" (1979:183–4).

Valverde has written: "The reader knows . . . that the hero will in the end marry his subordinate . . . he is exonerated from any accusation of exploitation. Marriage . . . justifies all means used to achieve it" (1985:85). But this view misses part of the meaning behind male exploitation in Mills & Boon books.

It is not marriage that justifies all means; it is love that is the justification for striving to achieve marriage. Further than this, the contempt the hero shows for the heroine can be seen as a reflection of Germaine Greer's statement that "women have very little idea of how much men hate them" (1970:249).

On the contrary, Mills & Boon authors show that women do understand and experience the violence of this hatred. They also show heroines counteracting this with the only weapon at their disposal – love. Through love, men and women become equal:

Whatever the years might hold for them, this would remain, a love which does not always come to husband and wife but which when it does makes them so truly one that there can be no question of inequality between them. (Phyllis Matthewman, *Utility Wedding*, 1946:190)

However, in most decades, the books also acknowledge that sexual attraction is not sufficient; mutual interests are also needed to keep a marriage viable after the decline of ecstatic passion.

From the 1930s:

> [They had] many tastes in common; the strong, sure ropes that bind when passion's mad flames start to die down. (Louise Gerard, *Secret Love*, 1932:143)

Through the 1940s:

> Piers and she had not yet found common ground on which they could safely build their future. Until they had they were not safe. (Margaret Malcolm, *The Master of Normanhurst*, 1944:140)

To the 1970s:

> When they were alone Annabel said anxiously, "Can I make him happy, Contessa?"
> ... "You love him for himself ... [And] I believe your mutual interest in Persian rugs will be a strong bond between you." (Anne Weale, *Now or Never*, 1978:182–3)

Whatever type of love is depicted, it is transforming:

> He was just the same, of course, and yet now, everything about him seemed changed. His eyes were kinder, his mouth more tender than she had remembered before. (Sara Seale, *Beggars May Sing*, 1932:194)

> She took his hand in both of hers, holding it to her cheek. It was the same hand she had known for a long time, but now it could be explored, viewed with new eyes ... (Jacqueline Gilbert, *Country Cousins*, 1979:186)

And love is always "defined as part of the feminine sphere" (Jackson, 1995:52):

> Her love for Hilary had somehow changed its texture. No, not changed, but been added to. It was still the fierce, consuming flame that would not be denied, but as well it held something of pity and tenderness. That a man so clever as Hilary could yet be so blind! He really believed that, for him, love simply did not matter! But ... no human being could claim that. And, surely, it was for *her* to teach Hilary so. (Margaret Malcolm, *That Eagle's Fate*, 1949:113, my emphasis)

By associating love with the heroine's world, not the hero's, Jones' argument that, "The turning point of the novel is often a moment of collapse through which power relations are reversed" (1986:200) is emphasized. In reversing the power relations of the hero and heroine at this point, the ending of the novel shows the heroine gaining power.

This female power is symbolized in Mills & Boon novels by the word "home". Home, in these books, is not a place, a building of four walls, nor is it a "comfortable concentration camp" (Freidan, 1963:266). It is a state of mind, a feeling: "Brian lingered, and his eyes fixed on Clem were the eyes of the exile who satisfies his hunger for home . . . 'Summer is come, dearest of women'" (Sophie Cole, *The Valiant Spinster*, 1940:248). And it is safety: "Through shoals of misunderstanding, over the bar of birth and class, and safely anchored in his harbour of desire – her love" (Louise Gerard, *The Harbour of Desire*, 1927:189). It is also trust, upon which much emphasis is put in Mills & Boon romances. Once the heroine realizes she trusts the hero with her life, she begins to accept that she loves him. Home also symbolizes part of that "complex knot of feelings, ideas and activities which have structured a sense of the feminine self" (Light, 1991:219).

Mills & Boon novels use "home" – that ultimate female space – to express not only a physical place, but an ideology that encompasses a re-ordering of society, with women at its centre. It is an ideal to be attained by both sexes, a symbol of society, of female civilization. Smith argues that home "has always meant a lot to people who are ostracized as racial outsiders in the public sphere. It is above all a place to be ourselves" (1983:li).

Mills & Boon authors, replacing "race" with "gender", take this concept of home and make it central to their ideology of love as an "ongoing process of attachment that creates and sustains the human community," as Gilligan (1982:156) describes it.

Belsey (1994) objects to the ending of *Conditional Surrender*, a 1991 Harlequin romance by Wendy Prentice, where the heroine leaves her husband when he wants his former mistress to take responsibility for the interior design of their new house. The heroine goes to live in a bungalow in Wales. Belsey says, with unconcealed scorn, that she lives there:

for the space of five months, "contemplating their relation-ship" ... However, when Greg decorates their home himself, in accordance with the designs she had abandoned in despair, Kate knows that he truly loves her after all. (1994:31)

Belsey comments, "The establishment of the nuclear family in a newly-decorated house seems oddly quotidian as the outcome of a passion which sears, obsesses, torments and finally transforms" (1994:31).

But this does not take into account the symbolic resonance of the ideal of home in these novels. Home is not a prison that keeps you separated from other people; on the contrary it is the place where you are truly connected with others, a connection that is essential to human life.

Boone, quoting Evelyn Hinz, points out that: " 'the thematic function of marriage in [all] wedlock plots is the same: it symbol-izes the entrance into society of the individual ... the movement ... to a *novelistic* sense of reality' " (1987:76). In Mills & Boon novels marriage does not just symbolize the entrance of the individual into society; it symbolizes the entrance of the hero into a female world – which is embodied in the concept of "home".

As Margaret Malcolm's second heroine in *Listen to Me!* (1949) says:

> "I'd like a home of my own. Something not too big and not too perfect, so that it was a home and not something out of an ideal home exhibition ... And above all ... I'd like to feel that I was making a home for – someone else – and that it all depended on me. That's really all that a woman does want, you know – just the whole world!" (1949:158)

In the much later *No Place Like Home* (1988), by Leigh Michaels, the hero and heroine spend most of the book looking for the perfect house for the heroine and her financé. Unknown to the heroine the hero buys the totally impractical house she likes, be-cause, " 'You see, I couldn't think of a better way to show you that I was deadly serious about you' ". She replies: " 'Any house would have done, Brendan. Home isn't a place –' " and, she ends the book in his arms, exclaiming " 'Hi, honey ... I'm home' " (1988:186–7).

The underlying philosophy of the novels of Mills & Boon is that love is omnipotent – it is the point of life. It is the solution to all problems, and it is peculiarly feminine. Men have to be taught how to love; women are born with the innate ability to love. Thus love, power and femaleness are inextricably linked in Mills & Boon novels. Every novel is pervaded by female power because the base plot is the triumph of female love over male lust.

The hero of Jayne Bauling's *A Dangerous Passion* (1987) eventually tells his heroine that he will give up mountaineering for her. She accuses him of doing it out of pity:

> "It's not pity, Renata, it's . . . the way I love you . . . I've known, since before I went to Everest, that all I had to do was stop climbing . . . but – forgive me, I had this insane, arrogant idea that I'd be diminishing myself in some way if I did, that I'd be less than a man and lose my self-respect because *it would give you too much power over me* . . . it seemed shameful to give up something I like doing for a woman . . . In fact, it was shameful to continue climbing, and stupid, selfish and self-destructive. I've harmed myself probably as much as I have you, Renata, by fighting so long, resisting the obvious . . . It's not pity, it's love . . . the most important thing in the world – the only important thing in the world." (1987:181, my emphasis)

In these novels, love exemplifies female power, and marriage becomes the act which recognizes and consolidates that power. All of which is symbolized by the word "home" – a place of caring, of emotional connectivity, of safety, of peace.

Arguing that "oppression is also in personal relationships", feminism demands a change in the ideological structures of society, which are encoded in law and enacted by the institutions of patriarchy and which keep women in a subordinate position. Feminists believe this is not an individual problem, but a social problem, as do Mills & Boon authors, contrary to first appearances. For while appearing to depict the problem at an individual level, they are also arguing for a change in the way society is organized. The very fact that so many books by so many different authors, writing at different times, have dealt repeatedly with the same problems that have faced women indicates that there was a demand (conscious or unconscious) for a change in society. The typical criticism of

Mills & Boon romances that they represent merely a solution based on fantasy to the heroine's problems does not hold true when they are examined as an entire body of work.

By taking the place traditionaly associated with female subordination and imprisonment – the home – and challenging and reversing accepted views Mills & Boon novels empower the female sphere, politicizing it as feminism has politicized the position of women in society.

Chapter Ten

Feminism – *I'm not a feminist, but . . .*

The anonymous reader of my original proposal for this book finished her report with the question, "Does this mean we have to re-evaluate feminism?" This chapter tries to answer that question with reference to Mills & Boon novels.

Quoting Charlotte Lamb, a popular Mills & Boon author I asked readers, editors and authors on my questionnaire: "Do you agree with the statement that Mills & Boon novels are by, for and about women?" I also asked, "Does this therefore make them feminist?" – as Lamb argues. Most answered "yes" to the first question and "no" to the second.

This objection to defining Mills & Boon novels as feminist just because they are written by women supports the feminist argument that we need to know both the financial and ideological politics of the firm publishing the book, and about the audience that firm may be creating for its books through various marketing strategies, before we can place a book in the genre marked "feminist". On these grounds, Mills & Boon novels have no necessary relationship to feminism.

The firm itself is now owned by the Canadian company Torstar, which is a capitalist organization. Its financial and political ideology follows from that – and can be simply defined as profit-making. In the days when Alan Boon was at the head and made all editorial decisions, Mills & Boon was a fairly paternalistic firm. Both Mr John and Mr Alan, as they were known to members of staff, kept bottles of wine in their offices to be shared with the staff in the event of any celebration that might unexpectedly arise; they would lend authors money in advance of royalties if they needed it and

took them out to long lunches at the Ritz or other well-known restaurants. In her autobiography Essie Summers, a New Zealand author, describes how well Alan Boon looked after her and her husband during the year they spent in England:

> Then we had what Alan Boon called a "top-level conference" because he took Bill and me to lunch in the restaurant at the top of the Post Office Tower . . .
> I learned a terrific lot from Alan re techniques, certain snags to avoid, reader reaction to particular situations, and we discussed books I would be writing in the future. (1974:150)

Alan Boon would also offer suggestions for the next book if an author was blocked, as Mary Wibberley records:

> On one occasion, I took a manuscript to my publishers, and having absolutely no idea about the setting of the next one, said to Alan Boon, "I haven't a clue where to set my next book. Any suggestions?" to which he replied, "Why not try Finland?" (1987:59)

The idea caught her imagination and, after doing some research, she wrote *The Wilderness Hut* (1975).

He also helped authors by generally looking after their interests:

> My second book was under way very soon after the acceptance of the first. Alan Boon handed me the idea on a golden platter, I felt. He wrote out to say what an impact Mazengarb's report had had, that New Zealand has so many surplus bachelors. Why not write a story based on this? . . . *Bachelors Galore* brought me another milestone, it was serialized by a Scots magazine, something that was negotiated by my publisher. He has attended to all secondary rights for me, translations, paperbacks, condensations, the lot. He took great pains with those early books, advising me to re-write certain chapters of the first three, till I caught on to the proper technique of maintaining tension and interest. (Summers, 1974:95)

This way of treating authors was a tradition started by his father, one of the original founders of the firm, as Mary Burchell records in her autobiography. She had a serial published in the

magazine she worked for, which the editor thought would make a book. He offered her a choice of three possible publishers:

> I chose Mills & Boon. And in nearly forty years, I have never had reason to be anything but thankful from the bottom of my heart for that decision.
>
> . . . [I] went along to sign my first contract.
>
> I was so bemused and excited that I would have signed anything. When Mr. [Charles] Boon handed me the contract, I reached for a pen immediately.
>
> "No, no!" he said firmly. "You must never sign anything like that. You take that contract home and show it to your father, and if he says you can sign it, you can." (Cook, 1976:101–2)

This was in 1935, when she would have been about 25!

With the Harlequin buy-out in 1971, this paternalism gradually changed, as the firm increased in size, and the authors' contracts were more rigidly adhered to. The more capitalistic ideology introduced by Harlequin's directors increased after Alan Boon's semi-retirement in the mid-1980s and by the 1990s Mills & Boon was no longer a family-run autonomous firm, but only one part of a worldwide organization.

The marketing strategies of Mills & Boon are not obvious. They do not advertise heavily on TV, nor in other branches of the media. They do, however, advertise next month's selection in the back pages of the current novels. This is a long-established practice, going back to the early days when they printed their whole catalogue at the end of their books. As the number of their publications increased, the list at the end of the novels became more selective, concentrating on forthcoming books and dropping any mention of a backlist.

This, perhaps, was because when they eventually joined the paperback revolution in the 1960s their sales started to soar. Rosamund Pilcher, who wrote for Mills & Boon under the pseudonym Janet Fraser, says that the earnings from her books published by Collins in the late 1950s were substantially more than from the similar books she was publishing with Mills & Boon in the same period. This would not have been the case in the 1970s and 1980s. Cheap mass paperbacks created a market for Mills & Boon books that, at its height, increased popular authors' print

runs to about 100,000 copies per title, and guaranteed new authors an income of "five figures" per title, as Mills & Boon coyly put it at the time. As with all publishing firms, this boom has ended, and print runs and incomes decreased with the recent recession. Harlequin remains, however, a profitable firm whose profits derive from women.

The books would not exist without women – the authors (almost exclusively women – to my knowledge in the past 15 years only two men have achieved success, writing as Victoria Gordon and Madeleine Ker), the readers (how many men read Mills & Boon romances for pleasure – as their preferred choice of novel?) and the editors. Today all editors at Mills & Boon and its sister companies are women. Alan Boon, as was acknowledged at a Romantic Novelists' Association meeting in the 1980s, however, is the exception that proves the rule as "the only man able to sympathetically edit a romance".

As this clearly shows, Mills & Boon's financial and political ideologies are capitalistic. Although they were unable, for financial reasons (McAleer, 1992), to join the paperback revolution in publishing until the 1960s, it was seen as an investment which would substantially increase their readership and thus their profitability. This reasoning was rewarded when their sales in Britain soared, while the merger with Harlequin in the 1970s increased their worldwide readership.

Their target audience of readers is women and their marketing strategies, such as they are, are aimed specifically at women. They rely on women for both the initial production (authors) and the secondary presentation (editors) of the product, but there are few, if any, women in positions of authority within either Harlequin or Torstar. Thus, although women have positions of power – as editors they are the gatekeepers who determine which books get published – and although the financial rewards for their primary producers, all women, are higher than in many other industries, they cannot be called a feminist publishing firm in the way that Virago and The Women's Press in Britain can. The reason for this is that feminism is a political group with political aims. Mills & Boon, Harlequin and Torstar do not have a stated feminist agenda. In that respect the *firm*, as a social entity, cannot be called feminist. However, it does not necessarily follow from this that individual

books, produced by individual women, cannot have a feminist content.

At the Romance and Roses Conference held at Liverpool University in November 1995, most commentators asserted that because Mills & Boon books end with marriage they reflect a "conservative patriarchal status quo". Both "conservative" and "status quo" imply "an existing state of affairs"; in other words the charge is that Mills & Boon books are against change. "Patriarchal" has a different connotation, especially for feminists. According to Eisenstein "patriarchy" is:

> A sexual system of power in which the male possesses superior power and economic privilege . . . The patriarchal system is preserved, via marriage and the family, through the sexual division of labor and society. (1979:17)

I argue that Mills & Boon novels, far from being against change, are in some areas ahead of society in their demand for a shift in public opinion. Although they accept that society is ordered so as to give men the advantage, they do not accept that this is inevitable. Nor do they preach that women are subordinate to men. On the contrary, the books create a literary world where women have the "culturally legitimated authority" (Rosaldo, 1974:21) that men have in the real world. George Paizis argued at the conference:

> since the books do not speak to the reader at only one level, it may well be that what provides the basis of the possibility of communication between text and foreign reader lies in the deeper narrative structures of the novels and it is these that carry the communality of experience of women world-wide, the gap between promise and allotment or impulse and constraint – which exists for women in different cultures. (1995)

At one level this gap – "the not said" – may be what carries the feminist message of the text. In which case "patriarchal" defined as suggesting "a fatalistic submission which allows no space for the complexities of women's defiance" (Rowbotham, 1983:208–9) cannot be applied to Mills & Boon romances. For, if the argument of this book is correct, Mills & Boon novels create a space where women's defiance is articulated.

Feminism, however, is not one monolithic philosophy. Wilson points out that Vera Brittain, writing in the 1950s, saw the philosophical divisions within as historically progressive.

> she traced three stages of feminism: the old original pioneers who had begun by demanding equality and rights; a second generation of feminists (her own) who had between the wars gone on to value the idea of self-support and economic independence; and, finally, a third that emphasized the special values women could bring to a society menaced by destruction, who had "perceived the importance, not of educating women to equal or excel men but of educating men to respect and adopt those women's values which emphasize the principles of love and toleration." (Wilson, 1980:165)

Banks argues that these three traditions are concurrent, and points out that:

> if they have some things in common, [they] are also to a large extent not only different but even contradictory . . . Thus it [feminism] has seemed to stand for both sexual repression *and* free love, for independence *and* protection for women, as identical with *and* essentially different from men. (1986:242)

Mills & Boon authors try to encompass most of these divisions in one "romantic" philosophy. They take as their starting point the importance of connectivity as "a primary feature of both individual psychology and civilized life" (Gilligan, 1993:48), which they call "love". They position this feeling as being primarily feminine. That is, they depict women as "bonding" – making connections – with other humans, while men keep themselves separate from others. The ultimate act of physical connection is sexual intercourse. But "sexual intercourse where there exists no bond of love and spiritual sympathy is beneath human dignity" (Christabel Pankhurst, quoted in Jeffreys, 1985:51). Without love, Mills & Boon novels argue, sex is "a fleeting solace . . . a shallow encounter whose motions mimicked those of love" (Claire Harrison, *One Last Dance*, 1984:8), but which is not "the dance of love" which is "far more exquisite and far more meaningful" (1984:190) than any dance the ballerina heroine has ever danced. Within this frame-

work, they try to reconcile the demand for equality while asserting differences between the sexes.

Anne Cranny-Francis (1990) argues that romance is the one genre where feminism cannot intervene to undercut the patriarchal ideology of its format. In science fiction, in crime, in fantasy, feminists have been able to take the form of the genre they are working with and twist it to their own ends. But romance remains impervious to even the possibility of that intervention. Perhaps because it has already intervened itself.

In 1912 Millicent Heathcote published, anonymously, her first Mills & Boon novel *Eve – Spinster*. In this society novel the heroine, aged 24, confides to her diary:

> I have something of the suffragette about me and rebel against the principle of working women to death in politics [canvassing, etc] and then telling them they haven't the necessary intelligence to vote. I should hate to have a vote, personally, but I'm sure all the clever, thinking women ought to have a vote if they want it . . . An MP sends all his womenkind and other people's womenkind to address men in the slums in order to teach them the principle of Tariff Reform and the evils of Home Rule for Ireland and of the Insurance Bill, and is quite happy they should be out all hours of the day and night ruining their health and temper . . . but . . . says it would unsex women to be allowed to sign their name on a ballot paper once every five or six years!
>
> Spindles [her brother, an Earl] is a convinced suffragette, but, of course, he wouldn't like me to be one, and I certainly have no martyr's spirit and should hate to be hustled by a mob and to go to prison; but I should rather love to sit up on a little impregnable perch and throw electioneering eggs at the people who say insolent things about Women's Suffrage without really going into the subject. (1912:246–8)

This classic "I'm not a feminist but . . ." statement reappears in the books of the period of the Second Wave of feminism, as Carolyn Smalley, who has worked at Mills & Boon as proofreader and then copyeditor for 14 years, pointed out on her questionnaire. However, some Mills & Boon novels from both periods of visible feminism took up feminist arguments directly. In the 1910s they

were arguing unambiguously for the vote. In S.C. Nethersole's *The Game of the Tangled Web* (published in 1916, but set pre-war) the heroine campaigns for the vote. She tells the other man " 'We women want the vote. Not for any fancied importance it will give us ... but that we may do something to counter-balance the mass of ignorant voting throughout the country' " (1916:250). After women gained the right to vote, partially in 1918, and fully in 1928, according to Constance Rover:

> We thought our task was to fight to remove existing legal inequalities and to keep a watching brief on laws, regulations and customs that discriminated against women. Equal pay was a big issue, and the removal of the marriage bar. (quoted in Spender, 1983:160)

Mills & Boon novels did argue against the marriage bar, though they never seem to have been concerned about equal pay. Neither are they interested in legal inequalities. But they do argue against prevailing customs that discriminate against women:

> "But it's all wrong! People may talk of women's independence because they have the franchise, they may declare women are as free as men – but they're not! They are bound by the opinion of civilized society, and civilized society does not re-cognise a woman's right to leave her husband unless he is notoriously unfaithful and either knocks her about or openly deserts her. Have you ever thought how impossible it may be for a nice woman – oh, I hate the expression, but you know what I mean – to induce her husband to do either? Men, our class of men, prefer to live formally with their wives and to keep their *affaires* for private occasions. And it is only the exceptional man who physically ill-treats his wife. You say Keith Kirkland is selfish and heartless – yet the world would not side with Mary should she leave him. It would blame her and pity him, it would remind her that a woman's duty is to be with her husband – and a woman can't go against the whole of her world, Jim. She may say she can but she can't – not the majority of women. Here and there there are excep-tions, but they are not the type to get into difficulties. They're

too selfish and heartless themselves. It's the gentle sensitive women who usually make the mistake of marrying the wrong man, and it's the type that attract him. There's the tragedy of it. Women ought to be free in the way men are – they ought not to be expected to bear more than a man would bear – God knows they have enough in just being a woman!" (Joan Sutherland, *Desborough of the Northwest Frontier*, 1928:210–11)

The 1920s saw the beginning of the "New" feminism, which argued

> that the time had come to stop concentrating on equality, defined as demands for those things that men had and women were without, and to work for those things women needed "not because it is what men have got but because it is what women need to fulfil the potentialities of their own nature and to adjust themselves to the circumstances of their own lives." (Beauman, 1983:70; quoting Mary Stocks, *Eleanor Rathbone*, Gollancz, 1949:116)

This diffusion of feminism away from one major demand towards a more general demand to "organise society so that women can be mothers, lovers, nurturers – and also lead active and meaningful lives in a public sense" (Dora Russell, quoted in Spender, 1983:102) is a philosophy for which Mills & Boon authors have always argued.

The inter-war years saw the decline of visible feminism. Neither the Conservative nor the Labour parties, despite their support for the enactment of women's legislation, "felt obliged to subscribe to a feminist rationale, or to depart from their view of women as wives, mothers and household managers" (Pugh, 1990:156).

It is during this period that Mills & Boon romances start arguing directly against the marriage bar, by having married heroines who work in firms which enforce it. They also show heroines, living apart from their husbands, who go out to work to support themselves and their children. This plot line emphasizes women's traditional nurturing role, their right to self-fulfilment outside the home, and the possibility of combining the two.

By the 1940s even Margaret Malcolm, one of the more conservative authors of this period, wrote passages where the traditional male views of femininity are undermined:

> "I suppose its because she looks so fragile, and that makes men want to look after her," Rilla thought, with considerable acumen. "Most women fight so much for their rights that it must be rather a nice change for a man to come across one that prefers to be allowed privileges." She gave a little squirm of distaste. (*The Master of Normanhurst*, 1944:80)

By the 1950s, despite the prevailing ideology of "mother at home and father at work", Eleanor Farnes was depicting the possibility of working mothers. In *The Constant Heart* (1956) the heroine, a fashion designer, is about to marry the wealthy hero, who has various homes around Europe. She asks:

" 'Charles, must we be bothered by all these houses?' "

" 'You don't have to be bothered. You can go on with your work, and staff can run the houses as they do already,' " he replies (1956:187).

A fantasy, maybe, but one which explicitly separates the heroine from domesticity, and aligns her with the world of work.

By the 1960s society expected its young women to be self-supporting. Women, however, were beginning to see the inequities of the system, and were demanding an end to sex discrimination. They wanted women to be treated as autonomous human beings, not sex objects.

Essie Summers' first novel for Mills & Boon (*New Zealand Inheritance*) was published in 1957. All her romances depict strong-charactered heroines who work for a living. Because most of them marry heroes with farms to run, these women continue to work after marriage and children, and there are many positive portraits of other farming women in the novels.

In her 1960 *Moon Over the Alps* the heroine literally saves the hero's life by: " 'dragging and heaving thirteen and a half stone of manhood, plus sled, plus mattress, plus blankets and a tent up the gully at Hurricane Point, on thin snow on her hands and knees' " (1960:174). In this novel the heroine refuses to marry the hero: " 'Because you don't really love me . . . you think I'd make a good mountain wife. But what woman wants a husband who thinks

she's homely . . . thinks of her as Penny Plain, not at all glamorous?'" (1960:180).

He replies he remembers the first time he saw her:

> "You had a vivid green dress on, and the sunlight was on your hair. It was just like a polished acorn. One leg was tucked under you, one was swinging. You had green sandals on your bare brown feet. Your eyes were the colour of the mountain tarns.
>
> "You looked so much the ideal every man has . . . that for days I daren't let myself believe you were as nice as you looked. That your mind matched your looks." (1960:182)

From the start he has seen her as an individual, with her own beauty. When the heroine compares herself to another woman, he says:

> "She is beautiful . . . deadly, monotonously beautiful. Her features are so perfect you tire of them . . . Chocolate-box beauty."
>
> "Most men would rave over her."
>
> Charles quoted, laughing, "'The rose that all are praising is not the rose for me.' Who said that? Thomas Bayly, wasn't it? Anyway, you know what I mean. Verona is like a painting . . . No life, no variety. But you . . ." his voice deepened. "Some of the time you're just a little brown thing, and then all of a sudden you're – oh, what's the word I want? – bewitching. Irresistible." (1960:183)

As with all her heroines, Summers positions this heroine as brave, caring, intelligent and loved for her uniqueness, not just her femaleness.

A few years later, in *All I Ask* (1964), Anne Weale has a heroine who, after a car accident, leaves England to rebuild her life in Andorra, where she obtains a job in an orphanage. When he proposes, the hero tells her:

> "I had to give you time. I wanted you to be sure you could be happy here. Now that doesn't matter [as] I shall be free to leave Andorra. But as long as I was tied here, I had to be certain that, if I asked you to marry me, I wouldn't be forcing

> you to make an impossible choice. I didn't want our future to
> be based on an unfair sacrifice on your part." (1964:184)

In other words, the heroine is seen as someone with her own life,
her own needs, which she should not be asked to give up for a man.

In fact, throughout the 1970s and 1980s Weale's heroines make
positive references to Germaine Greer and Gloria Steinem, and the
mother of the heroine of *Catalan Christmas* (1988) is a feminist,
as is the mother of the heroine of Celia Scott's *A Talent for
Loving* (1986). Both are depicted sympathetically, although they
are positioned as problematic mothers.

In 1978 the final demand was added to the previous six de-
mands of the Women's Liberation Movement: "Freedom for all
women from intimidation by the threat or use of male violence.
An end to the laws, assumptions and institutions that perpetuate
male dominance and men's aggression towards women." This de-
mand coincides with the depiction by some Mills & Boon authors
of violent heroes, who use sex as a coercive weapon. This is con-
demned in the novels, both by the direct opposition of the heroine,
and by the endings, when sex becomes an expression of love, not
of power. This type of Mills & Boon, so abhorred by feminists, in
which the hero is both verbally and physically abusive to the
heroine, shows that women are aware of misogynist violence but
they do not leave it there. As Batsleer (1985) argues: 'Romance
conventions are based on a recognition and knowledge of fear and
conflict between women and men' (1985:103). The novels attempt
to explain why this should be so and to offer a solution based on
the power of love. They reflect Rebecca West's argument that:

> It was crucial . . . that men should have to give up their prac-
> tice of seeing women only in relation to themselves and that
> they should be made to take women into account as an
> autonomus force outside their control. This, she said, was
> "the keynote of the modern Feminist movement." (Spender,
> 1983:50)

It is in the area of the balance of power between the sexes that
the novels most obviously undermine the dominant ideology, and
come closest to feminist ideology. Patriarchy demands the com-

plete subordination of the woman to the man in a heterosexual marriage. Feminism challenges this, and so do these novels, though not by direct confrontation, as feminism does, but by suggestion.

Thurston claims that American romances of the 1970s and 1980s "helped to spread feminism" (1987). She excludes Mills & Boon romances from this because they were sticking to the domestic romance formula, but many of her points do relate to Mills & Boon books. Not all had violent sex scenes in them. Heroines have careers that are important to them, heroes are supportive.

As Margolies (1982) concedes, "although romances are unlikely ever to further a positive confrontation with reality" some romances abandon the conventions:

> The narrowness of sexual role-typing is casually but effectively opened up in Flora Kidd's *Beyond Control* (1981): "Later the doctor came. She was a small Indian woman who wore a sari under her long white coat" (160–1). The heroine of *Semi-Detached Marriage* [Sally Wentworth, 1982] is satisfyingly involved in a career as a fashion buyer and she directs other people in her job. The heroine of *Beyond Control* makes powerful assertions of her own dignity which are not subjected to mockery, and the happy bourgeois marriage, which seems the goal of most romances, is itself mocked in *No Way Out* [Jane Donnelly, 1980]. Not all heroes are violent and they do not always know better than the heroine (e.g. *The Everywhere Man*, Victoria Gordon [1981]). (1982/3:13)

The heroine of Dailey's *That Boston Man* (1979) is a feminist, as is the heroine of Charlotte Lamb's *Man's World* (1980). She is the deputy features editor on a Fleet Street paper and the book opens with her interview for the job of editor when her boss retires. The interview takes place in a club where women are only allowed as guests, which Kate resents:

> There was only one other woman in the room; the rest were men in elegant lounge suits and self-satisfied expressions.
> Dee [the newspaper's editor] caught her eyes and grinned. "Yes, we're a chauvinisitc lot." (1980:16)

During the interview Kate argues strongly for the inclusion of more interviews with prominent women on the features page, not

the women's page, of the newspaper she works for. Echoing feminist arguments of the time she says:

> "I dispute the validity of a women's page in a newspaper these days. This isn't the nineteenth century. Women aren't housebound morons. They read the rest of the paper – why give them a separate page? You don't have a man's page."
>
> Dee asks: "If I removed the women's page where would I put the cookery articles and fashion?"
>
> "In the dustbin," Kate said furiously (19).
>
> The heroine also shows sisterly solidarity in the division between Dee and his wife, Judy, over their divorce, "Kate's instincts had been to see it all from Judy's point of view." (1980:157)

Men are seen as the enemy in this book, which echoes not only the feminist ideology of that period, but also one aspect of the 1980s' Mills & Boon hero. The sexual politics of this are spelt out in a scene between Kate and Dee, when Kate discovers that the job of features editor is to go to a man. She is furious:

> "Women are second-class citizens to you and always will be. Stupid of me to put in for the job, wasn't it? I'm acceptable to run the office, keep the routine moving, stand in for an absent boss while he takes three-hour lunches and clears off dead on six, but when it comes to actually appointing me offically I can forget it." (1980:47)

Dee angrily kisses her into silence. Later Kate analyzes what happened:

> And Dee claimed he was above sex prejudice? The minute you challenged them they reacted instinctively by imposing their physical superiority to prove that you were not their equal. That was how their minds worked. There was only room at the top for one sex and any woman who thought otherwise had to be shown she was wrong. (1980:51–2)

Later, when she calls a halt to her and the hero's lovemaking, he reacts violently, forcing a kiss on her, and then excuses himself:

192

"What do you think I'm made of? I can't just turn on and off like a tap . . ."

"What you mean is, I wasn't allowed to say stop – you can't allow me the common decency of a right to decide whether to go on or not. You have the physical edge over me, don't you? If you want it, I get it, like it or not." The words poured thickly, bitterly out of her, her eyes on him in a glittering stare. (1980:135)

In Mills & Boon books of this type, there are often two similar scenes, in one the other man uses sex as a weapon and in the other it is the hero who tries to sexually dominate the heroine. It has been argued that this duplication does not differentiate between the hero and the other man, and leaves the reader thinking that love justifies everything, including violence against women. But in fact it is a literary device used to reinforce the feminist argument that all men use sexual coercion to force women into submission (Brownmiller, 1975). Moreover, as I have shown in Chapter Eight, this plot type was only prevalent in the late 1970s and early 1980s, and other plots have now superseded it. As Daphne Clair said in her questionnaire, pointing out the historical specificity of this type of Mills & Boon: "Since abusive men in real life have become exposed, writers have been more careful – what we and most readers thought of as fantasy in a more innocent era we now know is all too common in real life and we don't wish to encourage any notion that it is normal".

In 1991 Mills & Boon published Susan Napier's *Deal of a Lifetime*. In this book the heroine is in line for the position of executive director of a large, family-owned, international firm. In a reversal of the more usual roles, her secretary is a man "looking to ride someone else's coat-tails to the top" (1991:9) as women are often portrayed as doing in non-feminist literature. The hero's 5-year-old son has been taught "to say 'women' instead of 'ladies' or 'girls'" (1991:82). The hero, the half-brother of the head of the company, tells the heroine: "'You were right about me not really caring about the business. It's too big, too diverse for me. I like to concentrate my skills, to be a big fish in a little pond'" (1991:184).

This reflects, while not directly replicating, patriarchal thinking of women's place in society, and what their place in the office

hierarchy should be which has led in the business world to women hitting the "glass ceiling". Napier, while not losing a sense of reality (her hero *chooses* to remain at a lower level) reverses traditional notions by only allowing her hero to go so far, while her heroine is promoted to executive director, thus becoming the hero's boss. This heroine gets it all: "'As long as our children are well-loved, darling, they're not going to lack for anything just because their mother has another kingdom to run'" (1991:186).

As Ricci says at the end of her article in *Everywoman* about the changes that have taken place in women's fiction between the years 1978 and 1988: "It could be that it is through women's engagement with things like romantic fiction that some feminist ideas are beginning, literally, to penetrate the heart of the matter" (1991).

Lamb says she stopped using feminism directly:

> not because I no longer believed in it so much as because I had said all I had to say on the subject and wanted to explore other areas. I had things to say on other subjects which are not unconnected with feminism, but which are not overtly so. For instance, women's choices in life; a purely personal matter, but the fact that they have a choice is a feminist achievement. (questionnaire)

She believes that Mills & Boon novels are feminist, as does Daphne Clair: "I certainly believe that they are feminist and always have been."

Do we then have to re-eavaluate feminism? Not necessarily; but we do have to acknowledge that feminism and romance are bound up with each other in complex ways that take us back to the position of women in society.

Feminism has been one of the most powerful oppositional ideologies of the 1970s and 1980s. A political movement that has concentrated in particular on the relationship between the sexes, it would seem an obvious choice for writers of romances to adopt as their own. As I argue in this book, a close examination of Mills & Boon texts shows how romance writers have adapted certain creeds of both the First and Second Waves of feminism to fit the dominant beliefs which their own writings exemplify. In particular, both feminist philosophy and romance ideology demand a change in

the way sexual, emotional, economic and working relationships between men and women are conducted. They both have a Utopian vision of a society which puts women's desires first, where men adapt themselves to women's needs, and not vice versa, and where there is no perceived difference between the status and social position of men and women.

Mills & Boon romances and feminism have differing political frameworks, but it may just be that under the skin they are sisters. Feminism has many faces. Perhaps romance fiction is one of them.

Bibliography and Further Reading

Harlequin Mills & Boon web site address:
http://www.romance.net/Books/Harlequin

Adam, R. (1975) *A Woman's Place 1910–1975*, London: Chatto & Windus.

Alberti, J. (1989) *Beyond Suffrage: Feminists in war and peace 1914–28*, Basingstoke, England: Macmillan.

Anderson, R. (1974) *The Purple Heart Throbs: The sub-literature of love*, Sevenoaks, England: Hodder & Stoughton.

Assiter, A. (1989) *Pornography, Feminism and the Individual*, London: Pluto.

Baker, N. (1989) *Happily Ever After?* London: Macmillan.

Banks, O. (1986) *Faces of Feminism*, Oxford: Basil Blackwell.

Batsleer, J., T. Davies, R. O'Rourke, C. Weedon. (1985) *Rewriting English: Cultural politics of gender and class*, London: Methuen.

Beauman, N. (1983) *A Very Great Profession: The women's novel 1914–39*, London: Virago.

de Beauvoir, S. (1988) *The Second Sex*, Basingstoke: Pan. (first published in 1949, first English Edition Translated and edited by H.M. Parshely, 1953)

Beidler, P.D. (1982) *American Literature and the Experience of Vietnam*, Athens, Georgia: University of Georgia Press.

Belsey, C. (1994) *Desire: Love stories in western culture*, Oxford & Cambridge, Massachusetts: Blackwell.

Berger, N. and J. Maizels (1962) *Women – Fancy or Free? Some thoughts on women's status in Britain today*, London: Mills & Boon.

Bland, L. (1983) "Purity, motherhood, pleasure or threat? Definitions of female sexuality 1900–1970s", in S. Cartledge and J. Ryan (eds) *Sex and Love: New thoughts on old contradictions*. London: The Women's Press.

Bolen, J.S. (1984) *Goddesses in Everywoman: A new psychology of women*, New York: Harper & Row.

Boone, J.A. (1987) *Tradition Counter Tradition: Love and the form of fiction*, Chicago, Illinois: University of Chicago Press.

Brownmiller, S. (1975) *Against Our Will: Men, women and rape*, London: Martin Secker & Warburg.

Brownstein, R.M. (1982) *Becoming a Heroine: Reading about women in novels*, London: Penguin Books.

Cadogan, M. (1994) *And Then Their Hearts Stood Still: An exuberant look at romantic fiction past and present*, London: Macmillan.

Capper, G. (1987) "Stoking the flame of desire: Four writers of romance". *Women's Review*. No. 21, July.

Cawelti, J. (1976) *Adventure, Mystery and Romance: Formula stories as art and popular culture*, Chicago, Illinois: University of Chicago Press.

Cecil, M. (1974) *Heroines in Love 1750–1974*, London: Michael Joseph.

The Changing Face of Romance (1983) London: Mills & Boon.

Chodorow, N. (1978) *The Reproduction of Mothering: Psychoanalysis and the sociology of gender*, Berkeley: University of California Press.

Cixous, H. (1975) *La Jeune Nee* (Paris: UGE); Quoted in T. Moi (1985) *Sexual/Textual Politics: Feminist literary theory*, London: Methuen.

Clair, D. (1992) "Sweet Subversions", in J.A. Krentz (ed.) *Dangerous Men and Adventurous Women: Romance writers on the appeal of the romance*, Philadelphia: University of Pennsylvania Press.

Cook, I. (1976) *We Followed Our Stars*, London: Harlequin-Mills & Boon.

Coward, R. (1984) *Female Desire: Women's sexuality today*, London: Paladin.

Cranny-Francis, A. (1990) *Feminist Fiction: Feminist uses of generic fiction*, Oxford: Polity Press.

Creed, B. (1984) "The women's romance as sexual fantasy: Mills & Boon," in *All Her Labours II: Embroidering the framework*, London: Women and Labour Publications Collective.

Dawson, G. (1991) "The Blond Bedouin: Lawrence of Arabia, imperial adventure and the imagining of English-British masculinity", in M. Roper and J. Tosh (eds) *Manful Assertions: Masculinities in Britain since 1800*, London: Routledge.

Dixon, j. (1987) "Fantasy unlimited: the world of Mills & Boon". *Women's Review*. No. 21, July.

Dixon, j. (1992) "Mills & Boon". *Million*, No. 7, January/February.

Donald, R. (1992) "Mean, moody and magnificent: The hero in romance literature", in J.A. Krentz (ed.) *Dangerous Men and Adventurous Women: Romance writers on the appeal of the romance*, Philadelphia: University of Pennsylvania Press.

Dyer, R. (1985) "Male sexuality in the media", in A. Metcalf and M. Humphries (eds) *The Sexuality of Men*, London: Pluto Press.

Ehrenreich, B. (1983) *The Hearts of Men: American dreams and the flight from commitment*, London: Pluto Press.

Eisenstein, Z. (1979) *Capitalist Patriarchy and the Case for Socialist Feminism*, New York & London: Monthly Review Press.

Falk, K. (1982) *Love's Leading Ladies*, New York: Pinnacle Books.

A Feminist Dictionary (1985) C. Kramare and P.A. Treichler (eds) London: Pandora Press.

Feminist and Non-Violence Study Group (1983) *Piecing it Together*.

Ferguson, M. (1983) *Forever Feminine: Women's magazines and the cult of femininity*, Aldershot, England: Gower.

Fowler, B. (1991) *The Alienated Reader: Women and popular romantic literature in the twentieth century*, Brighton, England: Harvester Wheatsheaf.

Friedan, B. (1963) *The Feminine Mystique*, Harmondsworth, England: Penguin.

Frenier, M.D. (1988) *Good-Bye Heathcliff: Changing heroes, heroines, roles, and values in women's category romances*, New York: Greenwood Press.

Gilbert, S.M. (1983) "Soldier's heart: literary men, literary women, and the Great War", *Signs* 8.

Gilligan, C. (1993) *In a Different Voice: Psychological theory and women's development*, London and Cambridge, Massachusetts: Harvard University Press.

Greenfield, B. (1985) "The archetypal masculine: its manifestation in myth, and its significance for women", in A. Samuels (ed.) *The Father: Contemporary Jungian perspectives*, London: Free Association Books.

Greer, G. (1970) *The Female Eunuch*, London: Paladin.

Grescoe, P. (1996) *Merchants of Venus*, Canada: Raincoast Press.

Harlequin Thirtieth Anniversary 1949–1979 (1979) Toronto: Harlequin.

Hodge, R. (1990) *Literature as Discourse: Textual strategies in English and History*, Baltimore: The John Hopkins University Press.

Holdsworth, A. (1988) *Out of the Doll's House: The story of women in the twentieth century*, London: BBC Publications.

Hubback, J. (1957) *Wives Who Went to College*. London: Heinemann.

Hull, E.M. (1919) *The Sheik*, London: Eveleigh Nash & Co.

Jackson, S. (1995) "Women and Heterosexual Love: Complicity, resistance and change", in L. Pearce and J. Stacey (eds) *Romance Revisited*, London: Lawrence & Wishart.

Jeffreys, S. (1985) *The Spinster and Her Enemies: Feminism and sexuality 1880–1930*, London: Pandora Press.

Jenson, M.A. (1984) *Love's Sweet Return: The Harlequin story*, Toronto: Women's Educational Press.

Jones, A.R. (1986) "Mills & Boon meets feminism", in J. Radford (ed.) *The Progress of Romance: The politics of popular fiction*, London: Routledge & Kegan Paul.

Klein, V. and A. Myrdal (1956) *Women's Two Roles: Home and work*, London: Routledge & Kegan Paul.

Korbel, K. (1994) *A Soldier's Heart*, Richmond, Surrey: Silhouette Sensation.

Lerner, G. (1979) *The Majority Finds its Past: Placing women in history*, Oxford: Oxford University Press.

Lewis, J. (1984) *Women in England 1870–1950: Sexual divisions & social change*, Brighton: Wheatsheaf Books.

Lewis, J. (1992) *Women in Britain since 1945*, Oxford & Cambridge, Massachusetts: Blackwell.

Light, A. (1986) "Writing fictions: femininity and the 1950s", in J. Radford (ed.) *The Progress of Romance: The politics of popular fiction*. London: Routledge & Kegan Paul.

Light, A. (1991) *Forever England: Femininity, literature and conservatism between the wars*. London: Routledge.

Lovell, T. (1987) *Consuming Fiction*. London: Verso.

McAleer, J.A. (1992) *Popular Reading and Publishing in Britain 1914–1950*, Oxford: Clarendon Press.

Mandel, E. (1984) *Delightful Murder*, London: Pluto Press.

Mangan, J.A. and J. Walvin (eds) (1987) *Manliness and Morality: Middle-class masculinity in Britain and America 1800–1940*, Manchester: Manchester University Press.

Mann, P.H. (1969) *Books, Buyers and Borrowers*, London: Andre Deutsch.

Margolies, D. (1982,3) "Mills & Boon: guilt without sex", *Red Letters*. **14**. Winter.

Melman, B. (1988) *Women and the Popular Imagination in the 20s*, Basingstoke, England: Macmillan.

Miles, A. (1991) "Confessions of a Harlequin reader: romance and the myth of male mothers", in A. Kroker and M. Kroker (eds) *The Hysterical Male: New feminist theory*, Basingstoke, England: Macmillan.

Miller, J. (1986) *Women Writing about Men*, London: Virago.

Modelski, T. (1982) *Loving with a Vengeance: Mass-produced fantasies for women*, London: Methuen.

Ogden, C.K. and M.S. Florence (1915) *Militarism versus Feminism*, London: Allen & Unwin.

Owen, M. (1990) *Women's Reading of Popular Romantic Fiction: A case study in the mass media: A key to the ideology of women* (Unpublished Ph.D. thesis, University of Liverpool).

Pearce, L. (1994) *Reading Dialogics*, London: Edward Arnold.

Pearce, L. and J. Stacey (eds) (1995) *Romance Revisited*, London: Lawrence & Wishart.

Philips, D. (1990) "Mills & Boon: The marketing of moonshine", in A. Tomlinson (ed.) *Consumption, Identity & Style: Marketing, meanings, and the packaging of pleasure*, London: Routledge.

Prentice, W. (1991) *Conditional Surrender*, Toronto: Harlequin.

Priestley, J.B. (1933) *English Journey*, Oxford: William Heinemann.

Pugh, M. (1992) *Women and the Women's Movement in Britain 1914–1959*, Basingstoke, England: Macmillan.

Rabine, L. (1985) "Romance in the age of electronics: Harlequin Enterprises", in J. Newton and D. Rosenfelt (eds) *Feminist Criticism and Social Change: Sex, class and race in literature and culture*, London: Methuen.

Radway, J.A. (1984) *Reading the Romance: Women, patriarchy and popular literature*, Chapel Hill: The University of North Carolina Press.

Radway, J.A. (1987) *Reading the Romance* (introduction to English Edition), London: Verso.

Reincourt, Amery de. (1974) *Woman and Power in History* (English edition 1983) Honeyglen Publishing Ltd.

Ricci, M. (1991) "Romance refuses to die" *Everywoman*, February.

Robins, D. (1942) *This One Night*, London: Hutchinson & Co.

Robins, D. (1965) *Stranger than Fiction*, London: Hodder & Stoughton.

Rosaldo M.Z. and L. Lamphere (eds) (1974) "Women, culture and society: A theoretical overview", *Women, Culture and Society*, Stanford, CA: Stanford University Press.

Rowbotham, S. (1983) *Dreams and Dilemmas*, London: Virago.

Sarsby, J. (1983) *Romantic Love and Society: It's place in the modern world*, London: Penguin.

Segal, L. (1990) *Slow Motion: changing masculinities, changing men*, London: Virago.

Segal, L. (1994) *Straight Sex: The politics of pleasure*, London: Virago.

Showalter, E. (1982) *A Literature of Their Own: British women novelists from Brontë to Lessing*, London: Virago.

Showalter, E. (1985) *The Female Malady: Women, madness and English culture, 1830–1980*, London: Virago.

Smith, B. (ed.) (1983) *Introduction to Home Girls: A black feminist anthology*, New York: Kitchen Table: Women of Color Press.

Snitow, A. Barr (1984) "Mass market romance: pornography for women is different", in A. Snitow, C. Stansell and S. Thompson (eds) *Desire: The politics of sexuality*, London: Virago.

Spender, D. (1983) *There's Always Been a Women's Movement this Century*, London: Pandora.

Summers, E. (1974) *The Essie Summers Story*, London: Mills & Boon.

Talbot, M.M. (1995) *Fictions at Work: Language and social practice in fiction*, Harlow, Essex: Longman.

Taylor, H. (1989) "Romantic readers", in H. Carr (ed.) *From My Guy to Sci-Fi: Genre and women's writing in the postmodern world*, London: Pandora.

Taylor, H. (1989) *Scarlett's Women: Gone With the Wind and its female fans*, London: Virago.

Thurston, C. (1987) *The Romance Revolution: Erotic novels for women and the quest for a new sexual identity*, Urbana & Chicago: University of Illinois Press.

Toth, E. (1983) "Who'll take romance", *The Women's Review of Books*, 1:5, February.

Treacher, A. (1988) "What is life without my love: Desire and romantic fiction", in S. Radstone (ed.) *Sweet Dreams: Sexuality, gender and popular fiction*, London: Lawrence & Wishart.

Usborne, R.A. (1974) *Clubland Heroes: A nostalgic study of some recurrent characters in the romantic fiction of Dornford Yates, John Buchan and Sapper*, London: Barrie & Jenkins.

Valverde, M. (1985) *Sex, Power and Pleasure*, Toronto: The Women's Press.

Watson, D. (1995) *Their Own Worst Enemies: Women writers of women's fiction*, London: Pluto Press.

Weeks, J. (1989) *Sex, Politics and Society: The regulation of sexuality since 1800*, Harlow, England: Longman,

White, C.L. (1970) *Women's Magazines 1693–1968*, London: Michael Joseph.

Whelehan, I. (1994) "Feminism and trash: destabilizing 'the reader' ", in S. Mills (ed.) *Gendering the Reader*, Brighton: Harvester Wheatsheaf.

Wibberley, M. (1987) *To Writers With Love: On writing romantic novels*, Leatherhead, Surrey: Ashford, Buchan & Enright.

Williams, R. (1973) *The Country and the City*, London: Chatto & Windus.

Wilson, E. (1980) *Only Halfway to Paradise: Women in postwar Britain: 1945–1968*, London: Tavistock Publications.

Woolf, V. (1919) *Night and Day*, London: Gerald Duckworth & Co. Ltd.

Worpole, K. (1985) *Reading by Numbers*, London: Comedia.

Index of Mills & Boon Authors

General Index